A Year in
ART

The Activity Book

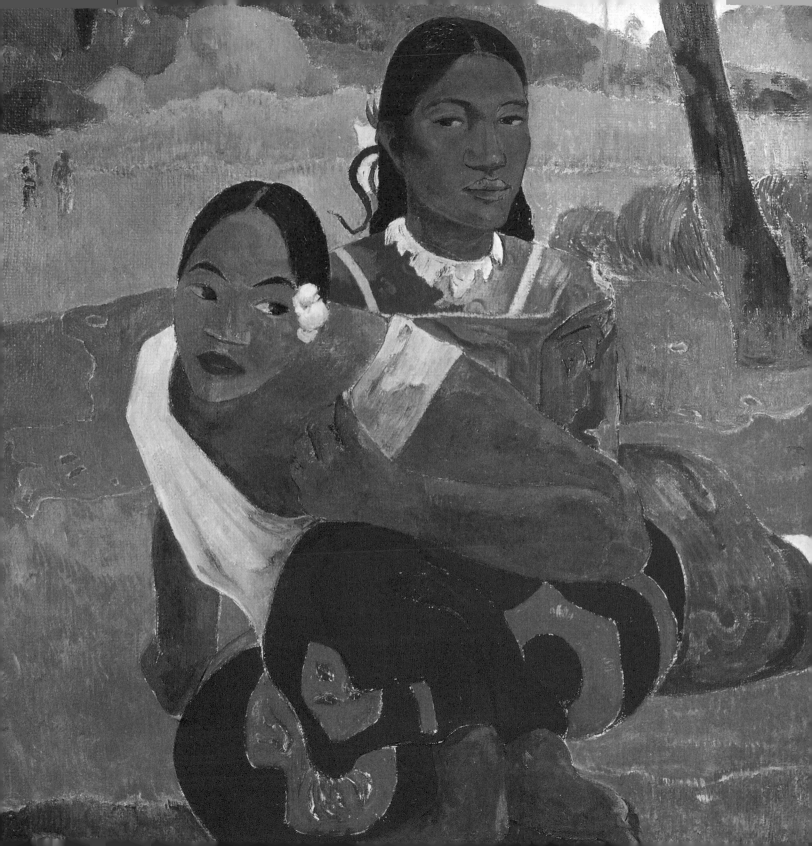

A Year in
ART

The Activity Book

PRESTEL
Munich · Berlin · London · New York

Welcome!

Do you like drawing and painting? Is art one of your favorite subjects at school?
Are you observant? Do you like trying to solve puzzles?
If you have answered "yes" to any of these questions, then this book is just right for you!

So you don't much like visiting art museums? And you sometimes find art rather boring?
Then it's high time that you discovered how much fun art can really be! Just try it out!
This book can lead you on a wonderful journey of discovery into the world of art.

**Soon you will have no time to be bored!
In this book you are about to find 365 adventures
in art waiting to be discovered:**

Let your imagination run wild!
**Can you think up stories
to match pictures?**

Solve tricky puzzles based
on artworks in a variety
of quizzes.

**I spy with my
little eye ...**
you need sharp eyes
for our observation
games.

Everyone is an artist!
Here you can color or complete great works of art; you
will also find lots of suggestions for pictures of your own.

And much, much more.
Have fun!

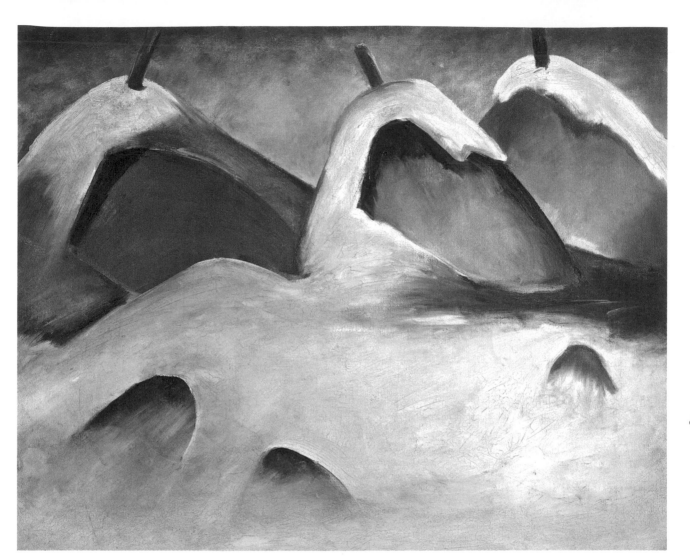

1
January

Franz Marc, Haystacks in the Snow, 1911, Franz Marc Museum, Kochel am See

Paintings can look like many things to many people. This painting by Franz Marc is like that. The shapes suggest snow covered mountains, or pears covered with melted ice cream or frosting.

Can you think of other things?

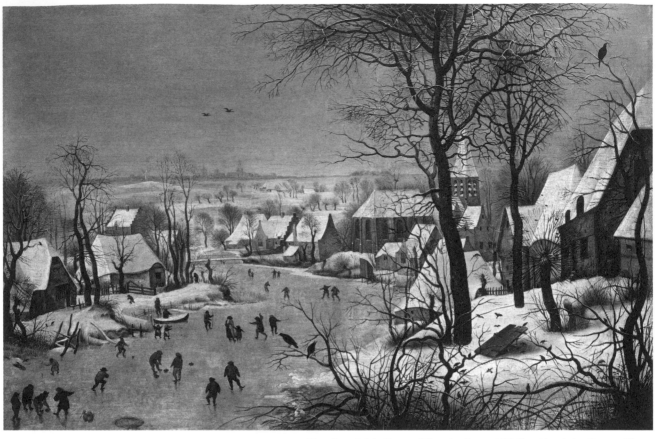

Pieter Brueghel the Younger, Winter Landscape, 1601, Kunsthistorisches Museum, Vienna

2
January

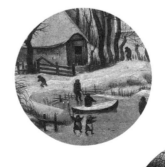

People have enjoyed ice skating for hundreds of years.

Can you see what some of the kids are doing in this painting from Holland? It is over 400 years old!

The artist Jan Vermeer is beginning to paint at his easel. If you would like to know what his studio looked like, you may turn to May 14.

Here however we would like to ask you to imagine what the artist is looking at. You may already be able to see a couple of blue lines...

3
January

People could read pictures before they could read words. Here the artist, Pieter Brueghel, is showing more than 100 famous sayings, some of which are still known.

Can you find the following illustrations:

a) To sit on hot coals

b) To bang one's head against a brick wall

c) To throw one's money out the window

d) To be as meek as a lamb

e) The world turned upside down

f) To swim against the stream

January

The artist is Pieter Brueghel "the Elder," the father of Pieter Brueghel "the Younger." Do you know other families whose children have the same profession as their parents?

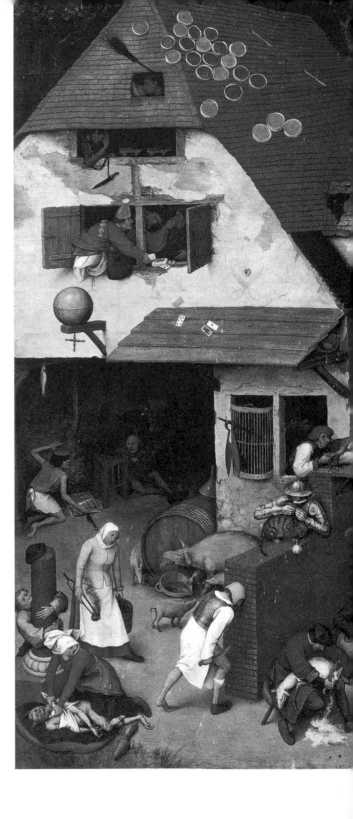

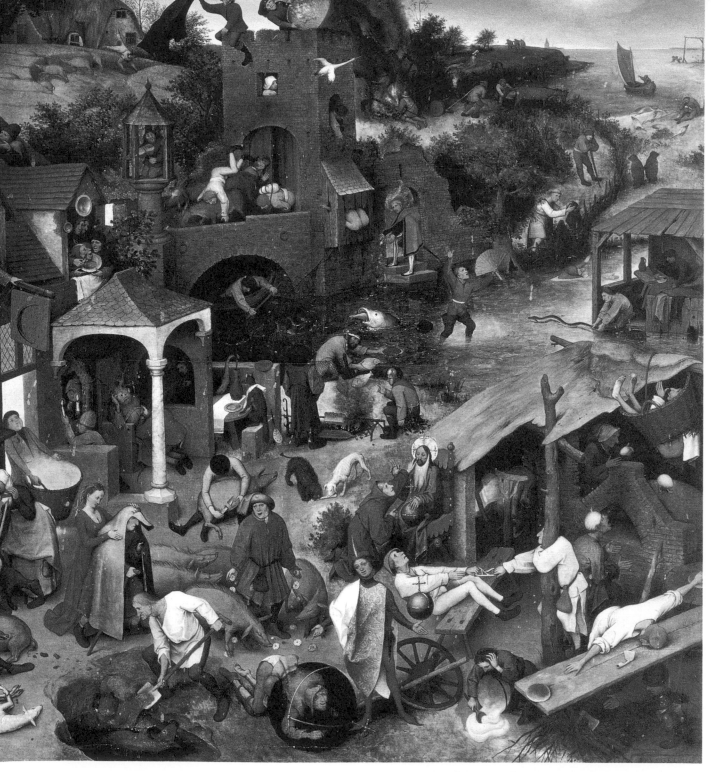

5
January

Pieter Brueghel the Elder, The Dutch Proverbs, 1559, Gemäldegalerie, Berlin

6
January

Gentile da Fabriano, Adoration of the Magi,
1423, Uffizi Gallery, Florence

This painting shows a scene from a famous story. Three men are visiting a stable in Bethlehem with gifts for a newborn baby named Jesus. They have brought gold, frankincense, and myrrh. Myrrh was used in medicine at the time of this story, and frankincense is still used in some churches.

**If you could add a gift,
what would you give?**

7
January

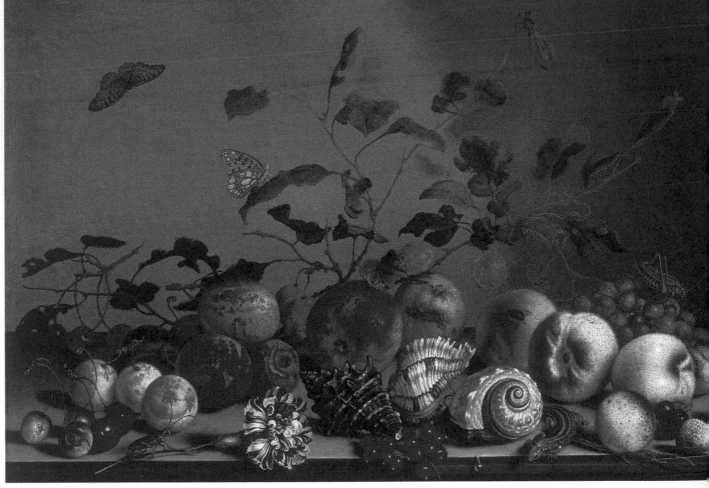

Balthasar van der Ast, Still Life with Fruit, c. 1635, Alte Pinakothek, Munich

8
January

A "still life" is a picture of things that are still, that don't move. In this picture, there are cherries, grapes, and even some shells. But the fruit is getting a bit old and attracting things that are moving.

Can you see some of these creatures?

Hercules, or "strong man," was the name of a Greek god of supernatural strength. As a baby, he was thought to have strangled a snake! You can read many stories, or myths, about him and other gods who could do amazing things!

9
January

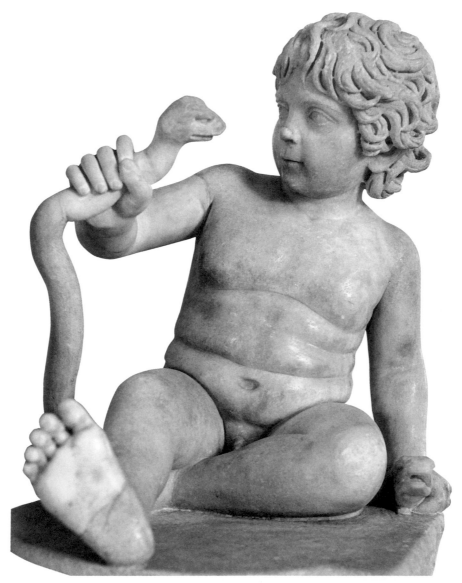

Hercules As a Boy Strangling a Snake, marble, roman artwork, 2nd century, Capitoline Museum, Rome

How do you think this empty town would look on market day?

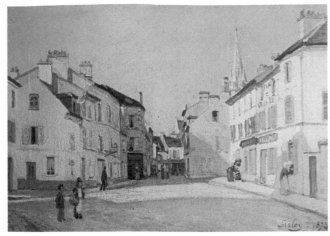

Alfred Sisley, The Square at Argenteuil, 1872, Musée d'Orsay, Paris

10
January

Farmers come to sell their fruit and goods on those days.

What do you think you would see?

11
January

12

January

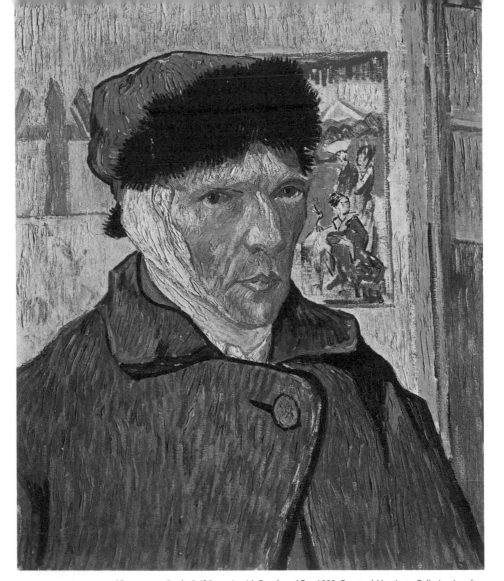

Vincent van Gogh, Self-Portrait with Bandaged Ear, 1889, Courtauld Institute Galleries, London

The painter Vincent van Gogh lived from 1853 to 1890. The self-portrait shows him with a bandaged head—he had injured his ear. You can see a Japanese picture on the wall behind him.

Why do you think that was?
a) Van Gogh was planning to visit Japan.
b) Van Gogh was very interested in Japanese art.
c) It shows a portrait of Van Gogh's Japanese girl friend.

Here are postcards that you can send to friends!

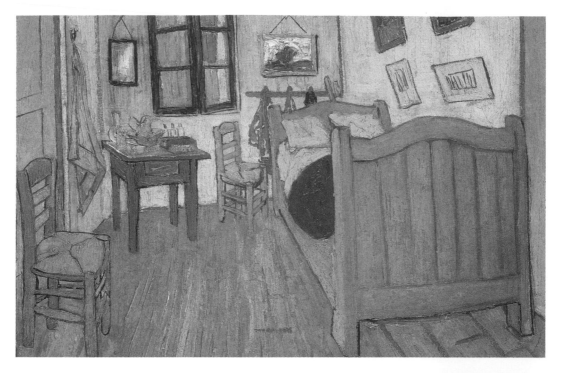

This is what Vincent van Gogh's bedroom in Arles looked like.

He lived in the little house on the corner.

13
January

Vincent van Gogh, The Bedroom, 1888,
Van Gogh Museum, Amsterdam
from "A Year in Art", Prestel

14
January

 Vincent van Gogh, The Yellow House, 1888,
Van Gogh Museum, Amsterdam
from "A Year in Art", Prestel

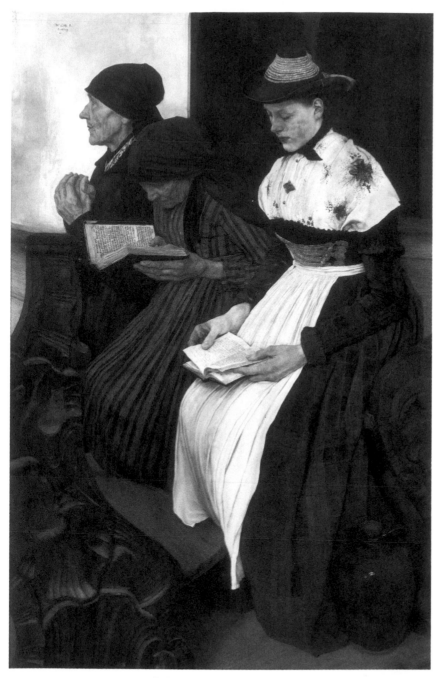

Wilhelm Leibl, Three Women in a Church, 1878/1882, Kunsthalle, Hamburg

Wilhelm Leibl spent over three and a half years painting this picture!

Can you recognize the details in the painting?

15
January

I spy with my little eye!

* a young man with a huge pom pom on his hat

* a little dog

* a woman with a bundle of brush on her back

* a girl warming her hands under her apron

16
January

* a woman has slipped and one can peek under her skirt

* clothing hanging up to dry on a ship

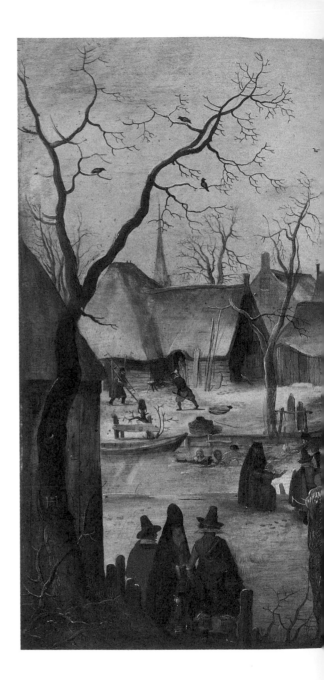

Even hundreds of years ago people loved to have fun on the ice: playing ice hockey, skating, and riding on sleds. But just compare their sleds and ice skates with the ones we use today. Can you see any differences? Clothes were different in those days, too: Look how big their collars are! Do you see other differences?

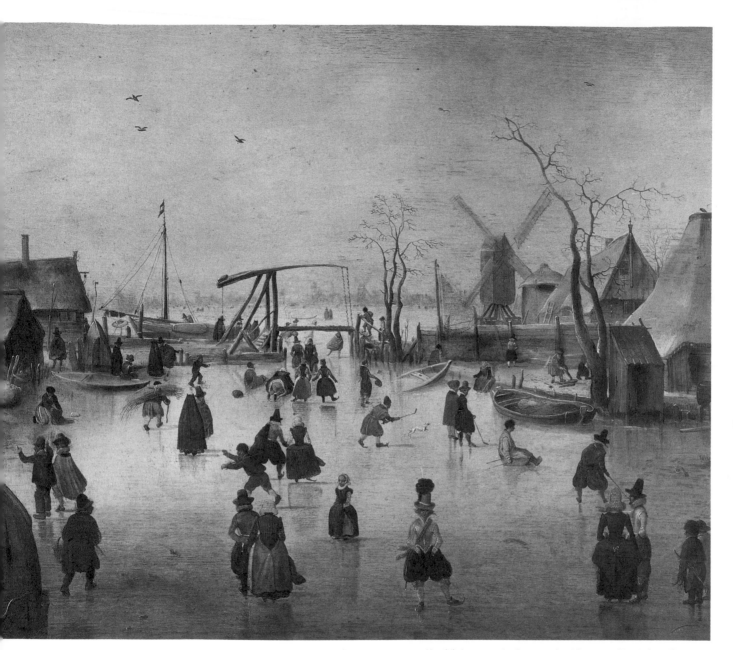

17
January

Hendrik Avercamp, Ice Scene, early 17th century, Mauritshuis, The Hague

18
January

Umberto Boccioni, Simultaneous Vision, c. 1912, Von der Heydt-Museum, Wuppertal

In this picture the painter
Umberto Boccioni has tried to
portray how busy a city can be.
Things are moving in so many
different directions!

**Can you find these
details in the picture?**

Why not color this picture? There's room for some more dancers!

On December 4 you can see the colors of the original picture by Edgar Degas.

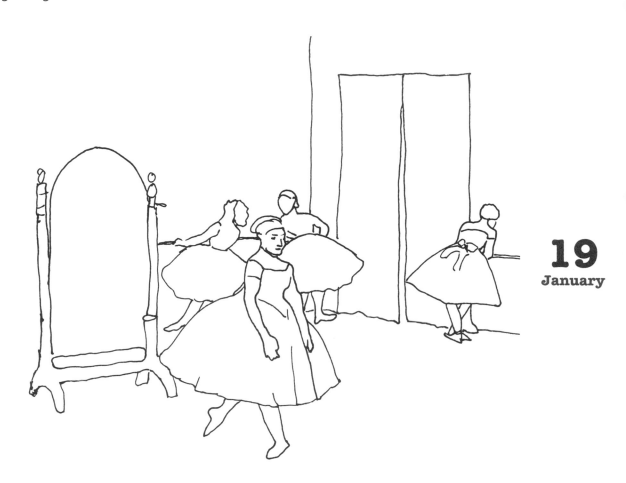

19
January

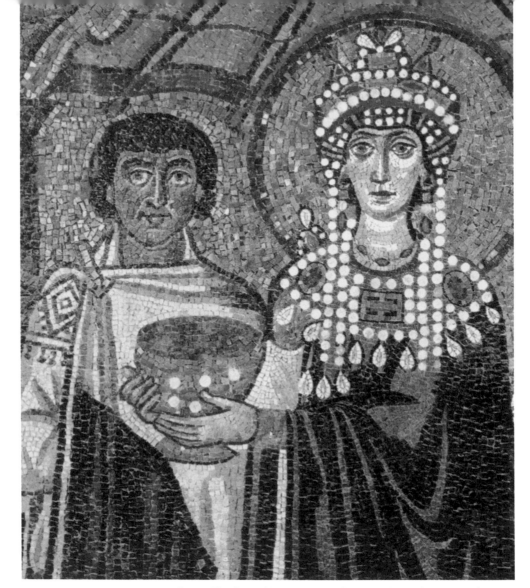

Empress Theodora and Her Retinue (Detail), Mosaic in San Vitale, Ravenna, 6th century

20
January

This picture is several thousand years old! It is part of a very large picture made of many tiny colored stones, like tiles. Some are gold and semi-precious gems. It is a mosaic and shows Empress Theodora with a court official.

You can make a mosaic with stones, beads or even pieces of paper.

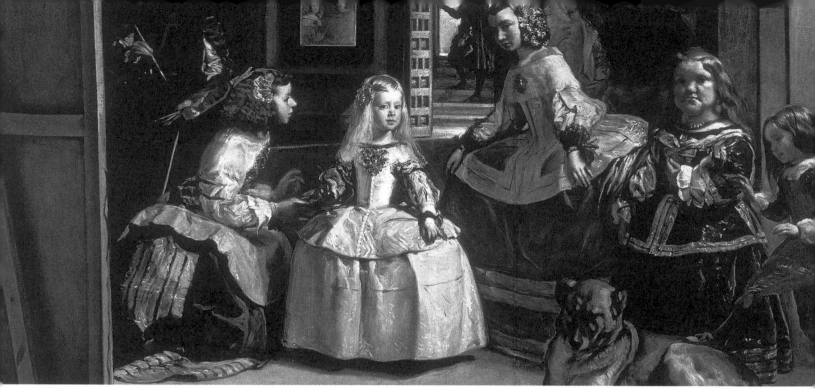

Diego Rodríguez de Velázquez, Las Meninas, 1656, Prado, Madrid

Write a story about the Spanish princess in the middle of this painting.

Her name is Margarita and she is five years old.

..

..

..

..

..

..

..

..

22
January

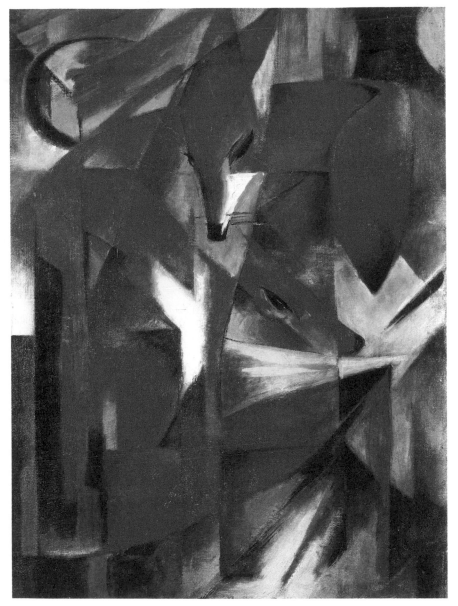

Franz Marc, The Fox, 1913, Kunstmuseum Düsseldorf

Franz Marc loved animals. Here he has painted foxes. Can you find them?

How many are hiding in this picture?

What color are you going to paint the foxes?

23
January

24
January

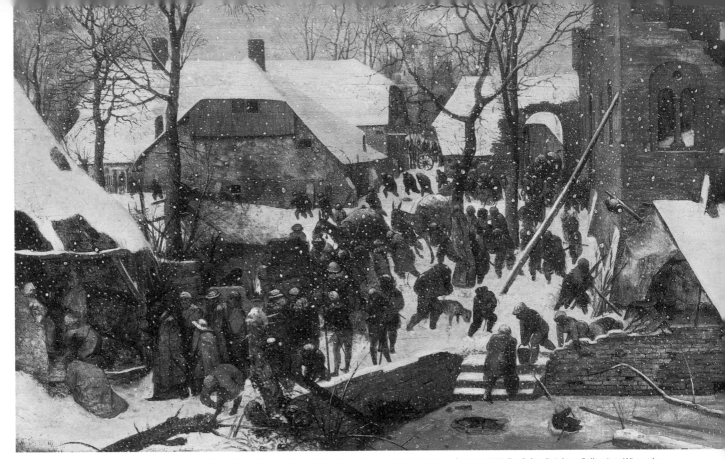

Pieter Brueghel the Elder, Adoration of the Magi in Winter Landscape, 1567, Dr. Oskar Reinhart Collection, Winterthur

There is a lot to see in this winter picture. Snowflakes are falling. There are people, two donkeys, and a large dog. There is also a child in the stable. Can you see all these things? The artist has hidden the Christ child in a stable. People have come to visit Him.

Can you see Him? And have you spotted the two donkeys and the big dog?

You can draw more animals in the icy winter landscape.

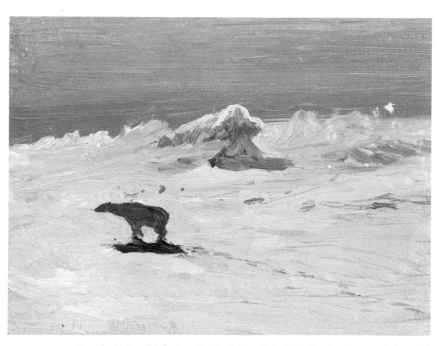

Alexander Borisov, A Polar Bear Hunting in Moonlight, 1899, Fine Arts Museum, Archangelsk

25
January

Just imagine you are sitting in a boat and someone is giving you a ride through canals. There are so many things to discover which you can add next to the picture.

Why don't you complete it?

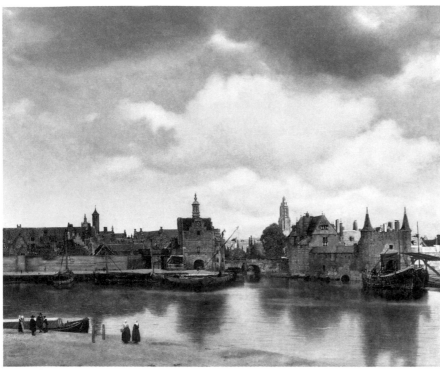

Johannes Vermeer, View of Delft, c. 1660, Mauritshuis, The Hague

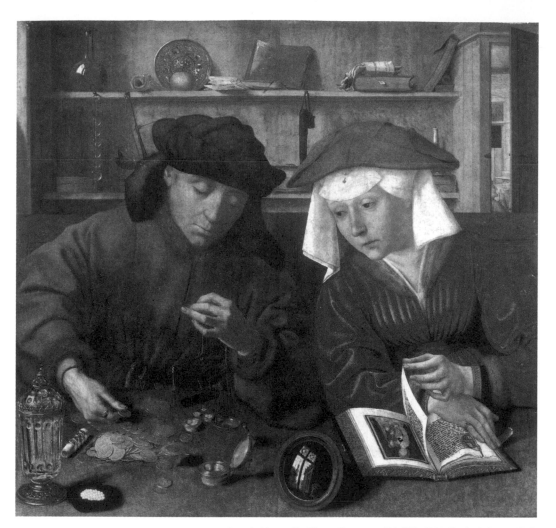

Quentin Massys, The Money Changer and his Wife, 1514, Musée du Louvre, Paris

27
January

This picture is full of secret signs. Lots of the things that you see here have special meanings. They are symbols. The round mirror is a sign of the fragility of life. The glass container, rings, and shimmering pearls show us how rich the couple is.

Can you find these things?

Can you guess what the scale is for?

a) **cooking**
b) **vanity**
c) **justice**

28
January

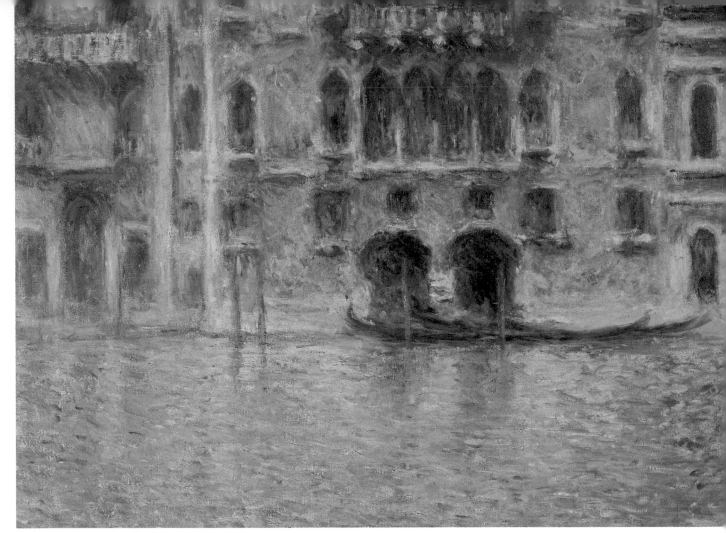

Claude Monet, Palazzo da Mula, Venice, 1908, National Gallery of Art, Washington D.C.

There is a special name for the boat that travels through the hundreds of canals in Venice, Italy. The canals are like roads through the city.

Can you guess the name of the boat?

a) canoe b) gondola c) raft

The artist's friend, Camille, is modeling traditional Japanese clothing.
Would you like to add color? What would you like to dress up as?

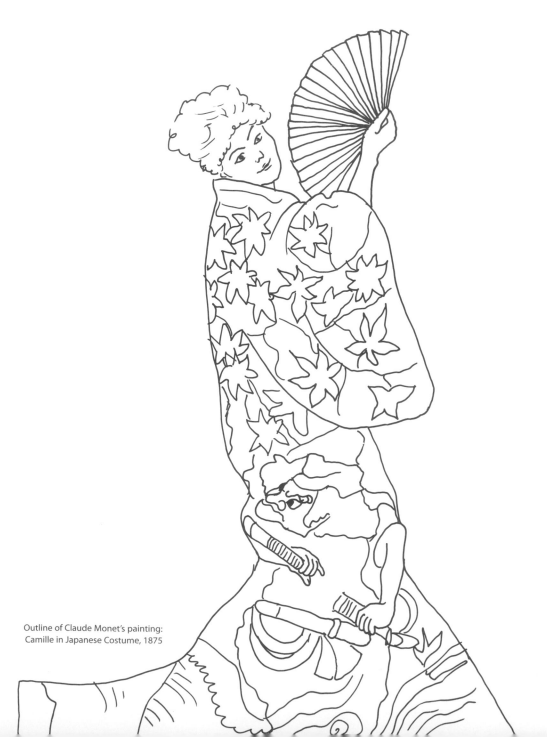

Outline of Claude Monet's painting:
Camille in Japanese Costume, 1875

29
January

Can you pass me that knife, please? Oh, it's only a painting! But don't you think the cupboard looks almost real? It is as if the artist was trying to tease us and to make us try to pick up the objects he has painted.

Do you see ...

※ a mirror?

※ a shell?

※ a skull?

※ a gun?

※ a black piece of coral?

※ a stag beetle?

What else can you see in the picture?

30
January

Domenico Remps, Glasvitrine mit vielen Gegenständen, 17th century, Opificio delle Pietre Dure, Florence

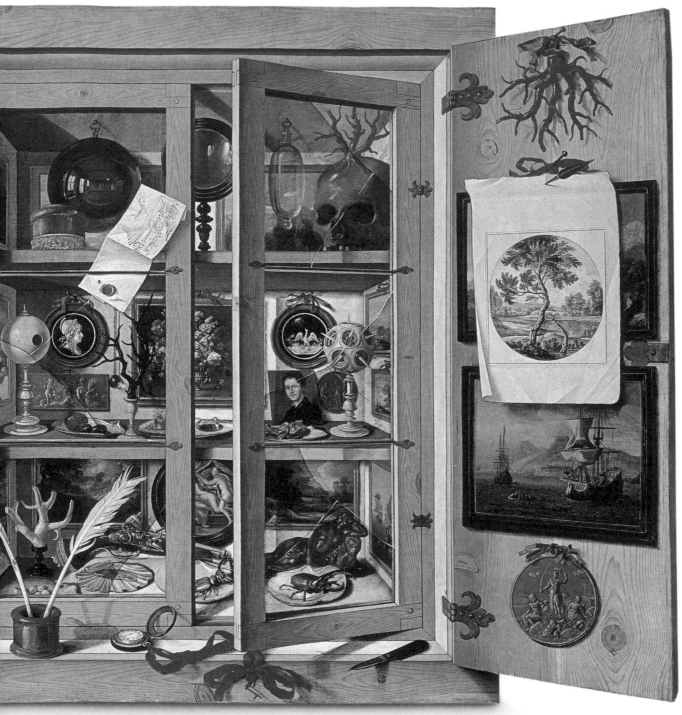

31

January

Domenico Ghirlandaio, St. Jerome in his Study, 1480, Church of Ognissanti, Florence

1
February

This picture of St. Jerome shows him in his study. He loved reading and is known for translating the Bible into Latin. He is also the patron saint of translators.

Are you able to tell from this picture that he spoke foreign languages?

Sometimes, shapes and colors are painted without being recognizable things that we know. Artist, August Macke, painted this way.

If you like, you can add more to the picture.

August Macke, Colored Forms I, 1913, Westfälisches
Landesmuseum, Münster

2
February

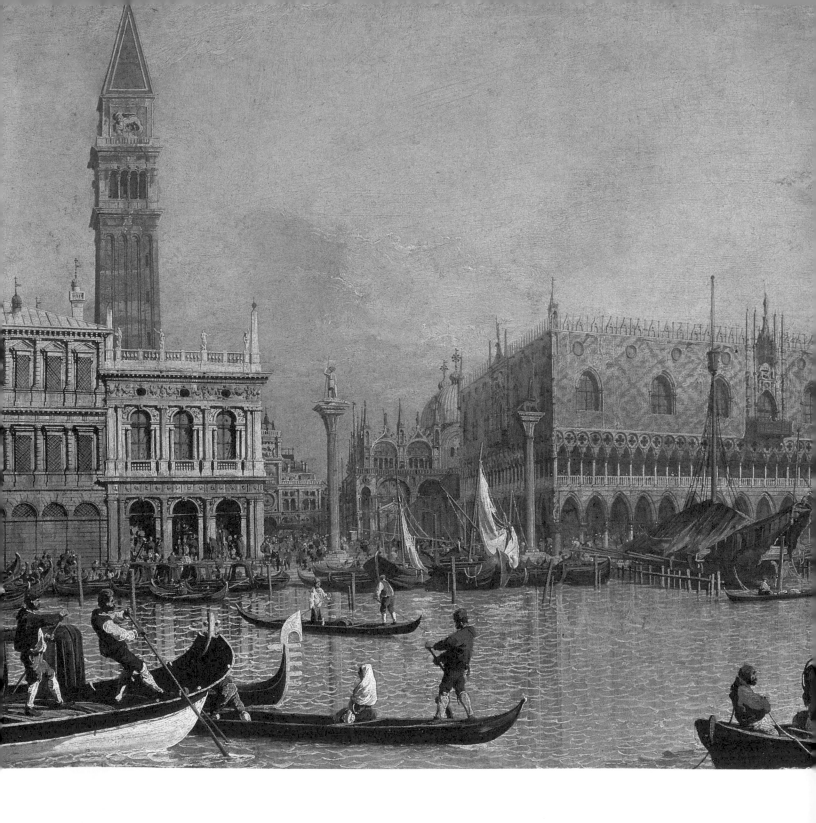

The artist Canaletto painted many, many pictures of Venice, his home. Aren't the buildings magnificent? In the middle you can see the Doge's Palace —to the left is the clock tower. The clock shows the phases of the sun and the moon as well as the signs of the zodiac.

You can see some things more clearly in the details below. Can you match them to the larger picture?

4
February

5

February

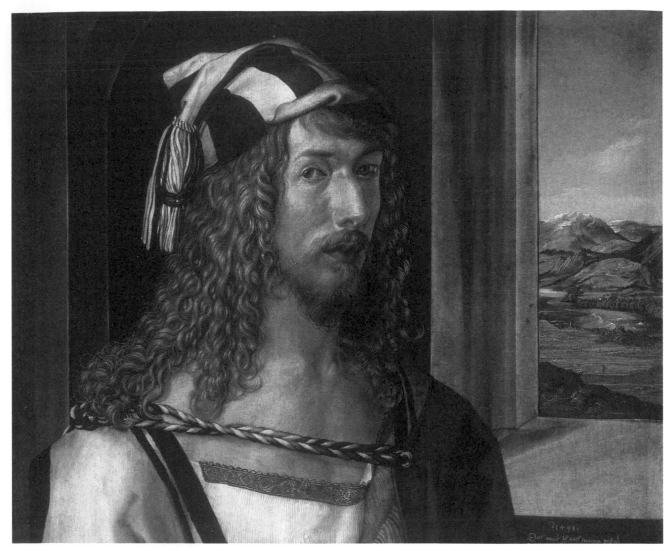

Albrecht Dürer, Self-Portrait at 26, 1498, Prado, Madrid

Albrecht Dürer was only 26 years old when he painted this self-portrait. That was more than 500 years ago! He was one of the first artists to paint pictures of perfectly ordinary people. Before that, only biblical figures or famous rulers could be portrayed alone.

Can you see the inscription on the right-hand side of the painting?

Where is this road leading to?

6
February

Mato Tope was an important Native American chieftain during the 19th century.
His name means "Four Bears." Look at his magnificent headdress!

Chief Four Bears, whom you can see on the right, is wearing a special eagle feather
in his headdress.

You can write a story about him and also add a picture.

7

February

It happened in the year of the great drought

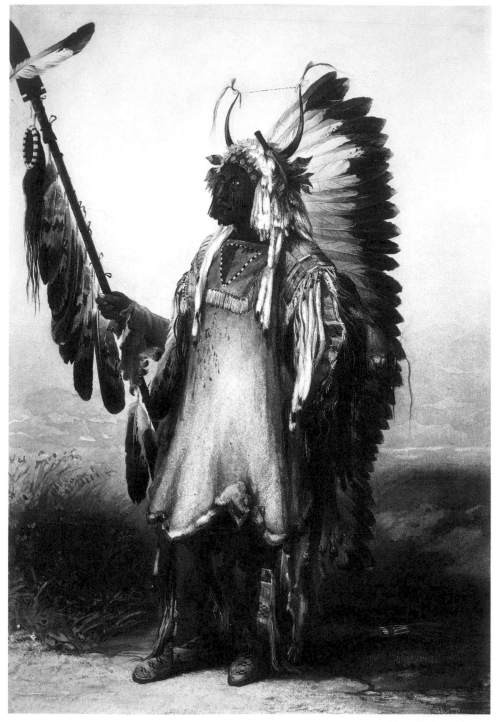

8
February

Mato Tope (Four Bears), a chieftain of the Mandan, watercolor

The Bible tells a story of people who wanted to build a tower up to the heavens, to God. They could not agree and argued and argued. God punished the people by making many languages so people could no longer understand one another. The building collapsed as well.

Do you know which city we are talking about?
a) Pisa
b) Babel
c) Paris

9
February

How would you build a tower which reaches to the sky?

Here you can construct your own.

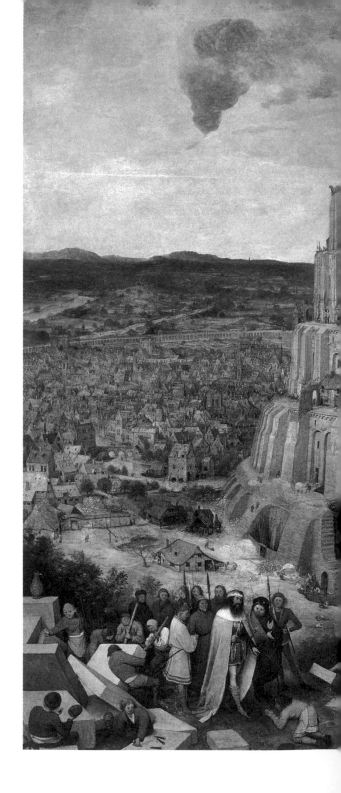

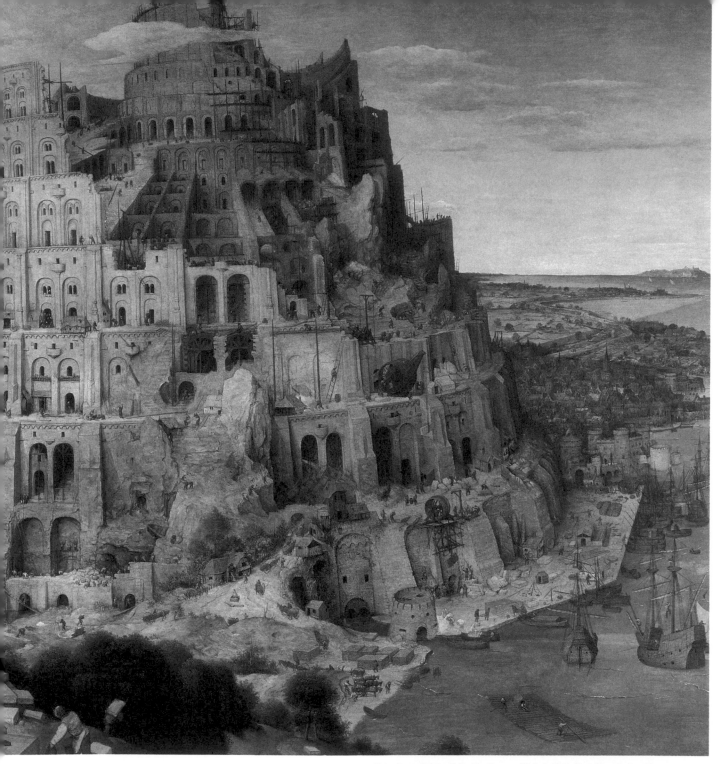

10
February

Pieter Brueghel the Elder, The Tower of Babel, 1563, Kunsthistorisches Museum, Vienna

This artist loved to paint flowers and fruit.

How many things can you spy with your eye?

Jan Davidsz de Heem, Still Life, undated, National Gallery, Prague

11
February

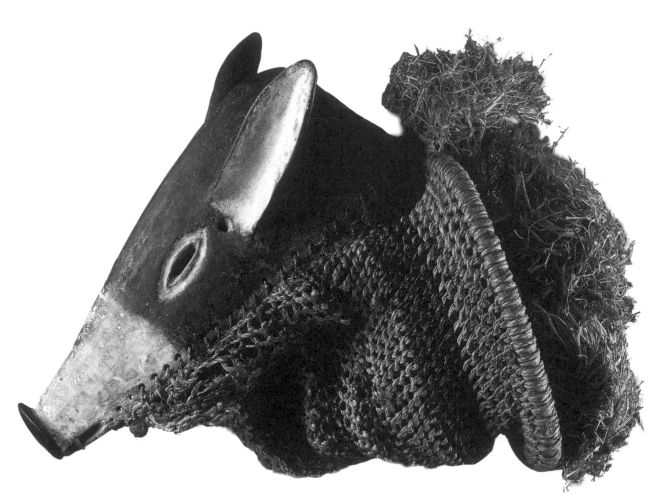

Anteater Mask, Chokwe, Angola, Zambia, Zaire

This animal lives in Africa and mostly eats termites. Some African people worship it as the animal form of Seth, the god of the desert.

Is it an ...

a) aardvark? b) antelope? c) anteater?

Put on your mask and imagine joining the crowd in this picture. No one will know you and you can be part of the Carnival celebration! You will be able to notice many things from a new perspective.

Where will you be? Like the boy running with his dog or looking out from a window? Can you see them?

Can you find these details in the picture?

Giovanni Signorini, Carnival in Florence, 19th century, Uffizi Gallery, Florence

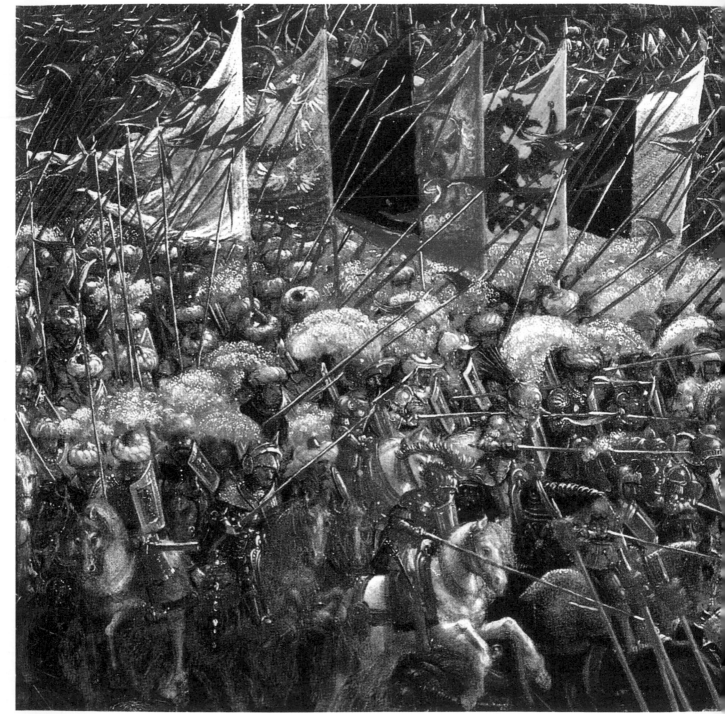

15
February

Pictures can tell stories. This painting tells the story of the victory of the young Greek king, Alexander the Great, over the Persian ruler Darius. Thousands of soldiers fought each other! You can recognize the Greeks by their white and blue uniforms; the Persians wore red, and often had turbans on their heads. Alexander the Great is dressed entirely in gold; he is pursuing Darius, who is fleeing the scene of battle. The date of this battle can be remembered with a rhyme: "The Persians and Darius did flee / in Issus in three three three" (333 BC).

16
February

Albrecht Altdorfer, The Battle of Issus 333 BC, 1529, Alte Pinakothek, Munich

Can you find these details in the picture?

Claude Monet painted many pictures of haystacks like these ones. You would be amazed to see all of them! Although the subject is the same, each painting is different! Monet was interested in the changing light. He painted haystacks at all times of day and in different seasons. Sometimes, the light seems to glow as if it were a warm evening. The haystacks look very different in a cool, morning light.

17
February

Can you imagine?

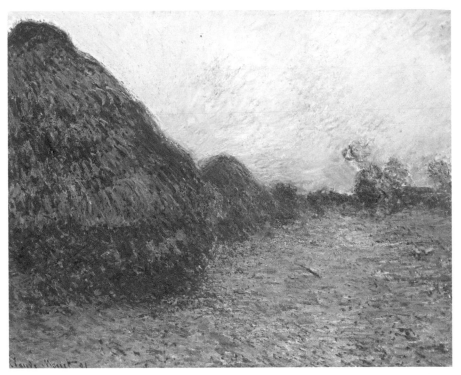

Claude Monet, Haystacks: Snow Effect, 1890/91, National Gallery of Scotland, Edinburgh

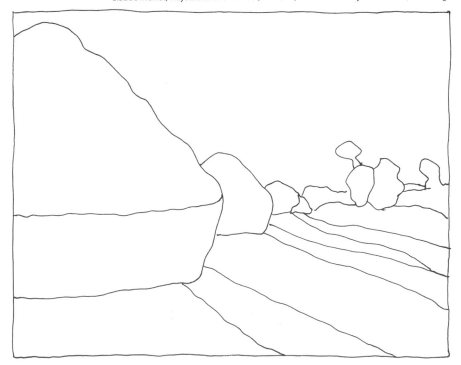

Which colors will you choose for this picture?

18
February

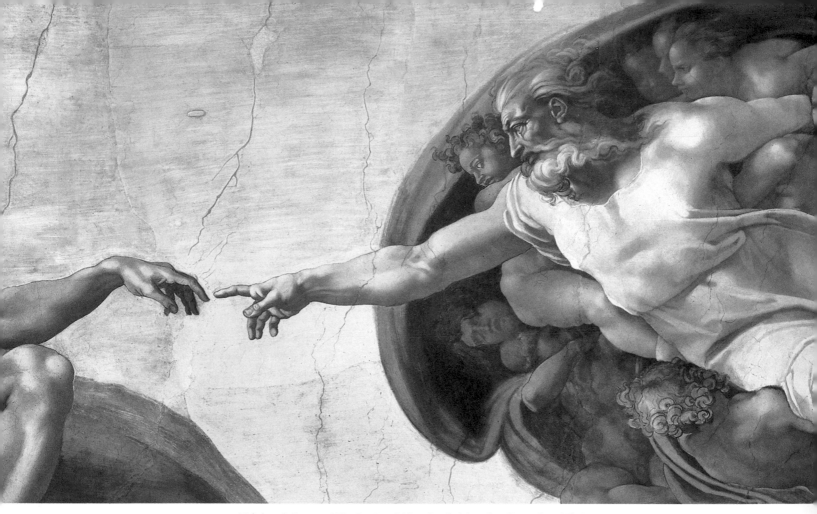

Michelangelo Buonarotti, The Creation of Adam, Detail of the ceiling, Sistine Chapel, The Vatican, 1511, Vatican Museum, Vatican City

How can you show the story of creation? Michelangelo painted it across the entire ceiling of the Sistine Chapel in Rome. Here is the detail that shows God as a bearded man touching a man's hand and bringing him to life. Michelangelo was already an old man when he painted this. For four long years, he climbed a high scaffold to lie on his back all day painting, his arm raised and tired and paint dripping on him.

Who is the man on the left side of this painting?
a) Adam b) David c) Abraham

Here is room for a picture!

20
February

How can you describe
what someone cannot see?
This young girl is describing
the colors of the rainbow
to the blind woman.

21
February

Can you guess
how many colors
a rainbow really
has?

Is it...
a) 3?
b) 7? or
c) 128?

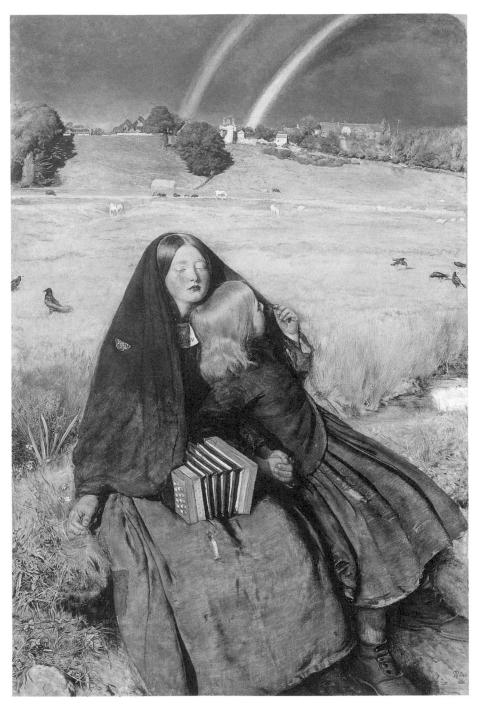

John Everett Millais, The Blind Girl, 1854-56, Birmingham Museums & Art Gallery

This painting of Mona Lisa is one of the most famous pictures in the world. The painter, Leonardo da Vinci, has always been admired for his skill. "Mona" means "Miss" or "Madam." Lisa is the young lady's name. People have always wondered about her smile.

What is she thinking? What might she know? Notice the finely painted details: her mysterious smile; the fold of the sleeves of her robe; the embroidery around the neckline?

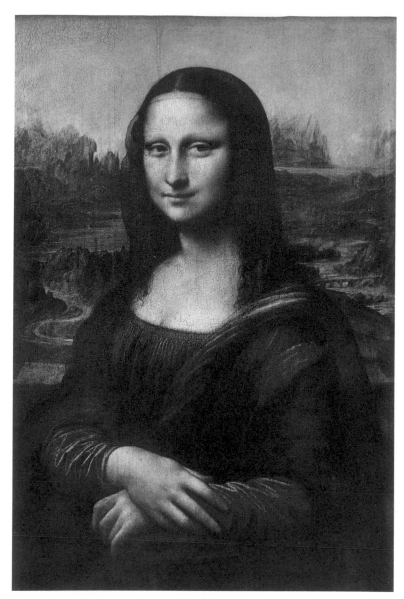

Leonardo da Vinci, Mona Lisa, c. 1503, Musée du Louvre, Paris

22
February

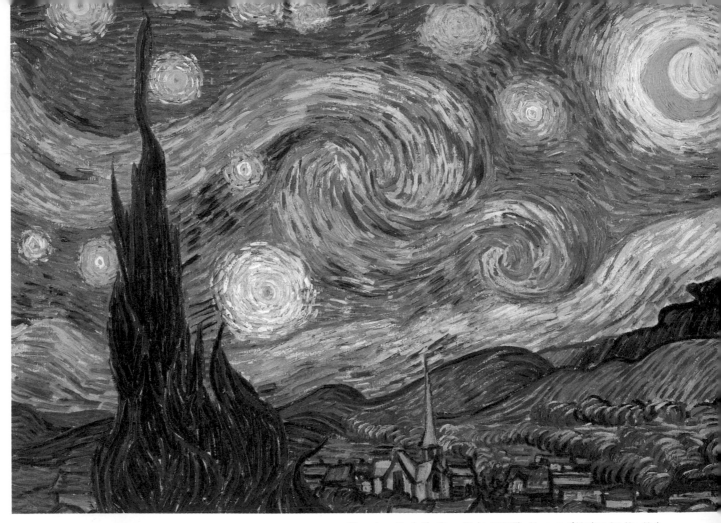

23
February

Vincent van Gogh, The Starry Night, 1889, The Museum of Modern Art, New York

Can you find these details in the picture?

The Dutch painter Vincent van Gogh used vivid colors and swirling, moving, curved, and strait brush-strokes in his paintings.

How would this landscape look during the day?

Would you like to show it in color?

24
February

Some of the games that these children are playing in this picture are the same games you may still be playing. Pieter Brueghel painted more than 80 games in this picture! It was painted over 400 years ago!

Do you recognize any of the games? Here is a start:

✳ leap frog

✳ blind man's bluff …

25
February

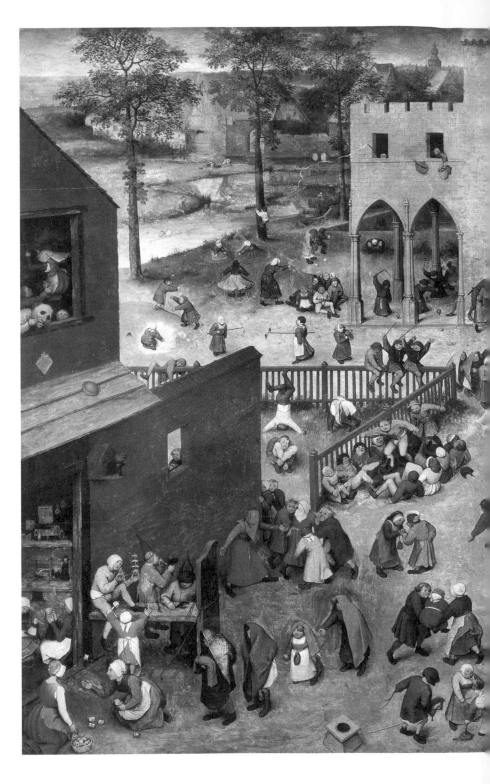

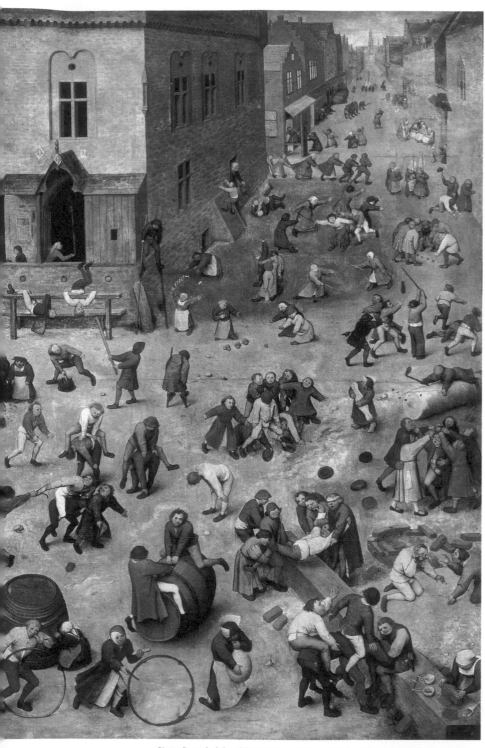

Pieter Brueghel the Elder, Children at Play, 1560, Kunsthistorisches Museum, Vienna

Can you find these details in the picture?

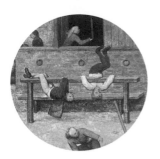

26
February

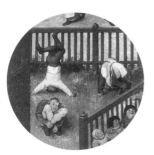

Can you imagine fruits and birds for this Tree of Life?
You can add them here. You can add other things here too!

27
February

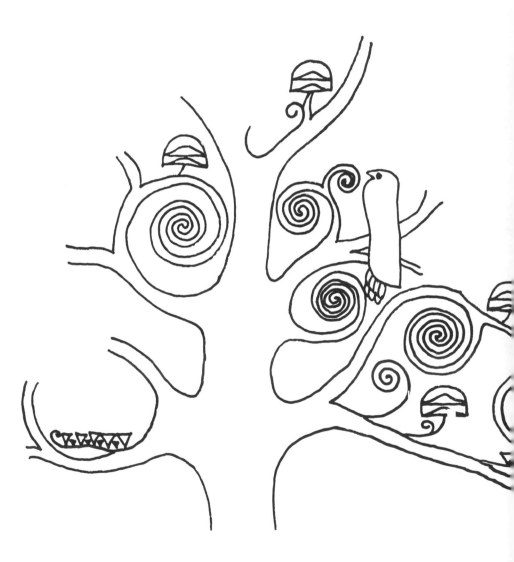

Gustav Klimt, details from the Stoclet Frieze, 1905-11, MAK, Vienna

This is part of a frieze by the artist Gustav Klimt. (We saw part of a mosaic frieze earlier of the Empress Theodora).
It is painted on a very large wall in a dining room in a villa, and has coral, gold, and semi-precious stones added to it.
A tree spirals along the wall, perhaps like the Garden of Eden. There is also a couple hugging.

28
February
29

Can you find these details in the picture?

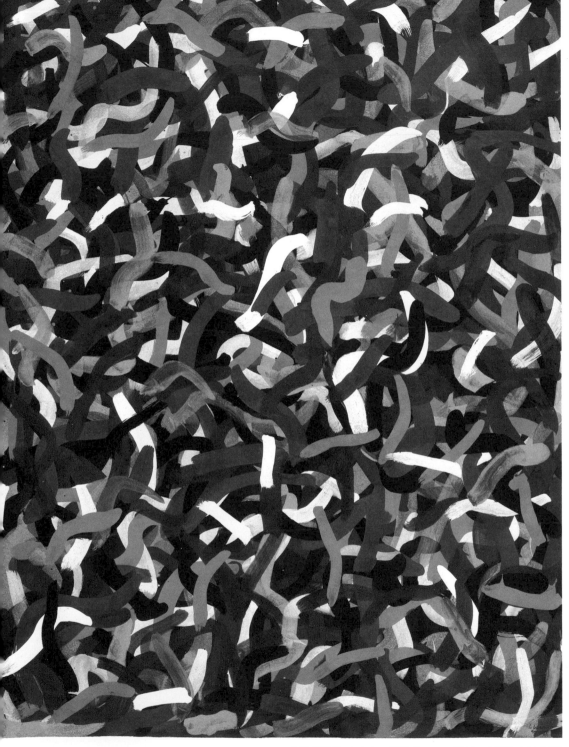

Sol LeWitt loved to paint or draw directly on the walls instead of paper or canvas. Much of his work is so large that he needed people to help him. He gave very clear instructions so that his work would look the way that he wanted it to.

Sol LeWitt, Brushstrokes, 1996, Museum of Prints and Drawings, Berlin

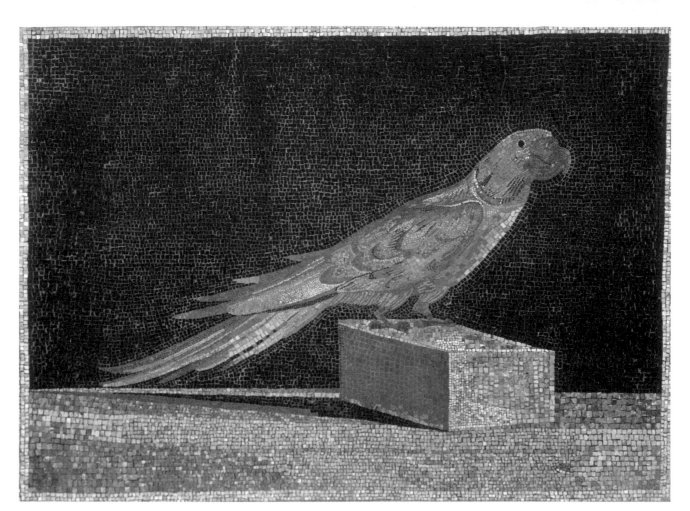

Parrot mosaic, 159–138 BC, Pergamon, Antikensammlung, Berlin

2
March

This is part of another mosaic found in a palace.
It is over 2,000 years old!

**Did you remember that you could make
a mosaic from pieces of paper that can
be attached to another surface? You can
even use beans or pieces of fabric.**

I spy with my little eye!

* A man dressed in yellow is lying on his back on the ice

* A second man in red is pointing at him

* Three people are performing a trick

Can you find them?

What else do you see? There are so many people and so much to see!

3
March

The person who painted this picture was named Robert van den Hoecke. His name might give you an idea of which country he was from.

Was it ...

a) Germany?
b) The United States?
c) The Netherlands?

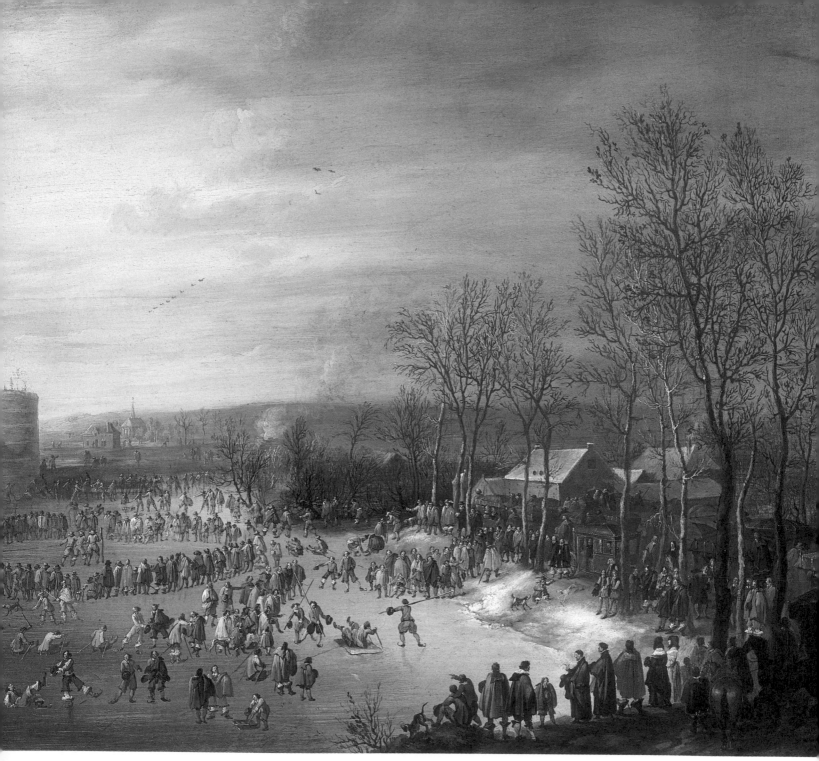

Robert van den Hoecke, Ice Skating on the City Moat in Brussels, 1649, Kunshistorisches Museum, Vienna

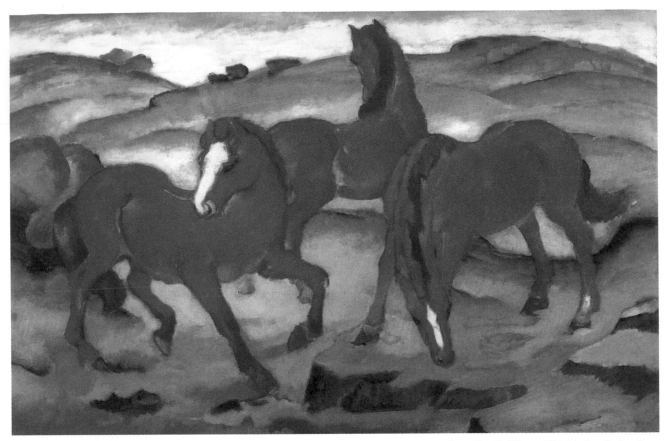

Franz Marc, Red Horses, 1911, Private collection, Rome

We have seen some of Franz Marc's foxes and birds. Now red horses! Marc and some of his friends joined together because they wanted to paint their own way. They wanted to use color and shape to describe the world differently from how it really is.

They gave themselves a name for their group: The Blue Riders.

What color should the horses be?

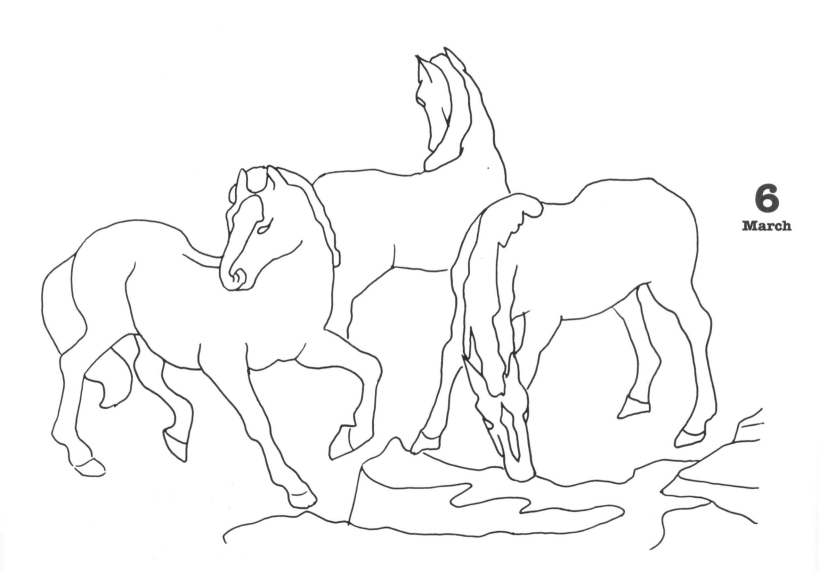

6
March

There are many famous people in this painting.
Some of them are politicians, some are artists,
and some are mathematicians.

I wonder what the jobs of the men in the center might be?

a) kings
b) philosophers
c) artists

7
March

Can you find these details in the picture?

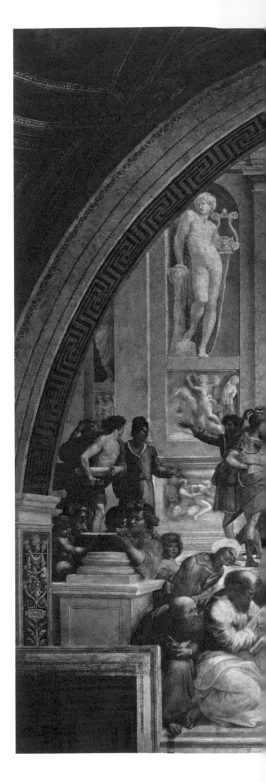

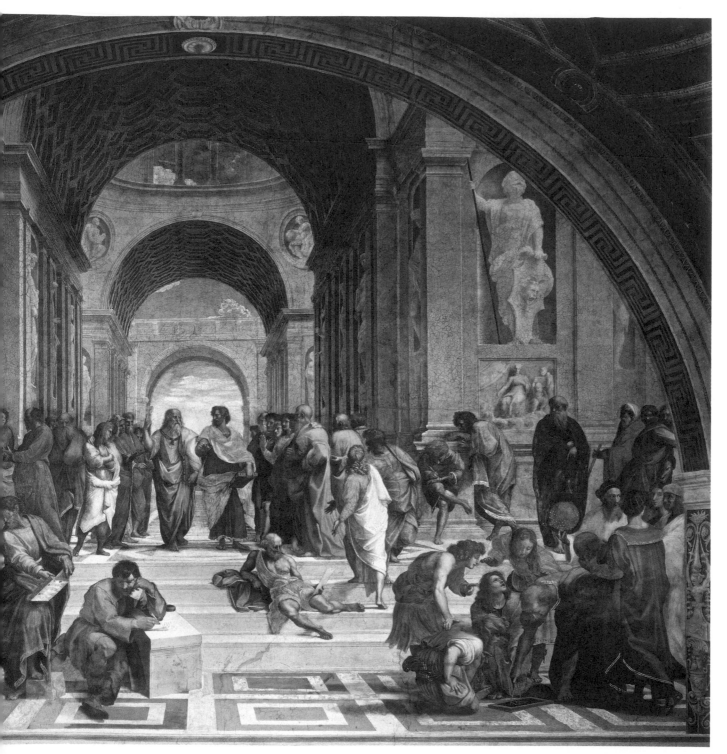

Raffael, The School of Athens, 1509/1510, Stanza della Segnatura, Vatican City

9
March

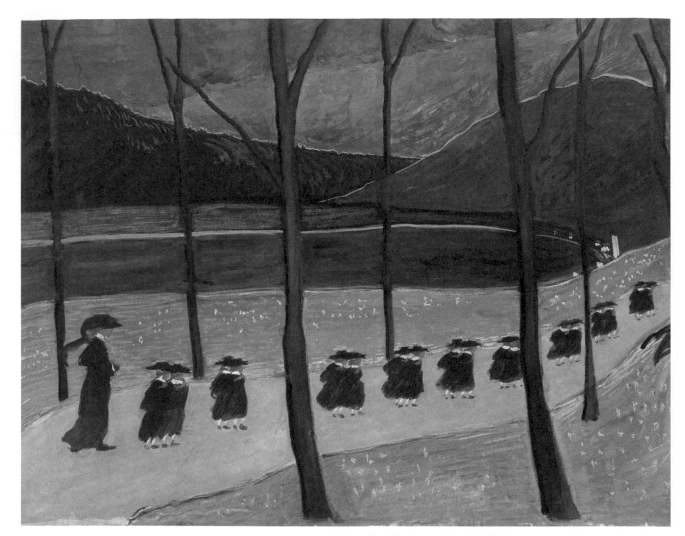

Marianne Werefkin, Autumn (school), 1907, Museo communale d'arte moderne, Ascona

These children are on their way to school. They are walking
with partners. The road looks pink and the sky orange!

**Could the colors suggest the time of year?
Spring, fall, summer, or winter?**

Would you like to add their school?

10
March

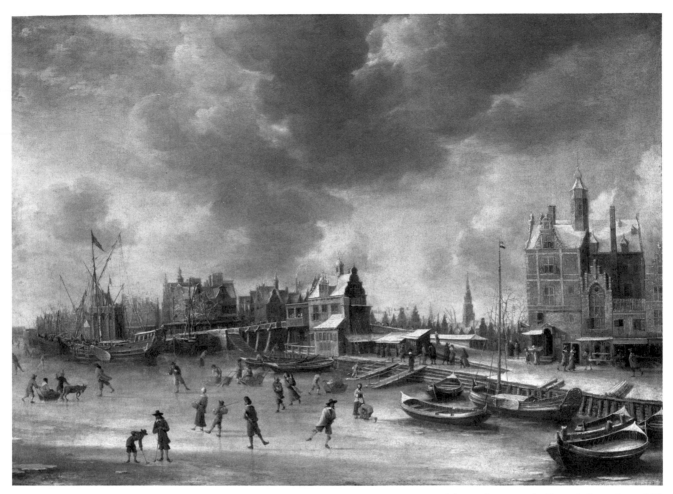

Johannes Beerstraten, Ice Skaters in Amsterdam, c. 1660

In the winter, the many canals of Amsterdam can freeze. Instead of using boats (do you remember the word gondola?), people skate through the city, sled, or play hockey! People did this hundreds of years ago, just as they still do today. Look at some of the details in the picture! If you look carefully you can see sleds, ice skaters, and people playing hockey.

Can you also find these details in the picture?

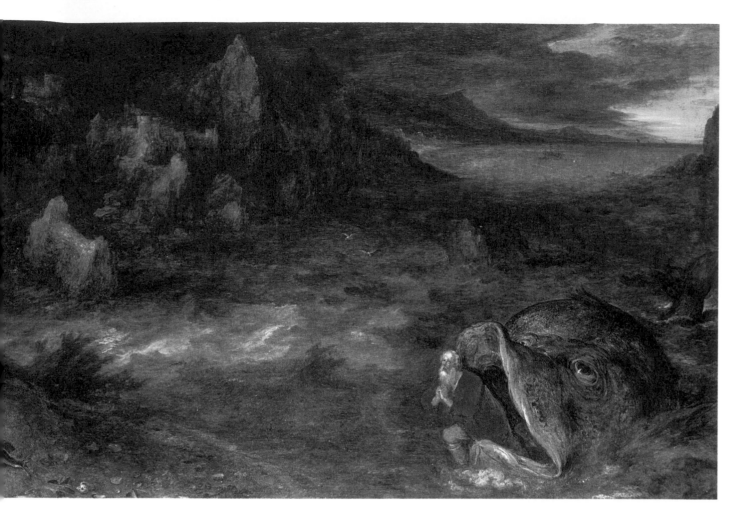

Jan Brueghel the Elder, Jonah and the Whale, c. 1596, Alte Pinakothek, Munich

This picture is telling a very old and famous story (from the Bible), the story of Jonah and the Whale. Can you imagine being inside a whale's stomach for three days and nights! How lucky for Jonah that he was able to escape!

What is the name of the whale in another famous story?
a) Moby Dick b) Sindbad c) Marvi Hammer

**Do you see the three hunters
in the jungle?**

Can they see the tiger and monkey? Do you?
Do you think the animals see the hunters?
Have they hidden well?

**Which of these creatures
will you not encounter
in the jungle?**

**a) ocelot
b) gerble
c) gorilla**

13
March

Henri Rousseau, Jungle with Tiger and Hunters, c. 1907, Private collection

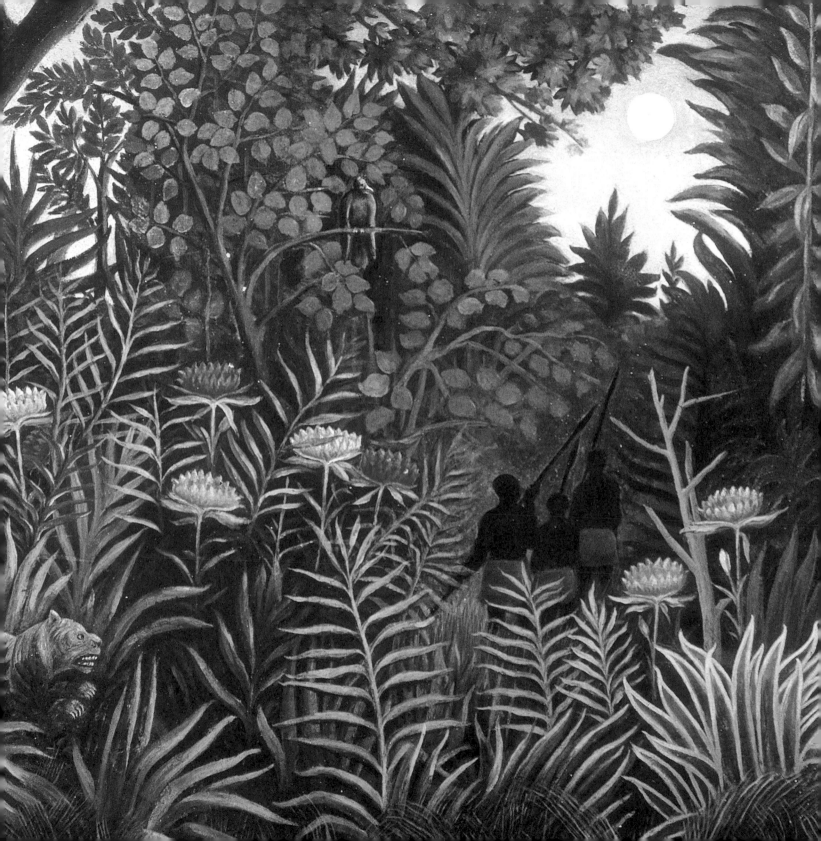

Carl Philipp Fohr, The Lost Knight, 1816. Nationalgalerie, Berlin

15
March

Here you can write a story about this painting.

It is called "The Lost Knight." You can start with "Once upon a time …" or any way you wish.

You already know that Franz Marc loved painting animals.
Horses were his favorite animals to paint.

Would you like to add something next to this horse?
You could draw a friend for him, or show where
the horse is standing or anything at all!

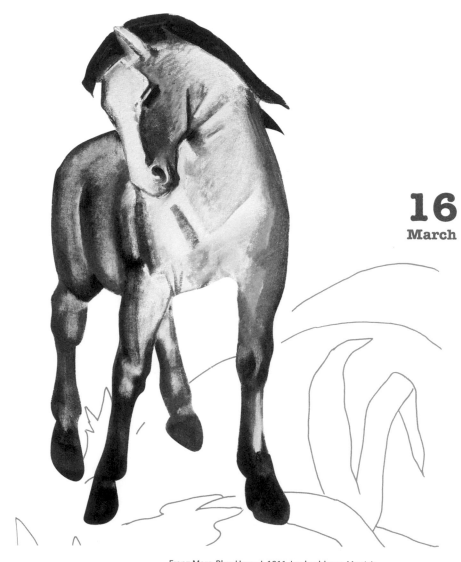

16
March

Franz Marc, Blue Horse I, 1911. Lenbachhaus, Munich

There was a mother who had four children

There was a mother
who had four children
spring, summer,
fall and winter

Spring brings the flowers
summer brings clover
fall brings grapes
and winter, snow

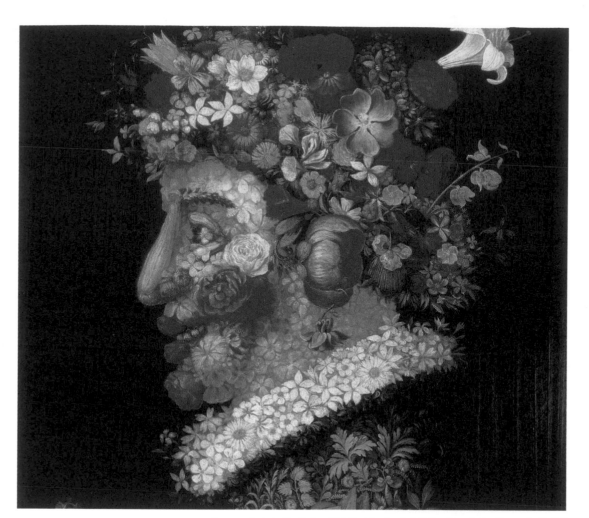

Giuseppe Arcimboldo, Spring, 1573, Real Academiade Bellas Artes de San Fernando, Madrid

This painter has made a profile of a head from flowers and leaves. He is showing us the season when these flowers bloom. The peony is where the ear would be and a columbine is an earring. Hair is made of hibiscus, pomegranate flowers and hollyhocks. The white lily could be like a feather in a hat.

Do you know in which month these flowers bloom? If you do, then you can figure out which season the painter wanted to represent.

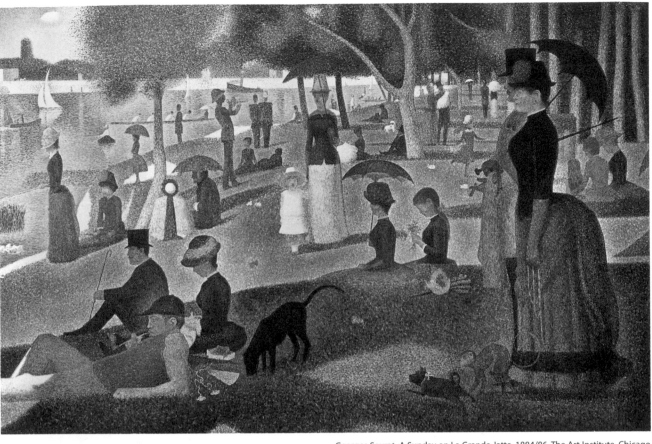

Georges Seurat, A Sunday on La Grande Jatte, 1884/86, The Art Institute, Chicago

19
March

Look carefully. This picture is made of many, many tiny dots of color.

Looking closely you can see the dots of color more clearly.

Can you find these details in the picture?

The French word for dot is "point." This way of painting became known as Pointillism. It is still called this today.

You can try painting like this too. One way is to paint with a small brush, using only the tip, over and over again. You can also try a faster way by dipping an old toothbrush in paint and rubbing the bristles over a screen. Be sure to aim the paint over paper!

20
March

21
March

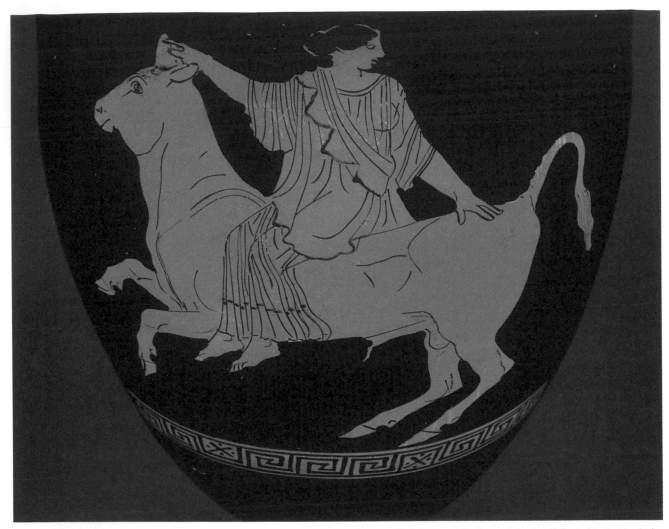

The Abduction of Europa by Zeus in the Form of a Bull. Painted Greek vase. Collection of Classical Antiquities, Berlin.

Here is another myth. This picture is painted on a very old vase from Greece. It tells the story of King Zeus who had fallen in love with Europa, the beautiful daughter of King Agenor. Here, Zeus turned himself into a bull and convinced Europa to climb on his back. He kidnapped her and carried her off to an island! When they arrived, he turned himself back into a king and they had many children. Europa is where the word Europe is from.

How many continents are there? a) 3 b) 4 c) 5

We have seen many different colors for animals and landscapes—different from how they really are.

You can add bright yellow to the cow, as the artist did,
or you can choose your own colors!

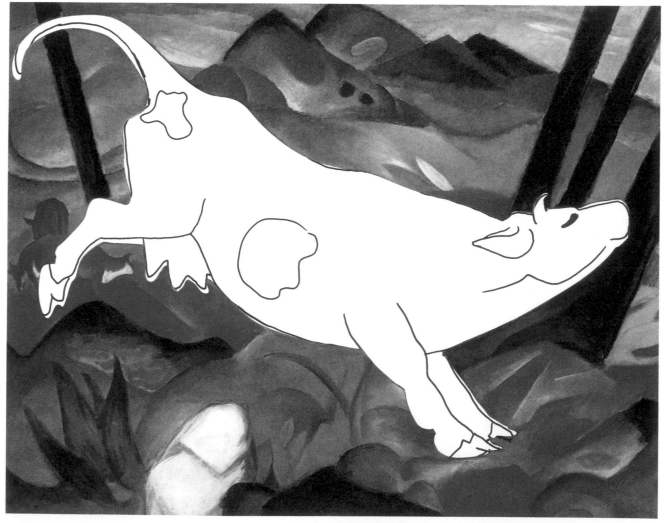

22
March

Franz Marc, The Yellow Cow, 1911, The Solomon R. Guggenheim Museum, New York

Theo van Doesburg planned his pictures carefully. His colored rectangles and squares are organized on the canvas with different amounts of space around each shape. A limited choice of colors is used, and the shapes seem to move on the canvas.

Would you like to make a pattern of shapes and colors? You choose the number or shapes and colors. Experiment with the arrangement.

23
March

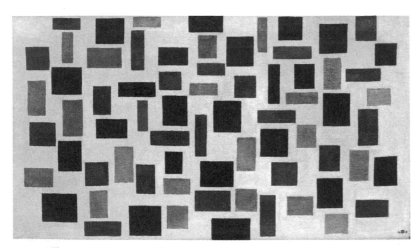

Theo van Doesburg, Composition XI, 1918, The Solomon R. Guggenheim Museum, New York

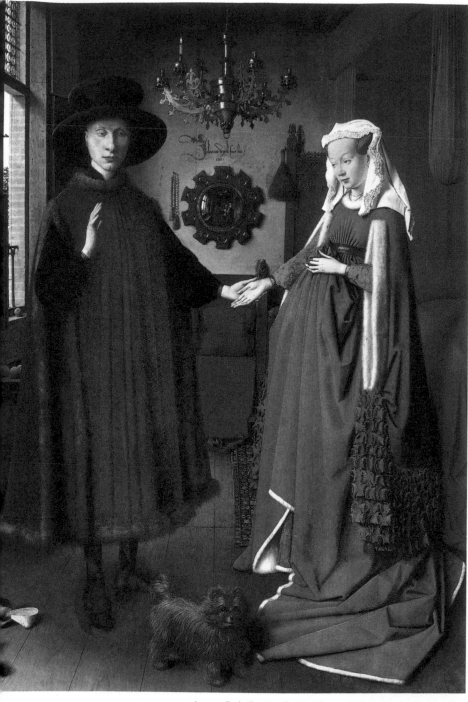

Jan van Eyck, The Arnolfini Wedding, c. 1435, National Gallery, London

When this picture was painted people married by promising to be faithful to each other at home, before witnesses. The bride and groom are here, but look into the mirror between them. Someone else is in the reflection! Could it be the artist?

Can you also see ...

* a burning candle?

* a statue?

* a dog?

24
March

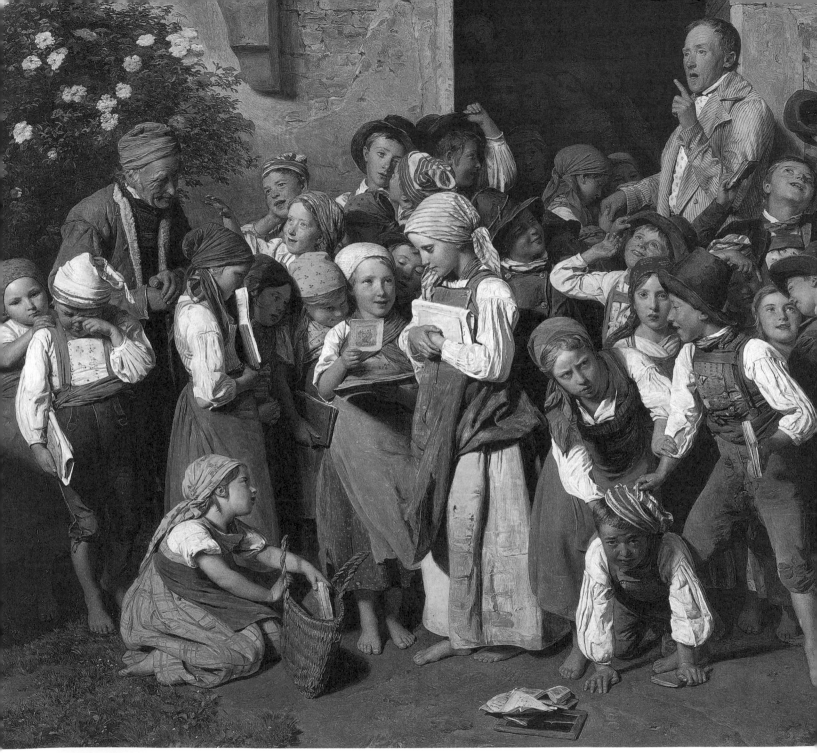

Ferdinand Georg Waldmüller, After School, 1841, Nationalgalerie, Berlin

These children are leaving school for the day. How different they look from students today!

How many ways are these children from 150 years ago different from you and your friends?

You can draw some friends here.

26
March

27
March

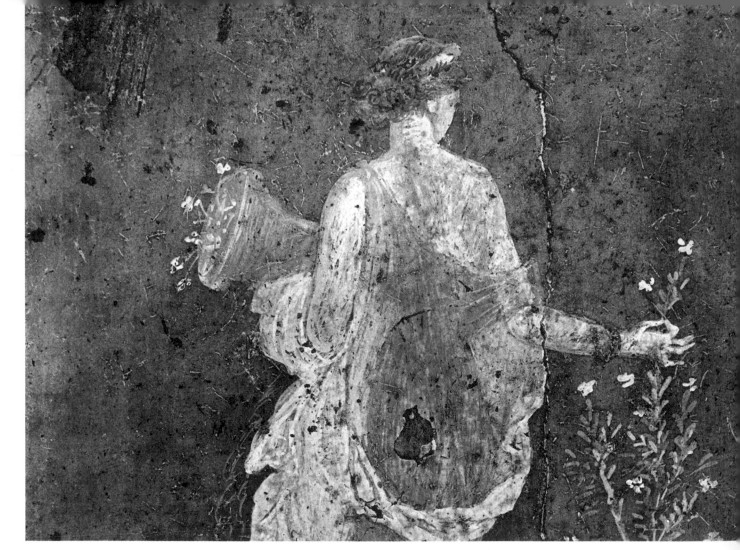

Flora with a Cornucopia, 1 AD, fresco, Pompeii, Museo di Capo di Monte, Naples

Another representation of spring (remember the man made of flowers and leaves?) is the Roman goddess of flowers. Her name is Flora. Her basket, which she is filling with fruits and flowers, is called a horn of plenty or cornucopia. It is a sign of good fortune, fertility, wealth, and abundance.

Do you know of other objects that bring good luck?
You can draw them here!

Heinrich Schliemann was an archeologist, someone who studies people and cultures from long ago. While on an expedition in Greece, he and his staff dug up this mask made of gold!

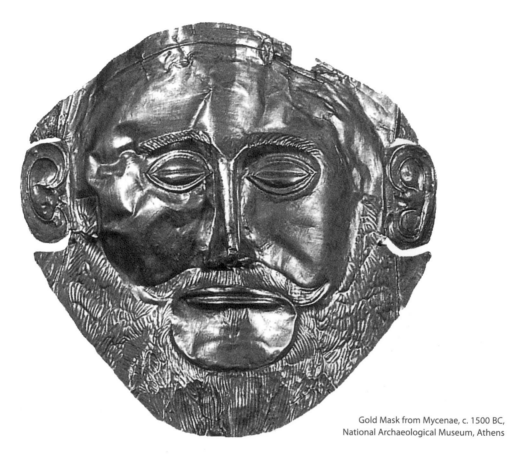

Gold Mask from Mycenae, c. 1500 BC,
National Archaeological Museum, Athens

28
March

Would you like to make yourself a mask too?

You can use aluminum foil for a silver mask! Cut a piece of foil a little larger than your head and press it firmly to your face. When you remove it you will have a model of your face. You can cut out holes for your eyes and your mouth. You can add details by gently drawing with a pen or pencil on the surface. You can add tape inside the mask to help hold its shape and to make it stronger.

29
March

Johann Heinrich Wilhelm Tischbein, Goethe in the Campagna, 1786, Städel Museum, Frankfurt

The man in this picture is the poet Johann Wolfgang von Goethe. During his lifetime, it was not common for people to travel. He went by coach from his native Germany to Italy where he found inspiration for his writing. You will find one of his poems on the next page.

Goethe expressed his longing for Italy in this poem:

Knowest thou where the lemon blossom grows,

In foliage dark the orange golden glows,

A gentle breeze blows from the azure sky,

Still stands the myrtle and the laurel high?

Dost know it well? 'Tis there! 'Tis there

Would I with thee, oh my beloved, fair!

30
March

31
March

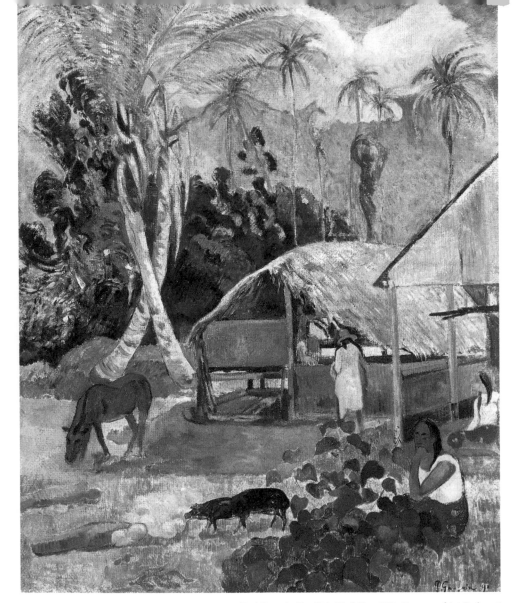

Paul Gauguin, The Little Black Pigs, 1891, Museum of Art, Budapest

The painter Paul Gauguin dreamed of the South Seas, which he imagined as a sort of paradise: with

✳ two black pigs ✳ two palm trees that are embracing each other and

✳ four women in white blouses. **Can you find them here?**

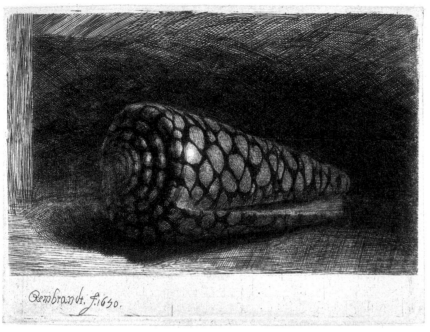

Rembrandt, The Snail, 1650. Kupferstichkabinett, Berlin

An exotic snail like the one you see pictured here was an unusual thing to see during the lifetime of the painter Rembrant. Sailors and merchants were among the only people who traveled to trade goods, bringing back stories as well as things to buy. (People, as we just learned with Goethe, rarely traveled).

If you like, add a picture of something you remember or have from a trip you have taken.

1
April

Have you ever seen a sky with these colors?
A woman is enjoying this sunset.

Here is an experiment you can do with food coloring, a freshly cut white flower, and a glass of water. Add equal amounts of red and yellow food coloring to the water and stir. Put the flower in this water and wait. Watch what happens!

2
April

Caspar David Friedrich, Woman Before the Rising Sun, 1818, Museum Folkwang, Essen

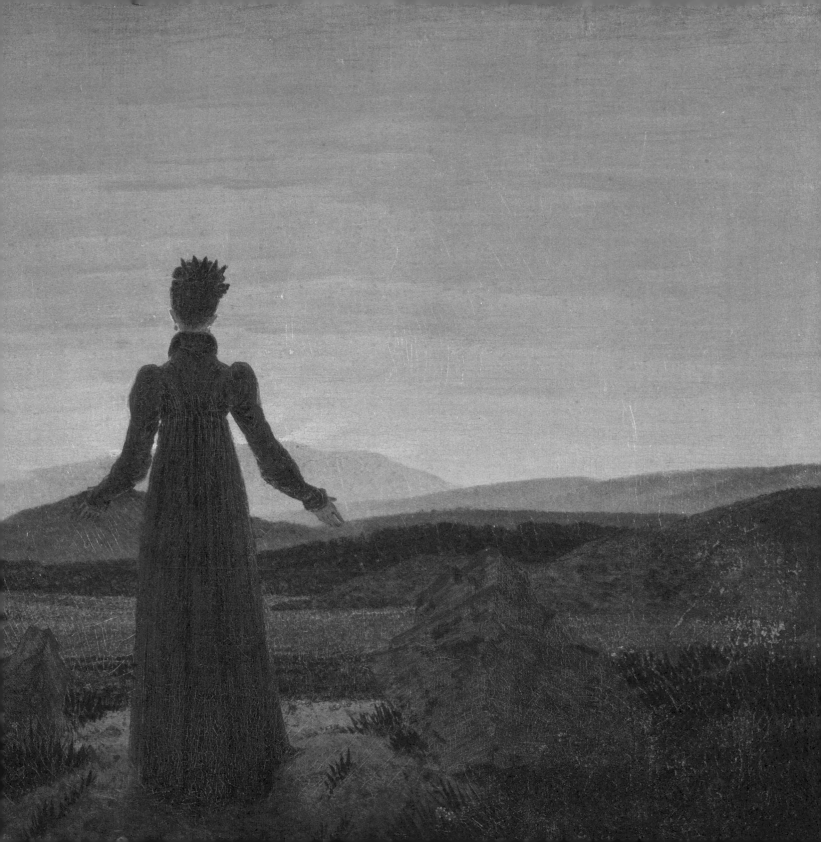

4
April

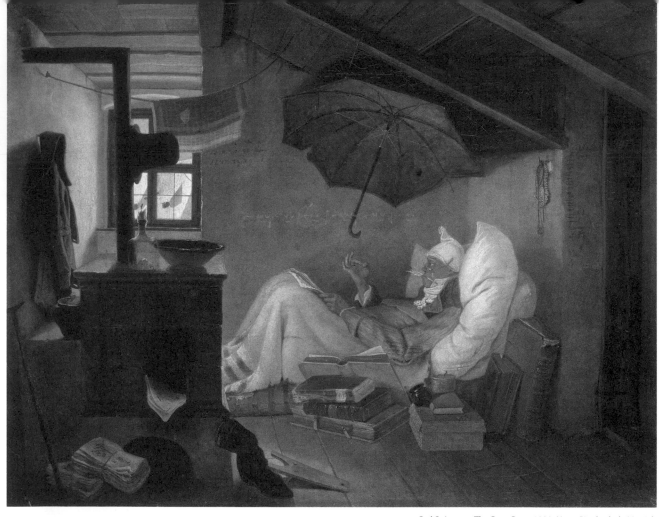

Carl Spitzweg, The Poor Poet, 1839, Neue Pinakothek, Munich

Can you see his pot of ink and the small candle that he uses at night for reading and writing. What is he doing with his right hand? Perhaps he squashed a flea between his fingers?

Find these details in the picture!

This man is reading or writing in bed. He may be sick or he may be cold. It looks like it is snowing outside. Why is there an umbrella over him INSIDE his room? I wonder if there is a hole in the roof ! His mattress is even on the floor! This does not seem to be a fancy place. The painter called this picture "The Poor Poet."

Can you imagine what the poet may be writing?
You can even write a story about the whole picture!

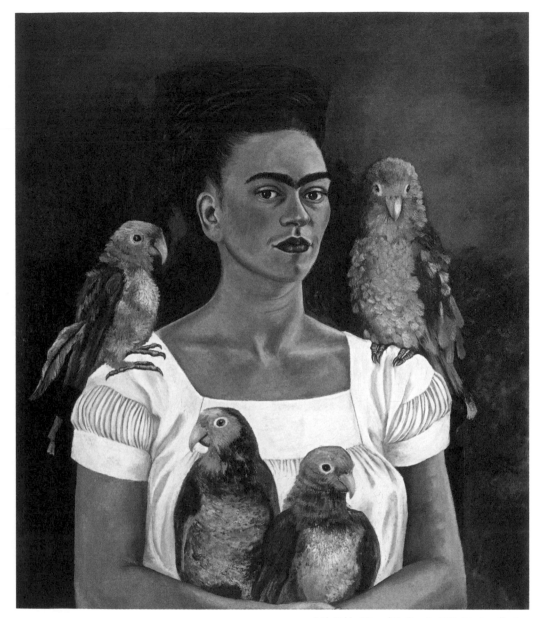

Frida Kahlo, Me and My Parrots, 1941, Private collection

When Frida Kahlo was seventeen, she was badly hurt in a bus accident. She had to stay in the hospital for a long time and began to paint. She painted many self-portraits and often included some of the animals that she loved. Here you can see her with her parrots. She also had pet monkeys, dogs, and a deer!

You could try to paint yourself using a mirror.

You can add a pet, like Frida Kahlo, or show a favorite place,
like Vincent van Gogh did with his bedroom.

7
April

8
April

In Bosch's pictures, strange creatures fly about in the sky.
Why don't you draw a friendly flying monster here?

9
April

This painting, made over 500 years ago, was actually the center section
of three pictures hinged together. It was a special painting, originally
housed in a church, not a museum. It was so special that it was only seen
on special occasions. There is so much to notice in this picture, so much
to delight our eyes!

Hieronymus Bosch, Garden of Earthly Delights (center panel), 1480/90, Prado, Madrid

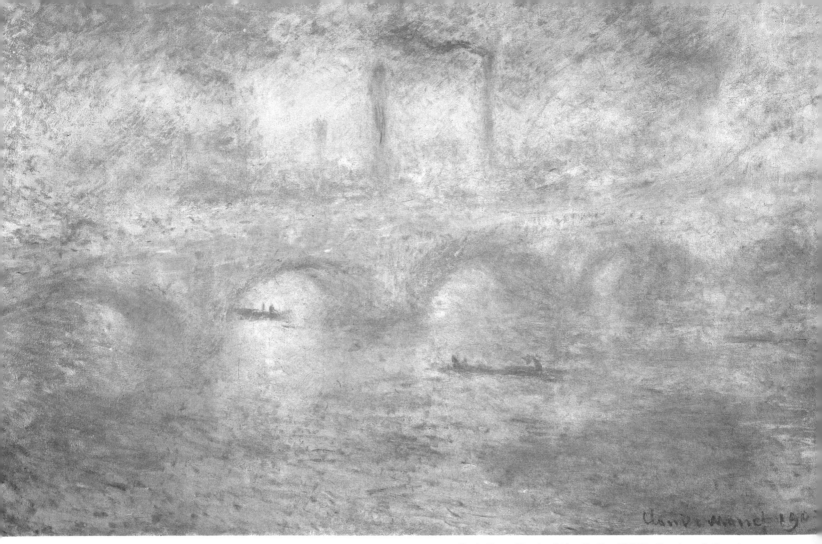

Claude Monet, Waterloo Bridge. The Fog. 1903, The Hermitage, St. Petersburg

Claude Monet chose a foggy day to paint this picture.
Take your time looking.

See if you can notice what emerges from the painting!

Could it be... a) a factory? b) a church? c) a bridge?

The fog is lifting; what can you see now?

11
April

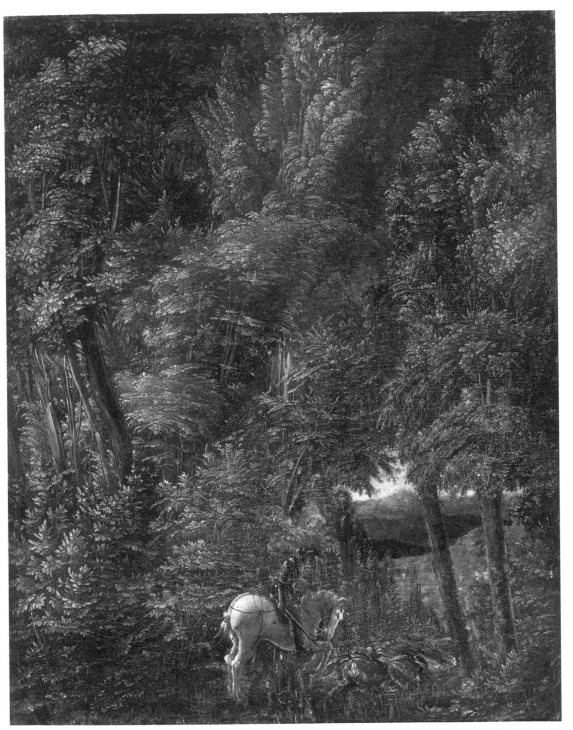

12
April

Albrecht Altdorfer, St. Georg and the Dragon, 1510, Alte Pinakothek, Munich

You may have heard of St. George. He was known many, many years ago for slaying a dragon who had been terrorizing people. The dragon was about to eat a princess when St. George stopped him in time. People thought it was a miracle and this story is remembered even today!

You have room here to draw a dragon or even a fire-breathing monster any way you wish!

13
April

Diego Velazquez, The Three Minstrels, 1616-20. Gemäldegalerie, Berlin

Do you play an instrument? Even though the
instruments are partially hidden in this painting,
you may know what they are. I wonder what it
would sound like to be in the picture!

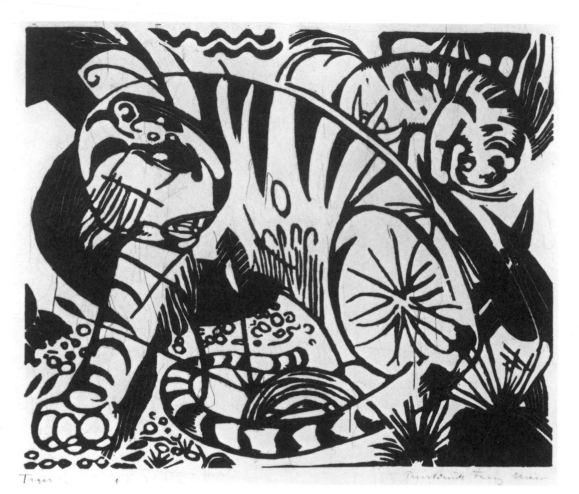

Tiger

Franz Marc, Tiger, 1912, Lenbachhaus, Munich

15
April

Have you ever made a print? This picture is printed, not painted or drawn. There are many ways to make a print. You may have made prints with paint on your hands or you may have pressed your hands in sand. Maybe you used potatoes with paint or ink and stamped them onto paper. You can even draw on styrofoam and use it as a stamp. Whatever you draw on the styrofoam gets printed in reverse on your paper.

Try it if you can!

What a nice day for a picnic!

Can you find these details in the picture?

16
April

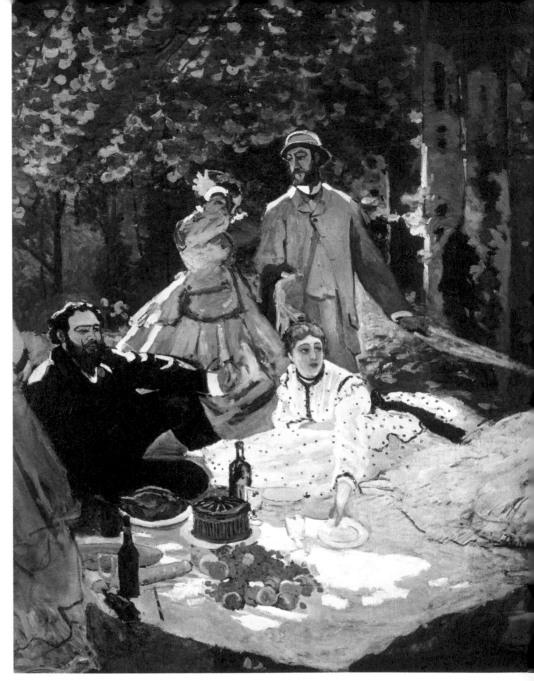

Claude Monet, Luncheon on the Grass, 1865/66, Musée d'Orsay, Paris

There are really twelve people in this picture. Here you only see part of it—after the painting had been stored for a long time in a damp cellar it was mouldy round the edges and they had to be cut off.

But here you have room to carry on painting:
Who would you like to invite to your picnic?

17
April

Sometimes things stay the same. Sometimes they change. Here is another picture of Venice! Do you remember the gondolas? Did you remember that this city was the artist Canaletto's hometown?

Can you find ...

✹ the eagle on a column?

✹ a small dog?

✹ or a man in a blue coat?

18
April

Imagine walking along with the people shown here. Venice is still a place that has many tourists visiting as it did even 300 years ago when this picture was painted.

Canaletto, The Molo in Front of the Doge's Palace,
c. 1730, Gemäldegalerie, Berlin

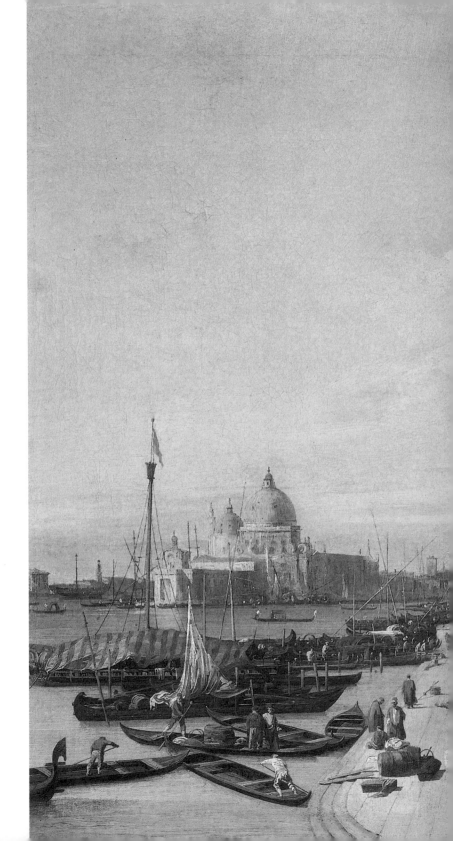

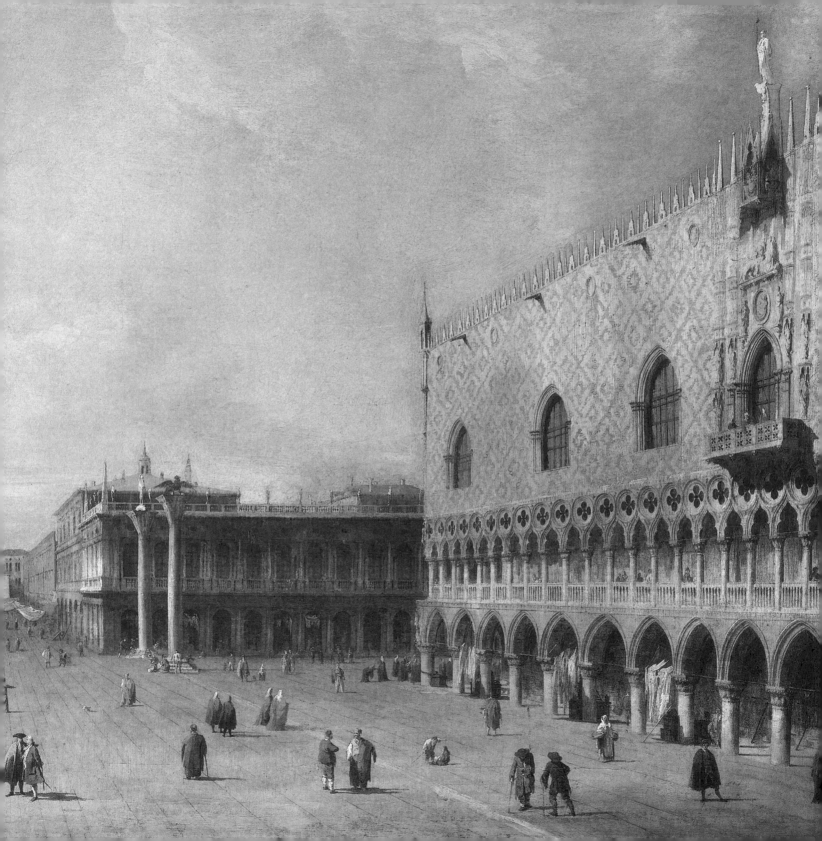

20
April

Giulio Romano, Fall of the Giants, 1526-35, Mural, Palazzo del Té, Mantua

Here is a scene telling the story from another Greek myth, painted on the ceiling of a summer house—a mansion, really. (Can you imagine a ceiling like this in a summer cottage?) This painting shows a battle being fought between the gods and the Titans. The Titans threatened Zeus's power. If you remember, Zeus was a king, the father of all of the gods. Zeus won the battle by sending thunderbolts from heaven.

The Titans are long-haired monsters with beards and snakes' tails who are attacked by thunder and lightning.

You can paint the Titans here running from the thunder and lightning! How will you show these monsters?

21
April

What a marvelous African mask!

Which animals are the strongest?

**Each animal is resting on another, like a tower, getting taller and taller:
first the antilope, then the hyena, with the rooster, snake, and bird on top.**

Could any more animals be added here?

22
April

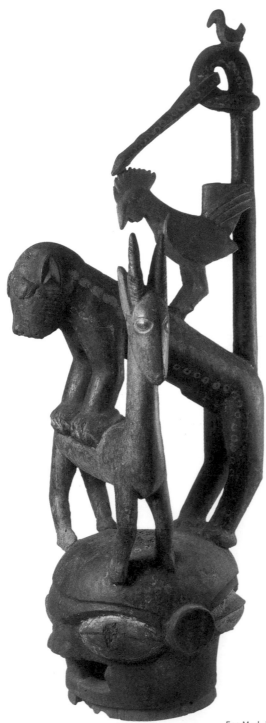

23
April

Epa Mask, Yruba, Nigeria, Dr. and Mrs. Bernard Wagner

Here is another Bible story. Like Jonah and the Whale, this is a very famous story—perhaps even more known than Jonah: the story of Noah and his Ark. The animals are heading to the ark, off in the distance.

Can you see it? There should be two of every animal.

How many pairs do you see? Two tortoises, the two ostriches ...

24
April

Can you find these details in the picture?

Jan Brueghel the Elder, Paradise Landscape with Noah's Ark, late 16th or early 17th century, Szépmüvészeti Múzeum, Budapest

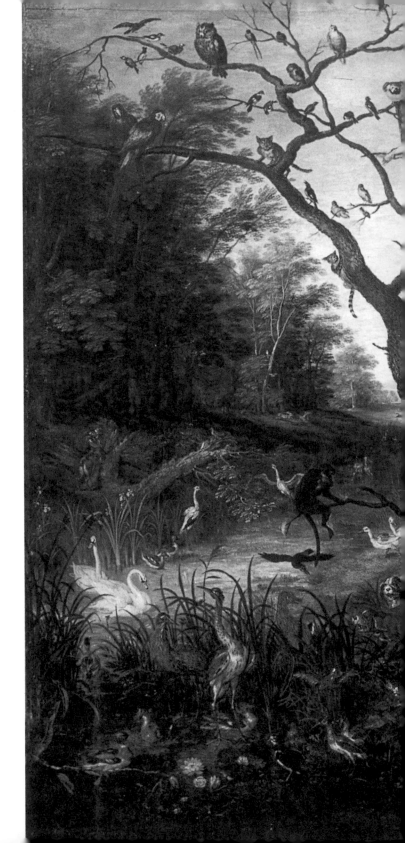

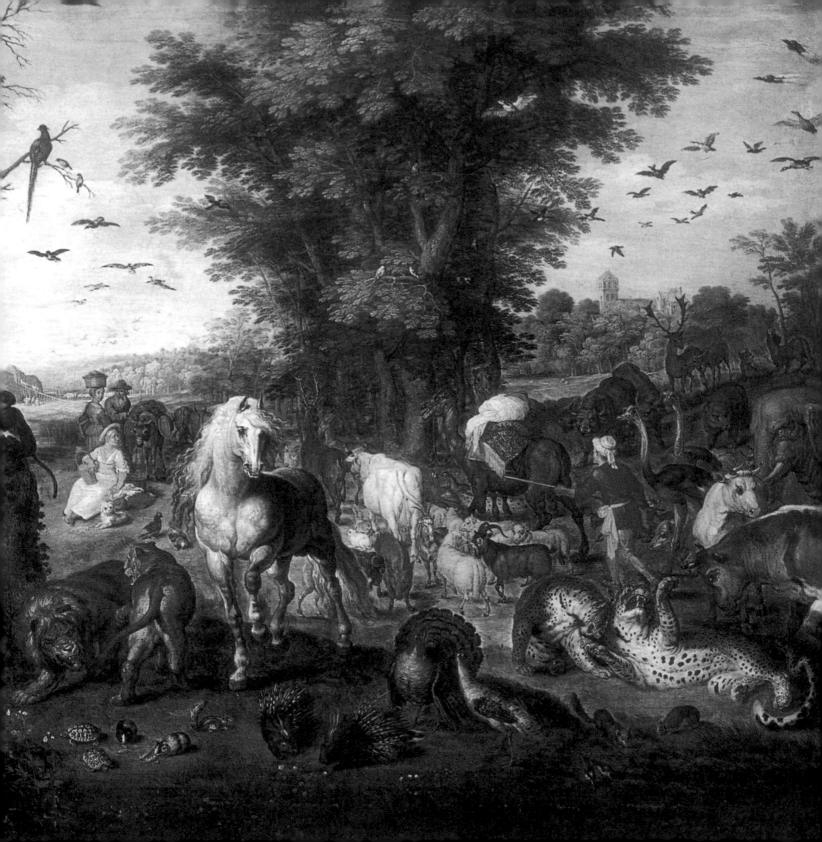

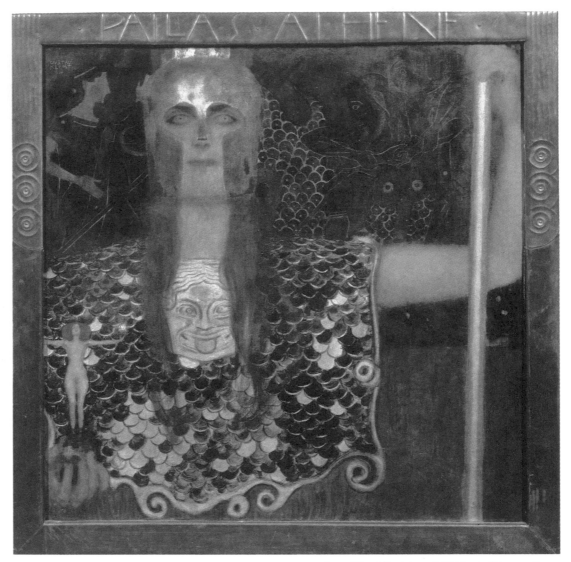

Gustav Klimt, Pallas Athena, 1898, Historical Museum, Vienna

Another Greek myth tells of the birth of Zeus's daughter, the goddess Athena. Zeus had such a terrible headache that he ordered the blacksmith Hephaestus to cut open his head with an ax. (Remember, he is a god!) Athena emerged full-grown and dressed in armor! She is known as the goddess of war and, since she came from Zeus' head, a symbol of wisdom and intelligence. The city of Athens is named for her.

You can draw the goddess Athena with her shield and a weapon.

She is often shown with an owl. Can you guess why?

27
April

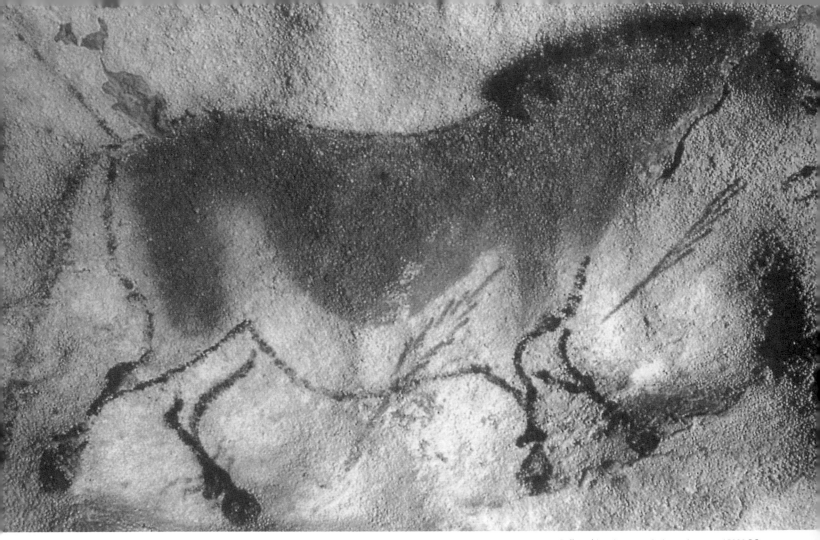

Bull, prehistoric cave painting at Lascaux, 15000 BC

Do you know what this is?

a) Graffiti on a city street.

**b) A painting by cave people during
the Stone Age.**

c) A fossilized bull.

How did people live during the Stone Age? Can you imagine what else they painted in their caves?

29
April

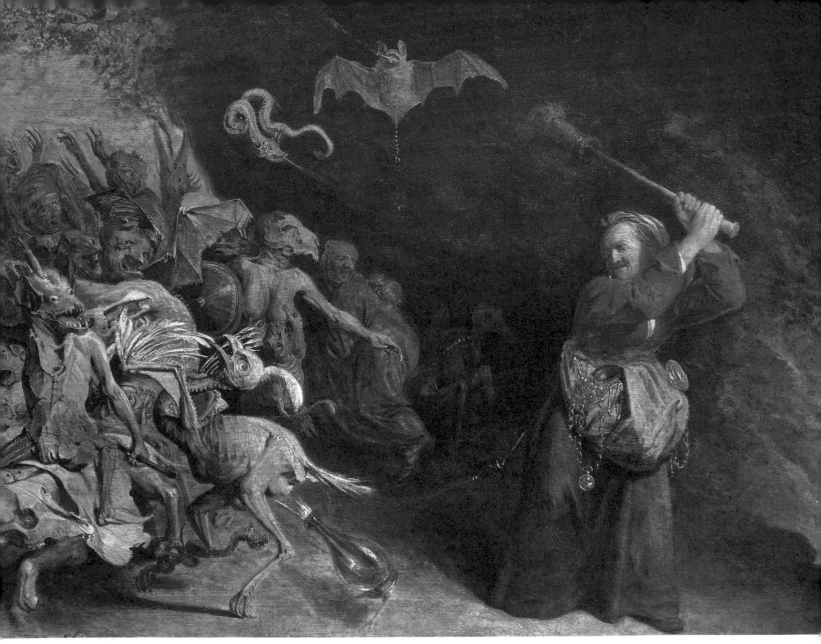

David Ryckaert III., The Witch, 17th century, Kunsthistorisches Museum, Vienna

What is happening here? Is this a witch casting a spell? Could she be afraid of the creatures and trying to keep them away with her broom? Bats can fly, but snakes? And what is in her apron?

You can write your own story!

..

..

..

..

..

..

There is no witch on top of this broom!

1
May

2

May

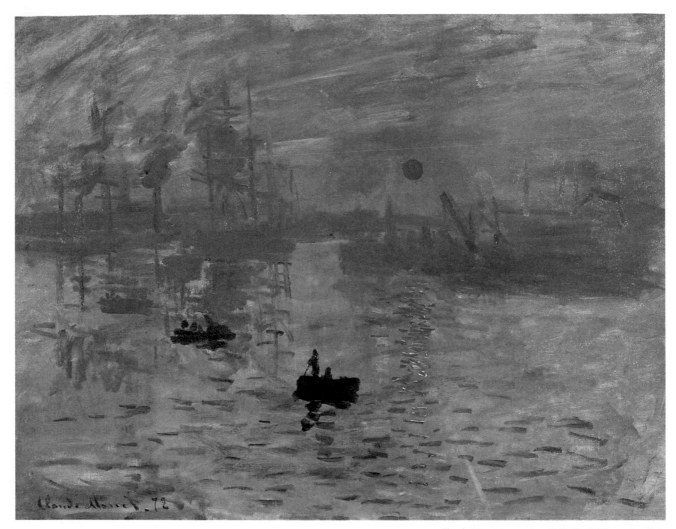

Claude Monet, Impression, 1873, Musée Marmottan, Paris

During the second half of the 19th century, painting outside, away from the studio, became popular.
Especially the artists known as Impressionists no longer painted in studios, but outside in the countryside.

Which invention made that possible?

a) The invention of a portable easel.
b) The invention of paint in tubes.
c) The invention of waterproof clothing.

This picture of the countryside is over 100 years old. I wonder if we will see more places with windmills around the world soon?

Here you have some space to complete the picture!

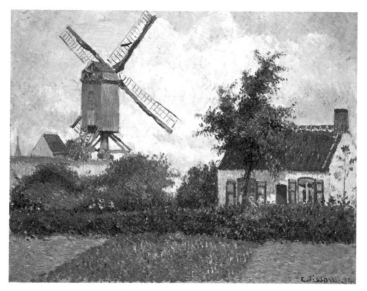

Camille Pissarro, Mill in Knocke (Belgium), 1894, Private collection

3
May

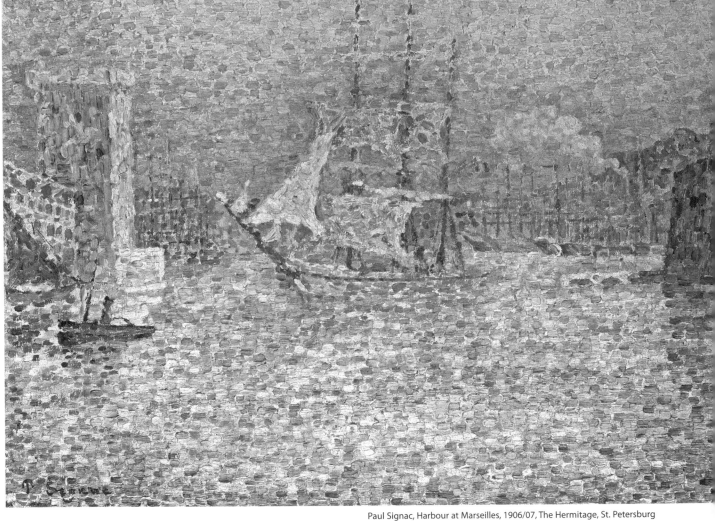

Paul Signac, Harbour at Marseilles, 1906/07, The Hermitage, St. Petersburg

Do you remember other pictures made with tiny dots of paint? There have been several. If you were standing in front of the real painting, you would need to stand some distance away to see this ship sailing in the port. Here, it is shown so you can see what the artist has painted.

Can you find these sections of the picture?

Here you can add more ships in the water.

5
May

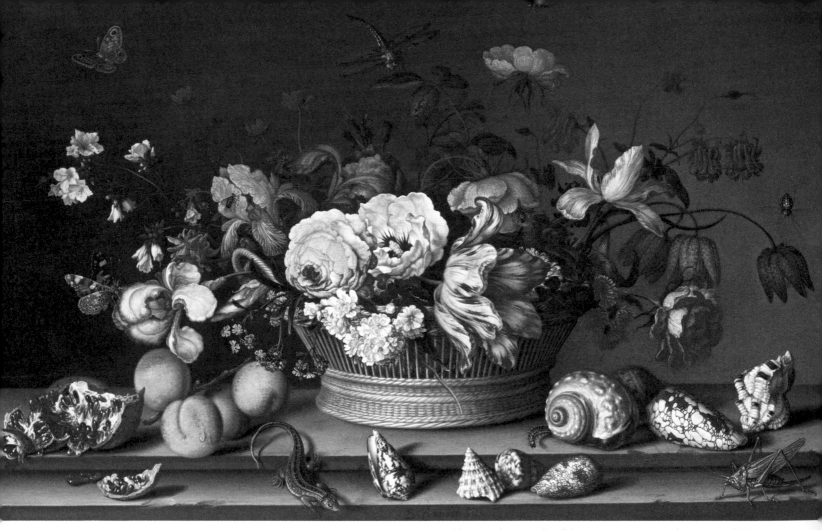

Balthasar van der Ast, Basket of Flowers, c. 1640/50, Nationalmuseum, Stockholm

Many of the flowers in this still-life were very rare
and expensive when this picture was painted. Tulips
certainly were.

**You can see the detail of a tulip here.
What other flowers can you see?**

This girl is taking care of her garden.

Do you want to add anything here?

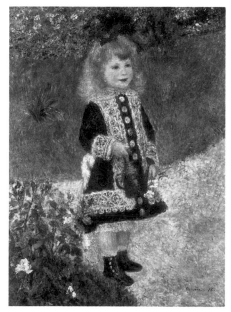

Pierre-Auguste Renoir, Girl with a Watering Can, 1876,
National Gallery, Washington

7
May

8

May

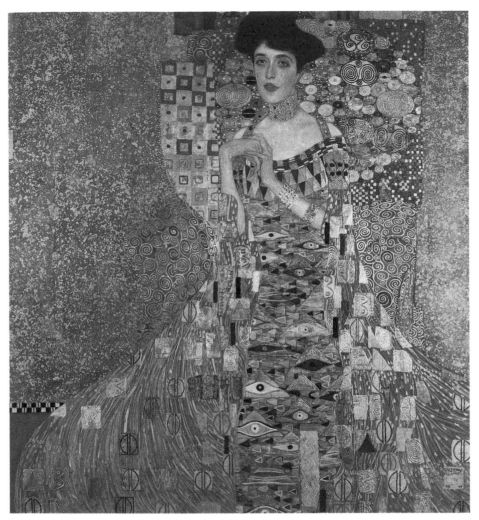

Gustav Klimt, Adele Bloch-Bauer I, 1907, Neue Galerie, New York

The most famous picture in the museum "Die Neue Galerie" in New York is by the Austrian artist Gustav Klimt. It shows Adele Bloch-Bauer, a fine lady from Vienna. You may recognize Adele Block-Bauer from another page in this book—turn to September 10. She is almost camouflaged by all of the pattern and decoration surrounding her!

Can you find these details in the main picture?

9
May

Here you can
design some
clothes for Adele
yourself. Just
color them in
with pretty pat-
terns and colors
and cut them out.
Now you have a
doll you can
dress as you like.

10
May

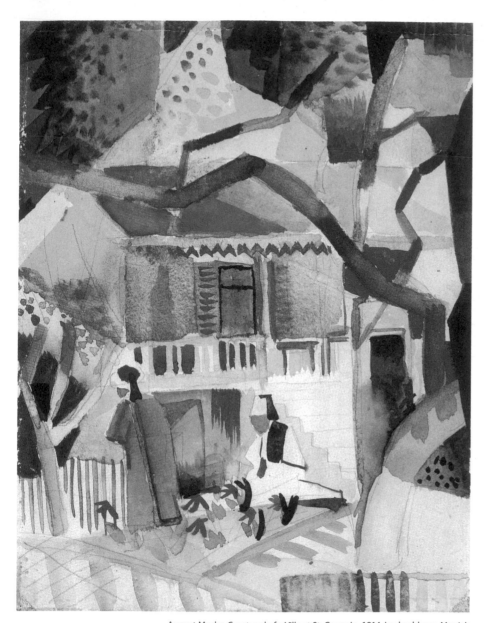

August Macke, Courtyard of a Villa at St. Germain, 1914, Lenbachhaus, Munich

Can you match the details shown here to the correct parts of the main picture?

11
May

This brightly colored painting is made with watercolors. You can see that some of the white paper is still visible in parts of this picture. Several of August Macke's oil paintings are also in this book.

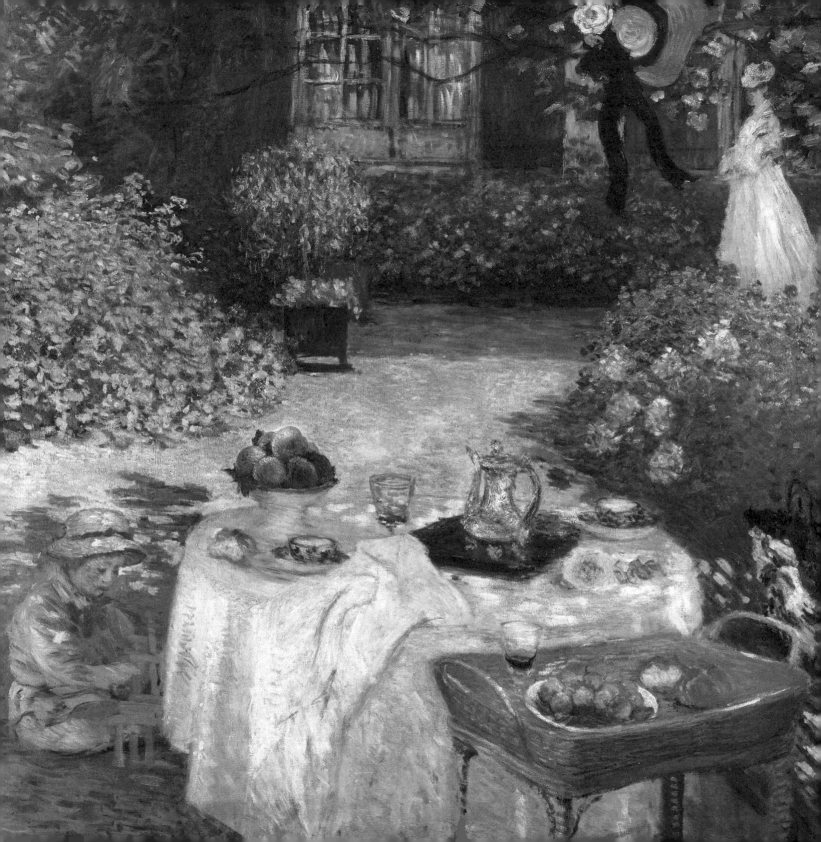

Claude Monet loved his gardens. This is the garden that he painted after lunch with his family. Part of dessert is still on the table: coffee, fruit, and cookies. The artist's son, Jean, is playing on the ground. The two women in the background may have just left the table. There are a few things remaining that may belong to them.

Do you know what they might be?

What else do you see here in Monet's garden?

13
May

Claude Monet, Luncheon, 1873, Musée d'Orsay, Paris

Here you can see the studio of the artist Jan Vermeer. Do you remember the unfinished drawing of an artist at an easel? The curtain is pulled away to reveal the source of light, a trumpet, and …

14
May

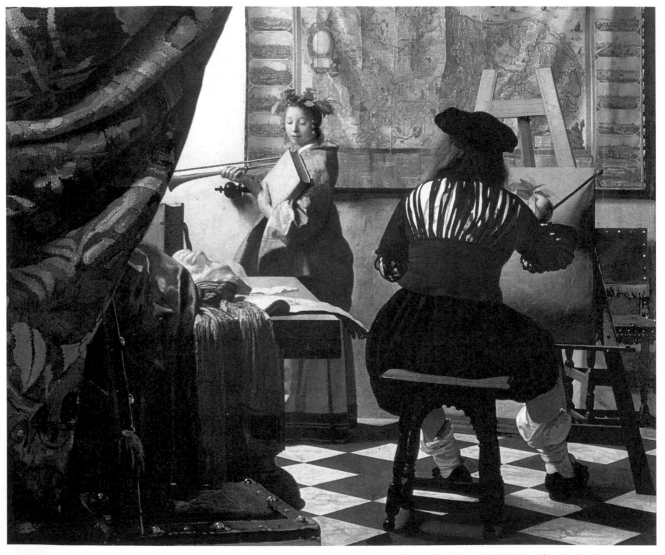

Johannes Vermeer, The Art of Painting, c. 1665/66, Kunsthistorisches Museum, Vienna

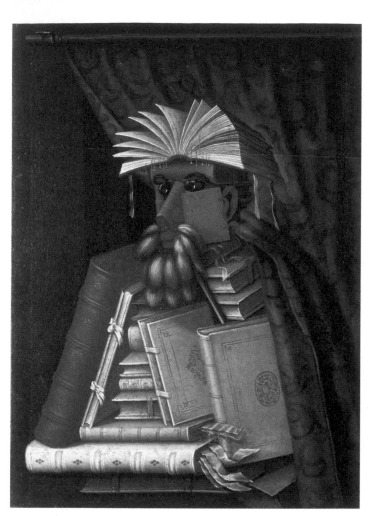
Giuseppe Arcimboldo, The Librarian, c. 1566, Skoklosters Slott

Giuseppe Arcimboldo has painted so many books and parts of books to make a picture of a librarian without showing a library or using the word. He was a bit like a magician, imagining new ways to say and show things.

Can you imagine how he would paint an artist or gardener or other jobs or professions?

15
May

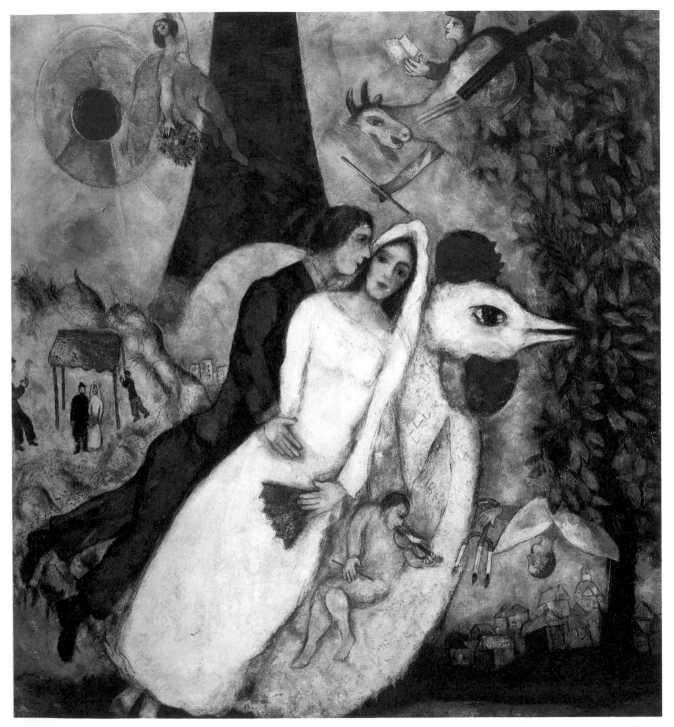

16
May

Marc Chagall, The Bride and Groom with the Eiffel Tower, 1938/39, Private collection

Marc Chagall imagined the world differently from other people. Here he has painted himself floating in the air with his wife. In the background they are shown again, this time under a wedding canopy. There is music being played and candles that are upside down. Things are not the way we expect them to be in his paintings, sometimes they are more like dreams.

Here you can write a happy dream that you remember.

18
May

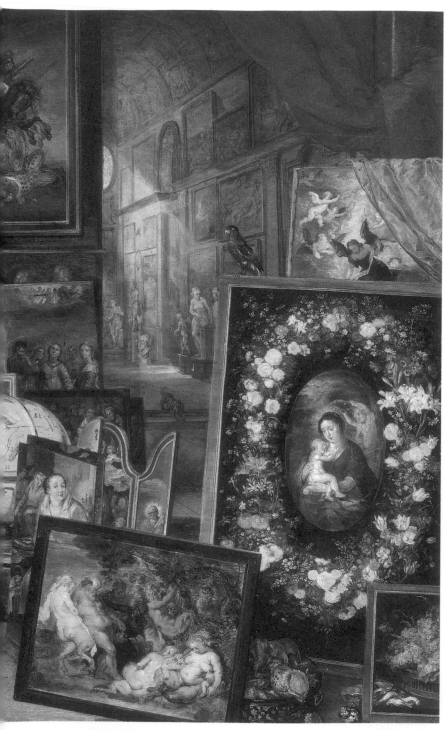

Jan Brueghel the Elder, with Peter Paul Rubens, Allegory of Vision, early 17th century, Prado, Madrid

A room full of treasures! There are so many things to see! How many paintings and sculptures are here! I hope the animals are careful!

Do you see ...

✸ the parrot?

✸ dogs?

✸ and monkey?

19
May

What is this type of statue called?

a) bust
b) cameo
c) plaster head

Ares, the Roman god of war, has laid his weapons aside. Is he exhausted by all the fighting?

What is this sculpture made of?

a) clay
b) marble
c) bronze

20
May

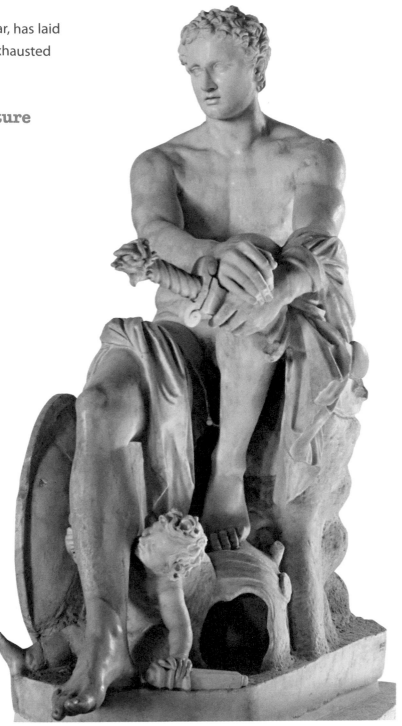

Ares Ludovisi, c. 310 B.C., Museo Nazionale Romano delle Terme, Rome

Piero di Cosimo, Myth of Prometheus, 1510/20, Alte Pinakothek, Munich

You can read the story of Prometheus among the Greek myths: he used clay and water to form men in the shape of the gods. The goddess Athena gave them the power of understanding. And she helped Prometheus to steal fire from Olympus for man to use. In this picture they are both flying back from heaven with the fire—can you see it? Zeus, the ruler of the gods, was very angry at the theft.

Do you know how Zeus punished Prometheus for what he had done?

a) He was chained to a rock and each day an eagle came
 and pecked away at his liver.
b) He was imprisoned in heaven and was never allowed
 to play with humans again.
c) He had to cook a banquet for the gods every day.

On this beautiful day Camille and her son Jean are walking through a field. The red flowers are poppies. The grass is so tall that Jean is partly hidden!

What else do you notice in this picture?

In the picture by Claude Monet the flowering poppies are no more than little red dots. Here is what they look like up close ?

22
May

Claude Monet, Poppy Field near Argenteuil, 1873, Musée d'Orsay, Paris

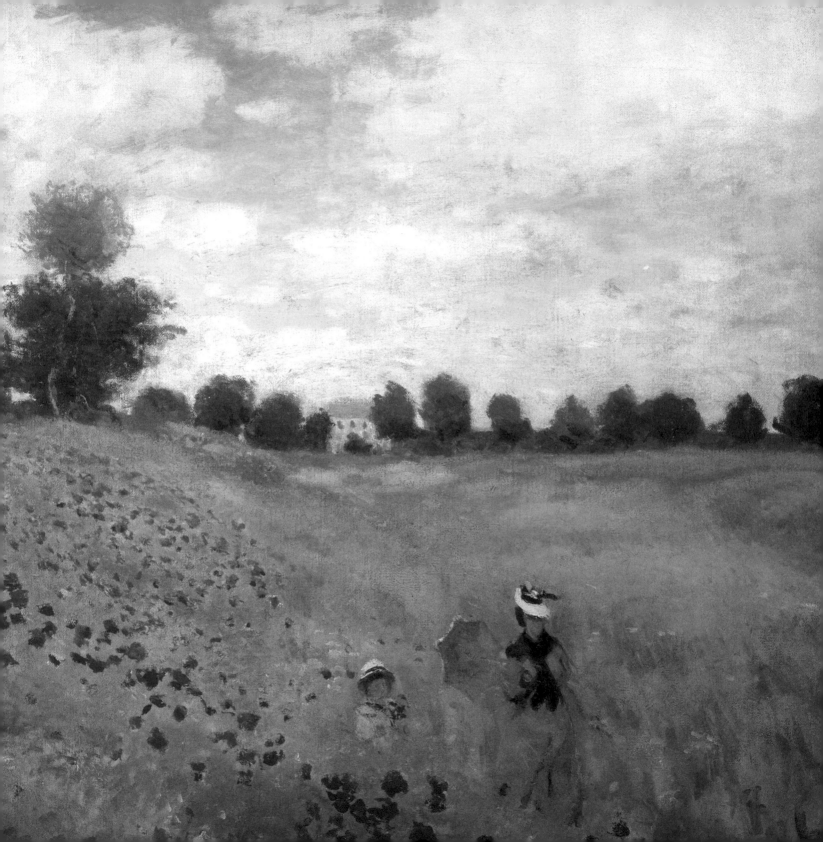

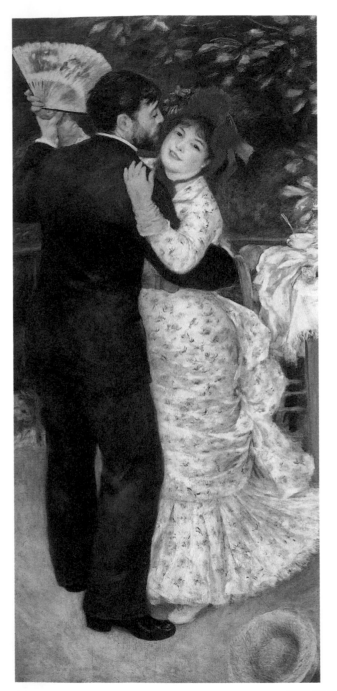 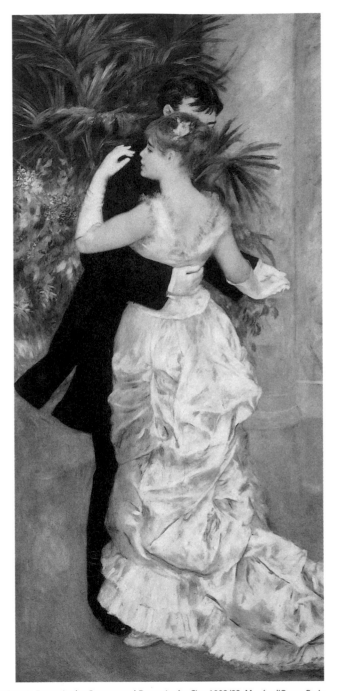

Pierre-Auguste Renoir, Dance in the Country and Dance in the City, 1882/83, Musée d'Orsay, Paris

These 2 paintings by August Renoir are similar, but also different. Both show a couple dancing. Both are long and rectangular. Both were painted close in time, showing people at a similar period in time. One painting shows a couple dancing in the country. Their clothes are less formal than the clothes of the couple dancing in the city.

You can add more here to this line drawing.

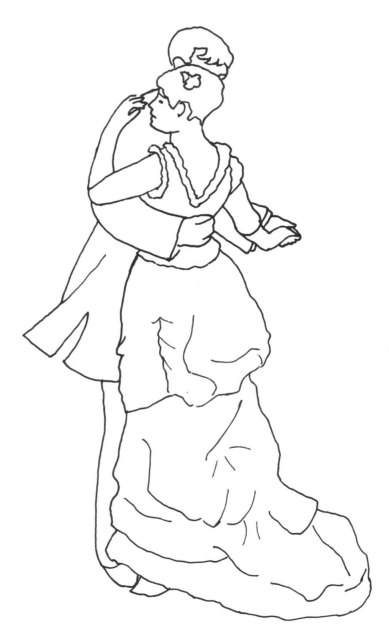

25
May

26
May

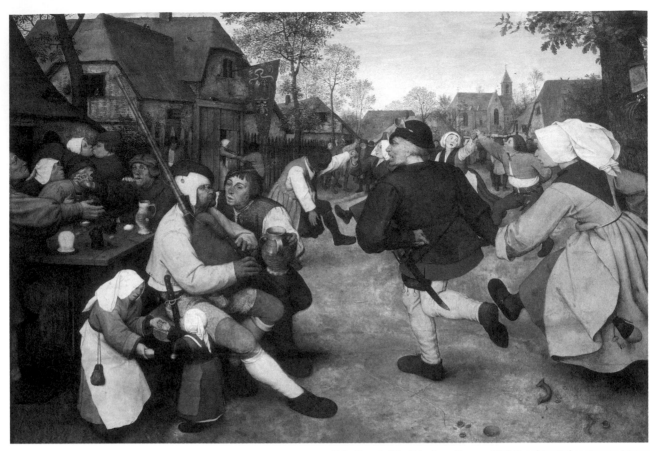

Pieter Brueghel the Elder, Farm Dance, c. 1568, Kunsthistorisches Museum, Vienna

The people in this village are also enjoying themselves, dancing outside on a pleasant day.
This painting, by Pieter Breughel the Elder, shows village people over 400 years ago!

Can you find ...

☀ people kissing?

☀ someone trading a cross made of straw?

☀ a key dancing with its owner ?

This woman is resting in her garden after a hard day. Paula Modersohn-Becker often painted older people and laborers who had worked very hard all their lives.

27
May

Paula Modersohn-Becker, Old Poorhouse Woman with Glass Bottle, 1907,
Paula Modersohn-Becker Museum, Bremen

Can you find these details in this picture?

28
May

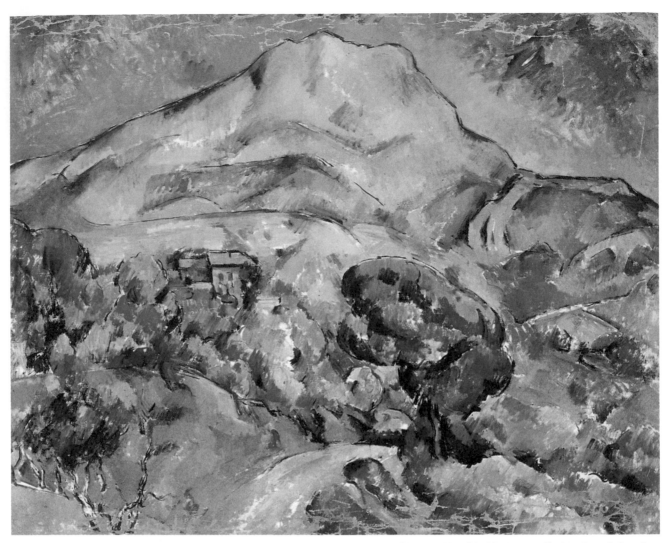

Paul Cezanne, Mont Saint-Victoire, 1900, The Hermitage, St. Petersburg

Paul Cézanne painted this place, Mont Sainte-Victoire, from many different angles and during every season. He was fascinated by light and perspective and how they change the way things look. The mountain was very close to his home in the south of France and he completed many paintings.

You can use color to show the time of day or even the year.
What colors will you choose?

29
May

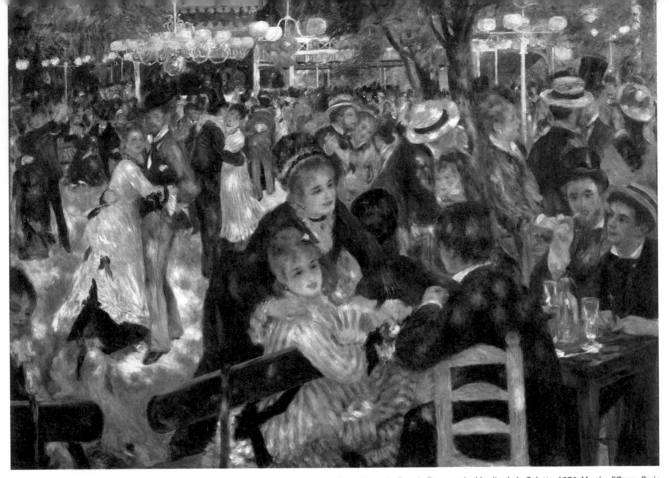

Pierre-Auguste Renoir, Dance at Le Moulin de la Galette, 1876, Musée d'Orsay, Paris

30
May

There are lights hanging above, near the trees, and shadows are cast from the trees onto the ground where some of the dancers and people are talking.

Do you see the young girl at the bottom of the picture?

Here are some details to find in the larger picture.

August Macke, At the Bazar, 1914, Private collection

Try to describe the picture:

What do you see?

What colors has the artist used? What shapes?

Describe all that you see!

31
May

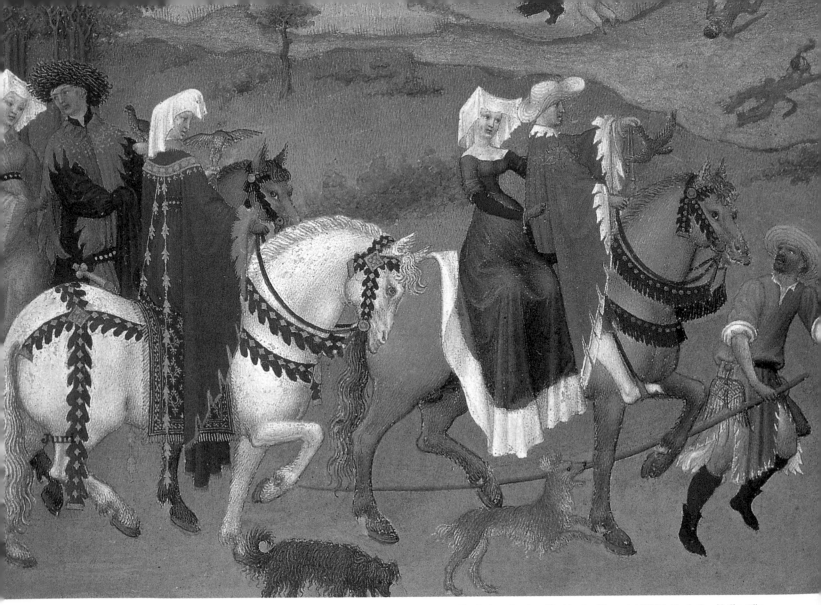

The Limburg Brothers, The Month of August, 1413/16, Musée Condé, Chantilly

Imagine the sounds in this picture. Listen to the horses trotting and dogs barking. You may also hear the birds singing or flapping their wings. The woman on the first horse is named Edwina.

Would you like to continue the story?

..

..

..

..

..

..

..

..

2
June

Where do you think Edwina lives? You can draw what you imagine here.

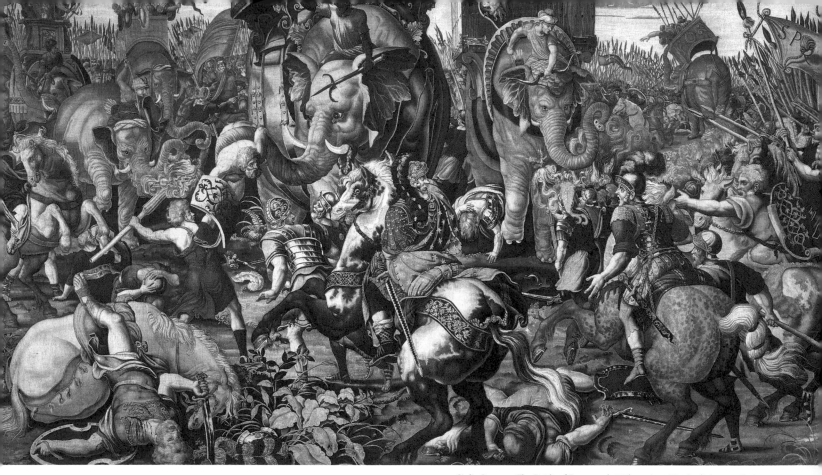

Giulio Romano, The Battle of Zama, early 16th century, Musée du Louvre, Paris

A battle with elephants against horses! Have you seen anything like this before? To win against the strong Roman army, Hannibal used elephants! They were less afraid of the trumpets and drums that the Romans used to scare the horses. This looks like a difficult battle.

How many elephants are here?

Franz Marc, The Tiger, 1912, Lenbachhaus, Munich
from "A Year in Art", Prestel

You can add
your own
drawing.

4
June

If you cut out these postcards, you can send them to friends.

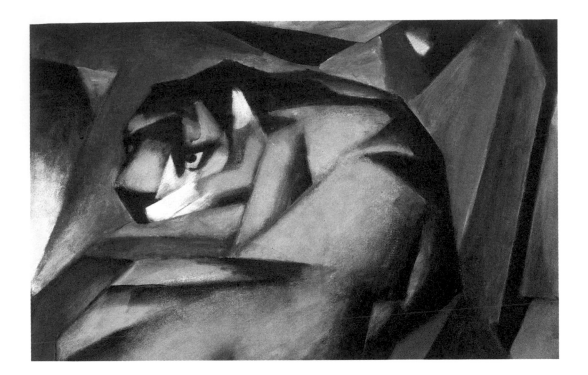

5
June

Who will you send the tiger card to? And who will receive the card you made?

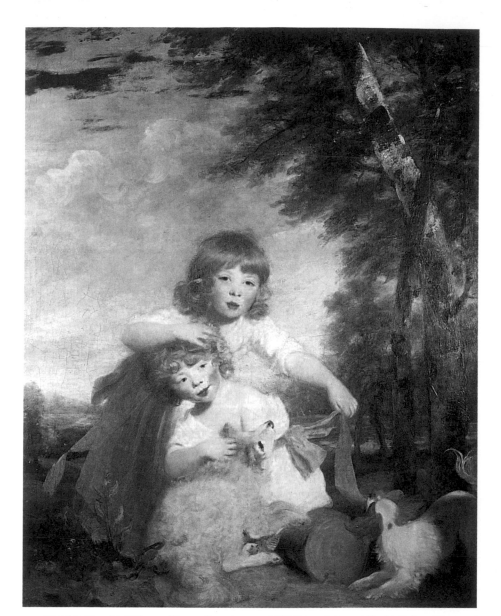

Sir Joshua Reynolds, William and George Bryan Brummel, 1781/82, Iveagh Bequest (English Heritage), Kenwood

These two children are dressed in white dresses with bows. They are probably not about to play outside in these clothes. They have long, curly hair—Would you have guessed that their names are William and George? The clothes they are wearing were typical for boys at the time this was painted.

William and George lived in ...

6
June

a) Germany?
b) England?
c) Spain?

Can you guess the answer?

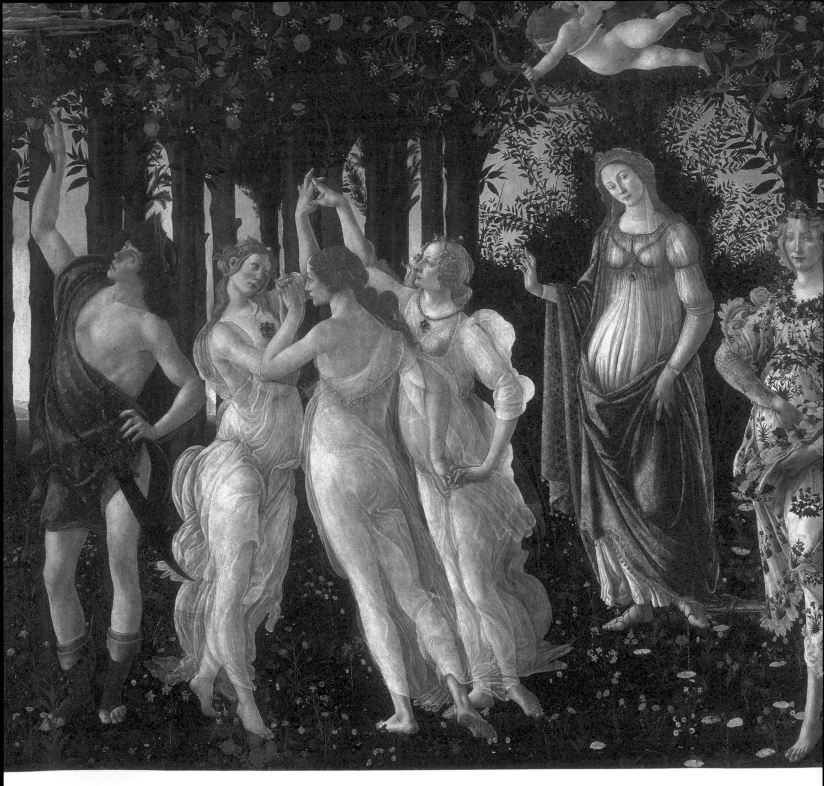

Here is the goddess Venus in a forest of orange trees. Cupid, the god of love, is above her. When he shoots his arrow, whoever he hits falls in love! The three graces are to the left side of Venus.

To her other side in a flowered dress is...

a) Flora, the goddess of spring?
b) Rosalia, the goddess of roses? or
c) Gardena, the goddess of gardeners?

8
June

Can you find these details in the picture?

Sandro Botticelli, Spring, 1478, Uffizi Gallery, Florence

Adults are playing a game usually played by children.

Do you know what it is called?

This is a great game to play when you have visitors! And this is how you play it! Put a blindfold on someone's eyes—he or she is the Blind Man. Then turn him or her round a few times so that he or she loses all sense of direction. All the other children stand around the Blind Man in a big circle. The Blind Man chooses someone and tries to guess who it is by touch. But remember—you need to be really quiet, otherwise you will give yourself away! When the Blind Man has correctly guessed who one of the children is, that child becomes the Blind Man next time round. Have fun!

9
June

Francisco José de Goya, Blind Man's Bluff, 1788/89, Prado, Madrid

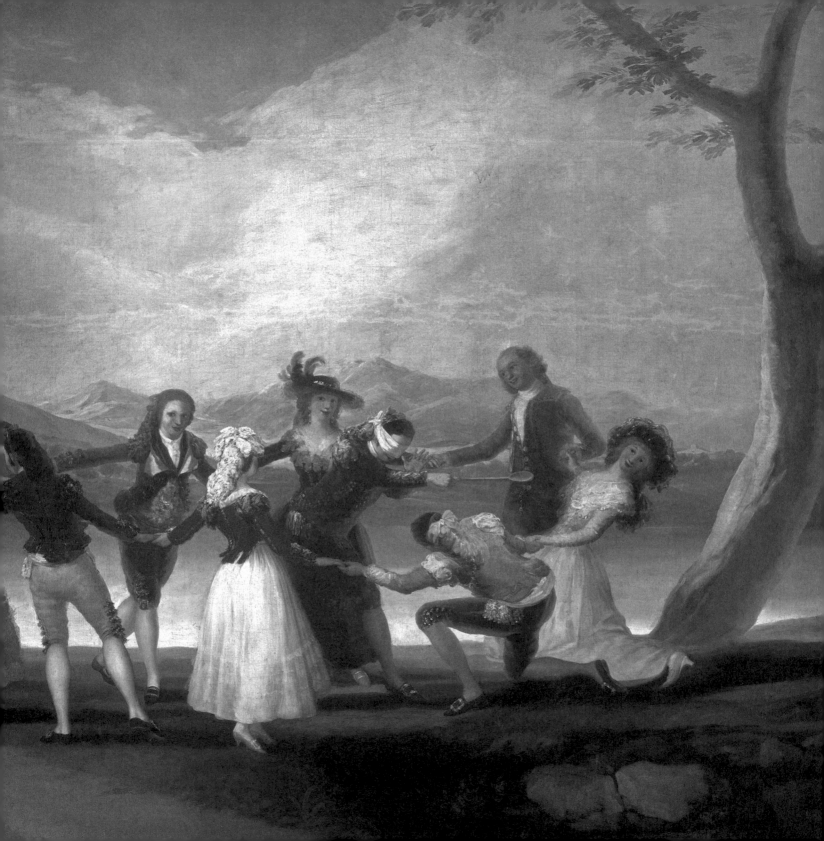

Claude Monet, Two Ladies in a Flower Garden, 1875, National Gallery, Prague

11
June

Here is another garden by Claude
Monet. People are partially hidden
again in the tall flowers.

**Can you match the
details to the picture?**

Medusa is another well-known name in the world of
myths. It is hard to believe that she once was beautiful.
Her hair was turned into snakes and her eyes would
frighten onlookers with their staring
gaze. Her appearance was
supposed to protect
her—whoever
looked at her
turned to
stone!

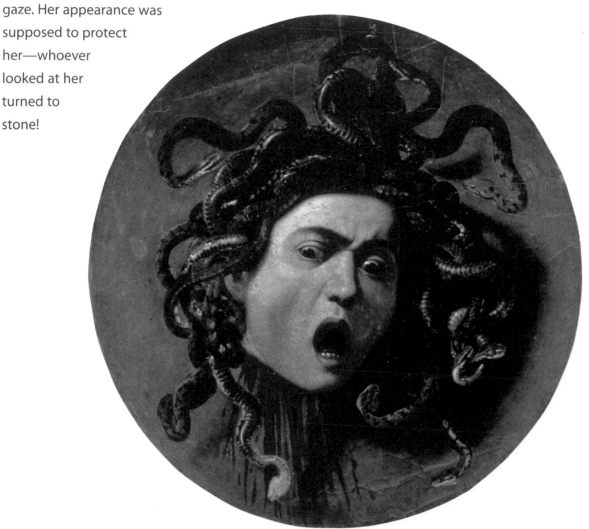

Michelangelo Merisi da Caravaggio, Medusa,
1598/99, Uffizi Gallery, Florence

12
June

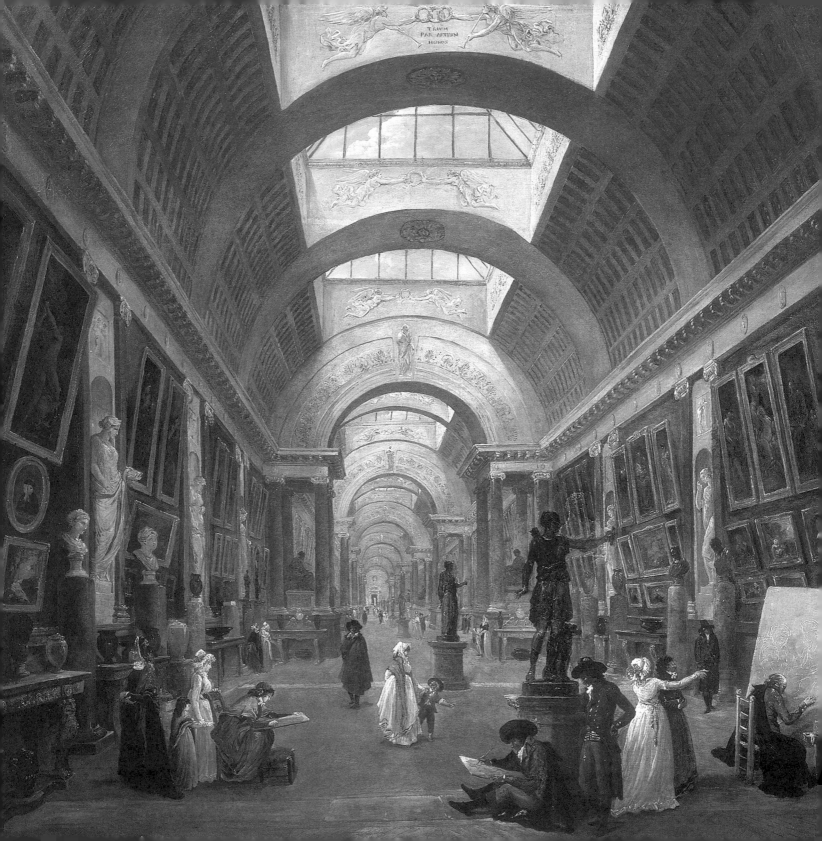

Here is a picture of one of the painting galleries in the Louvre in Paris, one of the greatest museums in the world. You can tell by the clothes that the painting was not made recently. It is from over 200 years ago, when the Louvre first opened.

I spy with my little eye!

* a man is sitting on the floor and drawing

* a mother and her child are watching a woman artist at work

* angels are watching everything from above

* a little boy wants to show something to his mother

* a man is working on a large canvas

* next to him is a big box of paints

14
June

Hubert Robert, Imaginary View of the Grande Galerie in the Louvre, 1796, Musée du Louvre, Paris

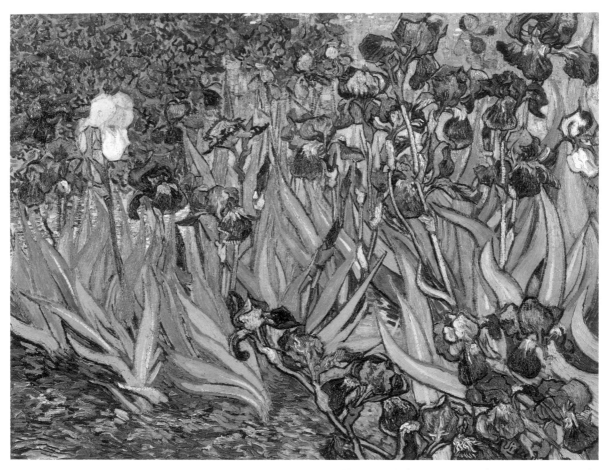

15
June

Vincent van Gogh, Irises, 1889, J. Paul Getty Museum, Los Angeles

You can match the details to the larger picture.

These flowers are named for the Greek goddess of the rainbow. We have seen them once before in another painting by Vincent van Gogh.

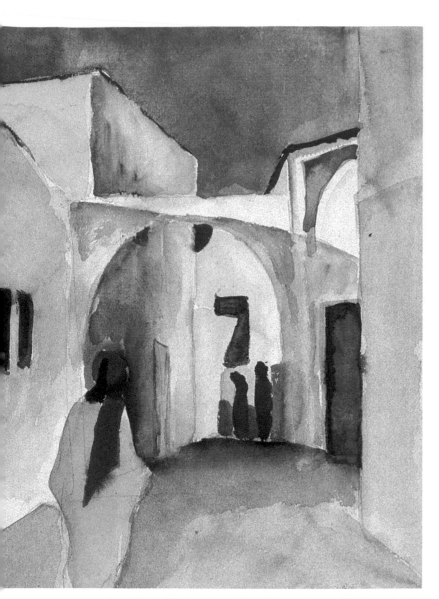

This is another painting made with water-colors. You saw one earlier by the same artist. In both, some of the white paper remains, like light coming through the picture, glowing and warm like the sun in summer.

Watercolor paints can be hard to control. They can also be fun to let drip and flow to make new colors.

16
June

August Macke, View into a Lane 1914, Städtisches Museum, Mülheim an der Ruhr

Look what's happening! A jousting tournament in the middle of the town square! Two horses start galloping towards each other. The riders use a blunt lance to try to knock each other off their horse. When they fall, they continue fighting on the ground with swords until one of them wins.

Here you can draw a knight in armor.
You can even invent a new coat of arms!

17
June

So many people are watching!

This must have been a very big event!

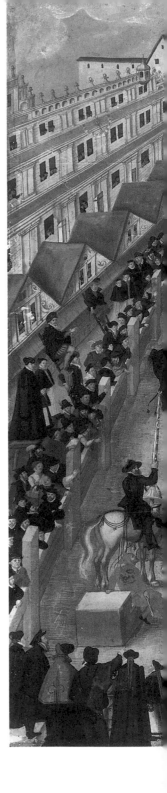

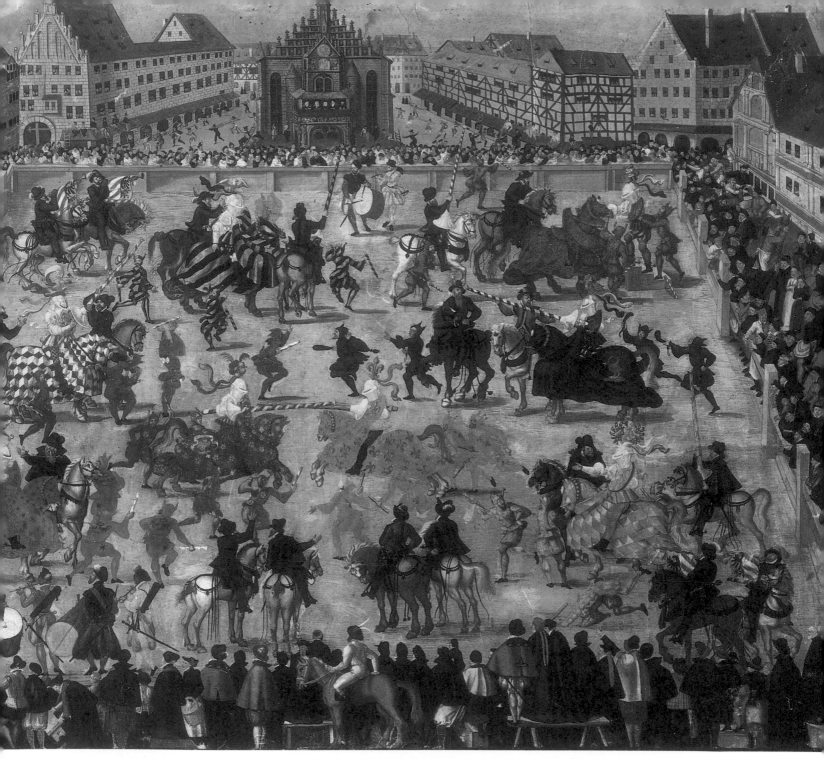

Jost Amann, The Middle-Class Patrician Sons in Nuremberg, 1561, Bayerisches Nationalmuseum, Munich

19
June

Hans Holbein the Younger, Portrait of the Merchant Georg Giese, 1532, Gemäldegalerie, Berlin

You can find the details in the painting.

There are a lot of clues here to tell us about this man. His name was George. Pictured near him is a scale, a seal, and account books. These are all needed for a merchant, someone who sells or trades goods. In this picture, George is 34 years old. And, there is another clue: When this was painted over 400 years ago, carnations were a symbol of engagement. George was about to get married!

You can add color to this room. You have already seen this picture with bright colors. It belonged to Vincent van Gogh.

You can add any colors that you wish.

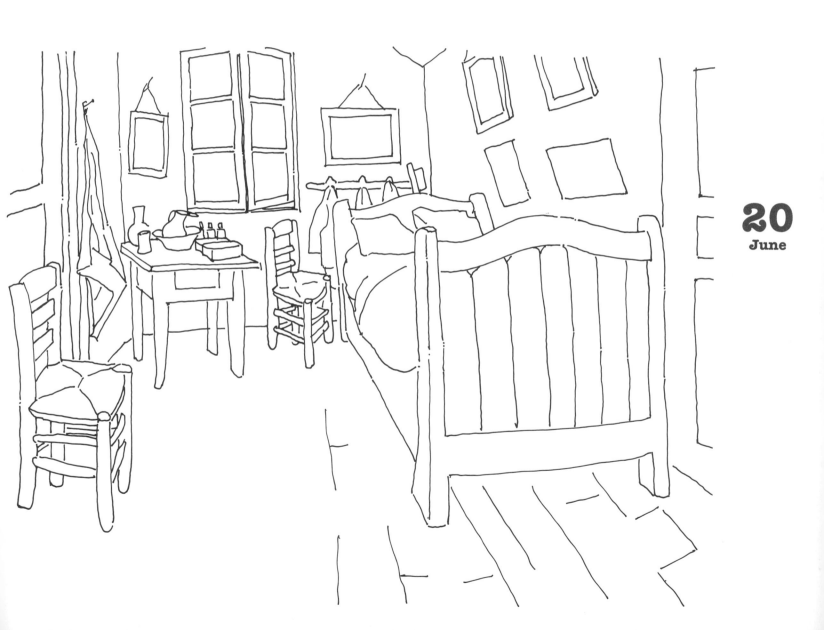

20
June

All of these creatures were painted to look just as they do in real life. There are many different species.

Which ones do you recognize?

Do you have a pet? Maybe you could persuade it to sit still so that you can draw it.

Or maybe you can find a picture of an animal to copy?

21
June

22
June

Frans Snyders, The Concert of Birds, c. 1630, The Hermitage, St. Petersburg

Can you find ...

✺ a snake charmer? ✺ an elephant? ✺ and two lions?

They are hidden in the jungle. Imagine all of the sounds you would hear in this painting!

You can draw more things from the jungle here!

24
June

Henri Rousseau, The Dream, 1910, The Museum of Modern Art, New York

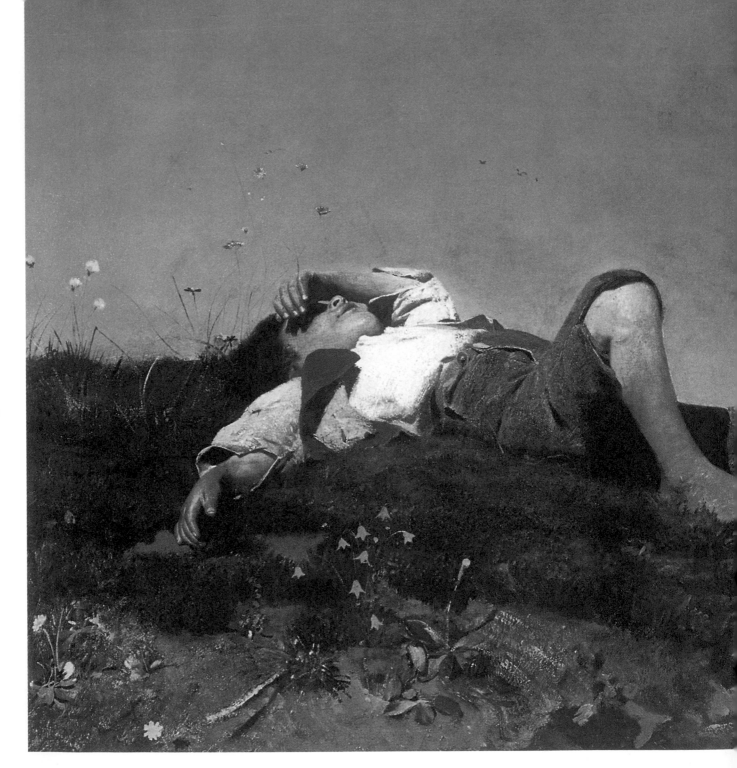

25
June

What a beautiful, clear blue sky! This looks like a wonderful place to rest and think. The sun must be strong—notice the dark shadow the boy's hand makes as he covers his eyes. You can learn a lot about pictures by noticing the details as well as the main areas. For example, the boy's clothes do not look the way clothes look today. This painting must have been painted some time ago.

Why do you think he is barefoot?

26
June

Franz von Lenbach, A Shepherd Boy, 1860, Schack-Galerie, Munich

27
June

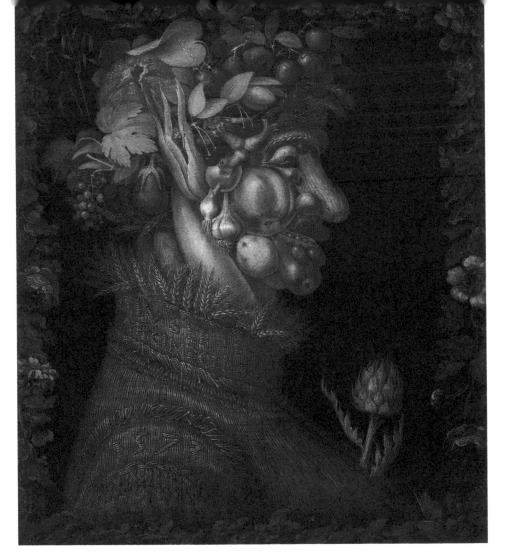

Giuseppe Arcimboldo, The Summer, 1563, Kunsthistorisches Museum, Vienna

You've seen a librarian made of books, a man made of flowers, and now a figure made of a pear, peas, apple, and many other fruits and vegetables. It is a painting of summer, when all of these things are in season, ready to eat.

How would you paint summer?

You can add more trees to this painting. They can be fruit or flowering trees or you can add your own design!

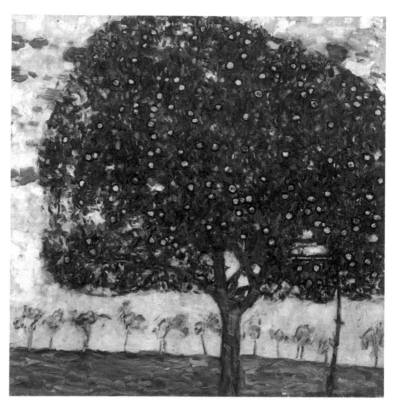

Gustav Klimt, Apple Tree II, 1916, Private collection

28
June

Here is a picture of another lovely day for relaxing outside.
Where would you put a hammock to swing and relax?

You can add to this picture too!

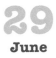

29
June

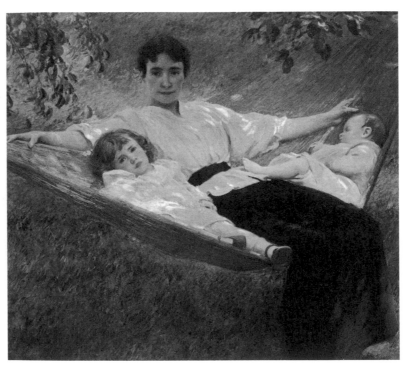

Joseph DeCamp, The Hammock, c. 1895, Adelson Galleries Inc., New York

Can you see ...

✳ a little dark gray terrier? ✳ a woman wearing black gloves who is covering her ears?

✳ and a bunch of rotten grapes?

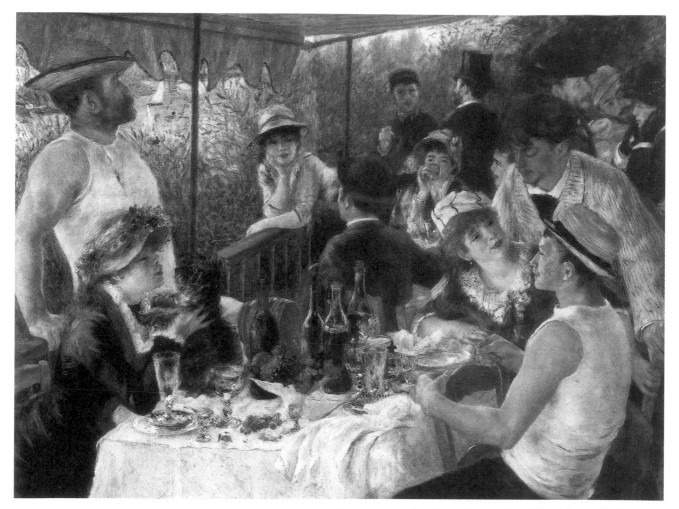

30
June

Pierre-Auguste Renoir, Luncheon of the Boating Party, 1880/81, Phillips Collection, Washington D.C.

The people in this picture are also enjoying their day outside.
Some of them may have already taken a boat ride.

1
July

Willem van de Velde, the Younger, Warships at Amsterdam, Mauritshuis, The Hague

Can you match the details to the big picture?

This artist loved to paint the sea: harbors, sea battles, boats, ships, and sailors. In this painting, the water appears calm.

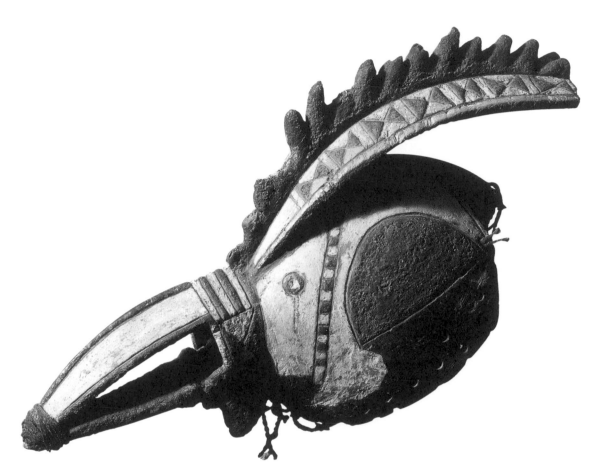

Cockerel Mask, Mossi, Burkina Faso

This mask is from Africa. It was carved out of wood. The patterns are both carved and painted with natural colors. Does the animal look familiar? It lives all over the world, and every morning it greets the sun.

This mask is of a _____.

Here is space for a flag. Why not paint one that you know or design one for an imaginary country!

3
July

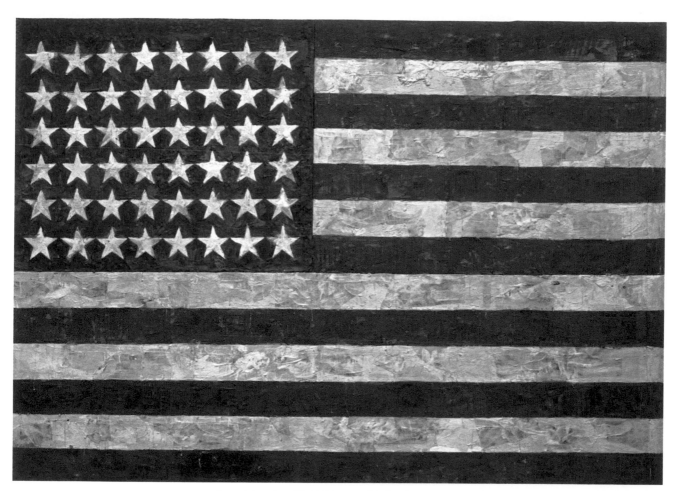

Jasper Johns, Flag, 1954/55, Museum of Modern Art, New York, Gift of Philipp Johnson in honor of Alfred H. Baar, Jr.

4
July

This American flag is not actually a flag. It is a painting of the American flag. The artist, Jasper Johns, painted many versions of this flag. One is even all white! The paint is mixed with wax and bits of newspaper, a very old process called "encaustic painting." In some areas of the painting, you can see through the surface to some of the bits of paper mixed in. You may see more American flags outside today than usual.

The Plischke family is out for a Sunday walk. Mrs. Plischke and her daughters are using umbrellas for the sun and wearing large hats. What has Mr. Plischke done to shield himself from the sun?

Can you tell more about the family's Sunday walk?

...

...

...

...

...

5
July

Can you find these details in the picture?

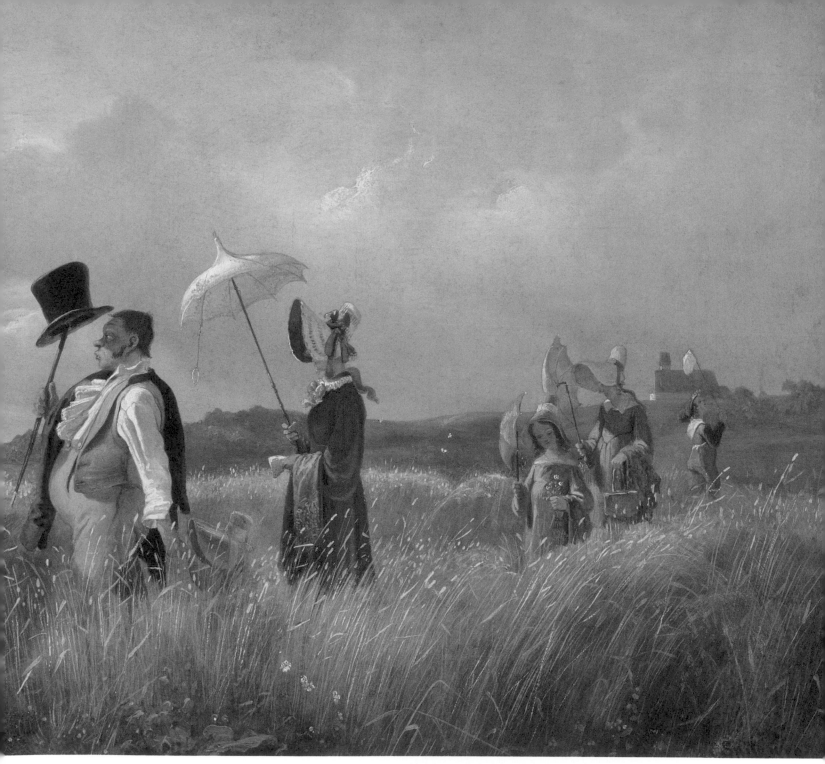

Carl Spitzweg, The Sunday Walk, 1841, Museum Carolino Augusteum, Salzburg

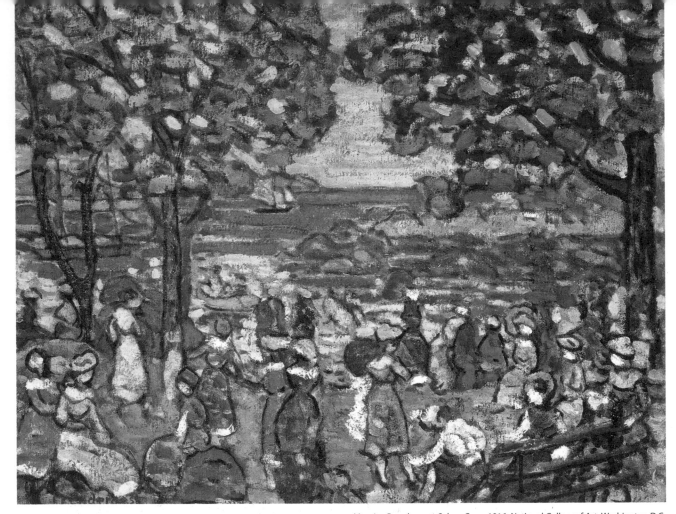

Maurice Prendergast, Salem Cove, 1916, National Gallery of Art, Washington D.C.

7
July

Can you find these details in the main picture?

It seems to be a beautiful day. People are enjoying sitting by the water and boating. Notice all that is happening!

You can add more to the drawing here.

8
July

9
July

Franz Marc, Stables, 1913, The Solomon R. Guggenheim Museum, New York

You have already seen a lot of paintings by Franz Marc. You may remember that horses were his favorite subject to paint.

Can you find more horses, or parts of horses in this painting?

10
July

Finish painting the picture with your brightest colors!

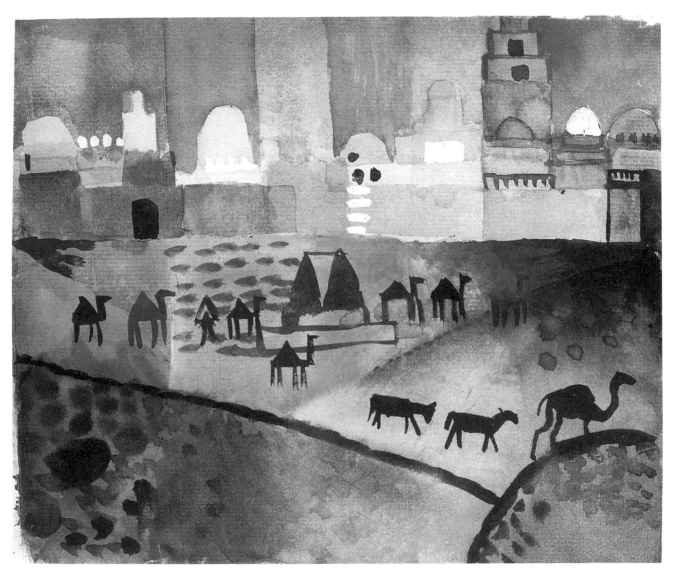

11
July

You may be able to tell that this painting is made with watercolor paints. The camels and round-topped buildings tell us something about where this is. The artist, August Macke, traveled to Africa. This is a painting that he painted while he was in Tunisia. You can look at a map and find this part of Africa.

You can add your own colors here.

12
July

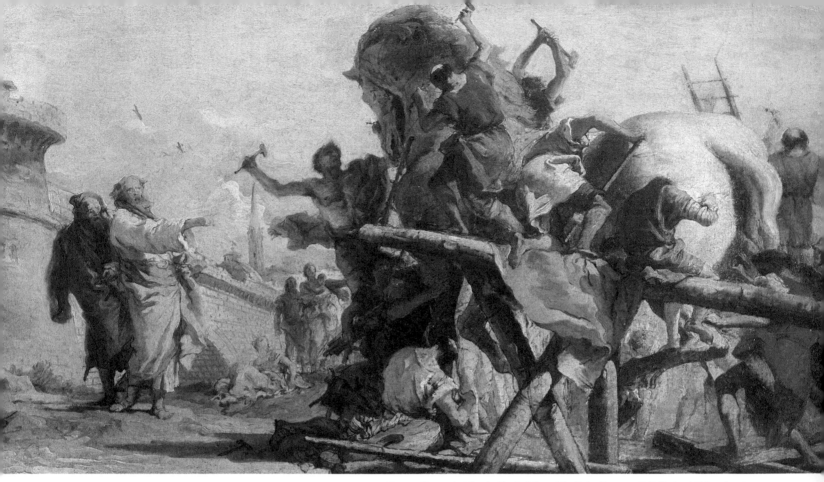

Giovanni Domenico Tiepolo, The Building of the Trojan Horse, c. 1760, National Gallery, London

Do you know the story that this picture describes? The Greeks are building a huge wooden horse as a gift to their Trojan neighbors. But, in this famous story of The Trojan Horse, 30 warriors are hidden inside the horse. The city of Troy is surrounded by a gate to protect itself. Once this large horse is inside the gate, the warriors will come out of hiding and open the gate. Now, the Greek army can easily enter Troy and win the battle.

The idea of the Trojan horse supposedly came from a famous Greek hero. What was his name? a) Odysseus b) Asterix c) Nero

Here lots of people are helping to pull the Trojan Horse into the city.
Would you like to add more to this picture?

14
July

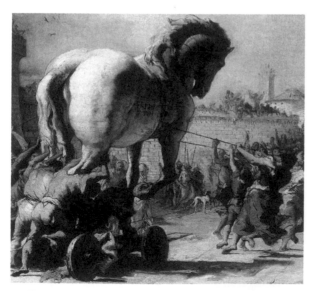

Giovanni Domenico Tiepolo, The Procession of the Trojan Horse, c. 1760,
National Gallery, London

Many pieces and shapes of wood make these sculptures. I wonder if Pablo Picasso found some of these pieces of wood already cut. The shapes may have given him some ideas. He called these sculptures "Bathers." What do you think of this title?

These sculptures are a lot like collages, but instead of pieces of paper, fabric, or other found materials, Picasso has used wood. You can make a sculpture using pieces of light-weight wood along with other materials. Once you have arranged the pieces, glue them together.

15
July

Pablo Picasso, The Bathers, 1956, Kykuit, National Trust for Historic Preservation, Nelson A. Rockefeller Bequest

Frida Kahlo, My Dress Hangs There, or New York, 1933, Hoover Gallery, San Francisco, Joint heirs of Dr. Leo Eloesser

Frida Kahlo named this painting "My Dress Hangs There." If you look back to April 6 you will see a self-portrait painted by Frida. There are many things to see in this picture, painted when the artist was in America. You can see many things of New York here, but the dress is a traditional Mexican dress. It is like another self-portrait, this time, in New York. Could she be missing her home in Mexico?

Here you can see the outlines of Frida's painting. You can choose
your own colors to make it into a new artwork!

18
July

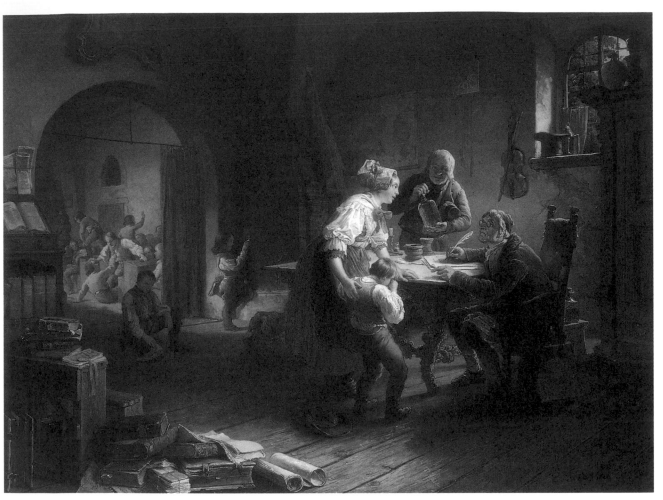

Eduard Ritter, The Town School, 1845, Private collection

There are two pictures in this picture! The children in the back of the painting are having a very different time than the people closer to us. The light from the window shows a woman and young boy. He does not look too happy. He is standing in front of his principal at school.

What do you think will happen next?

These children are brothers and sister. We see them playing over 200 years ago, pulling their young brother in a cart.

What games do you like to play with family or friends?

Philipp Otto Runge, The Hulsenbeck Children, 1805/06, Kunsthalle, Hamburg

20
July

Gustav Klimt had a special way of arranging and composing his pictures. Think of taking a photograph. When you look through the viewfinder of a camera, you decide what to include or exclude from your picture.

Cut out a square or a rectangle from a piece of paper. Look through it as you move it around. You can also move it closer and farther away from your eye. Stop when you find what interests you the most. You have "composed" a picture. You have made a viewfinder from paper.

21
July

Can you find these details in the picture?

Gustav Klimt, A Farmhouse on Lake Atter, 1914, Private collection

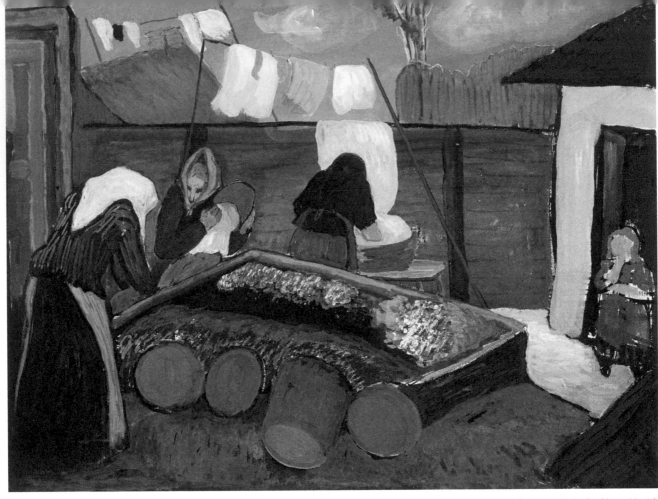

Marianne von Werefkin, Laundress, c. 1909, Lenbachhaus, Munich

One hundred years ago, people still did their laundry by hand—the washing machine had not yet been invented. These three women are hanging their wash out on a line to dry. I wonder if the young girl will help?

Can you find these details in the picture?

You can add color and details here also!

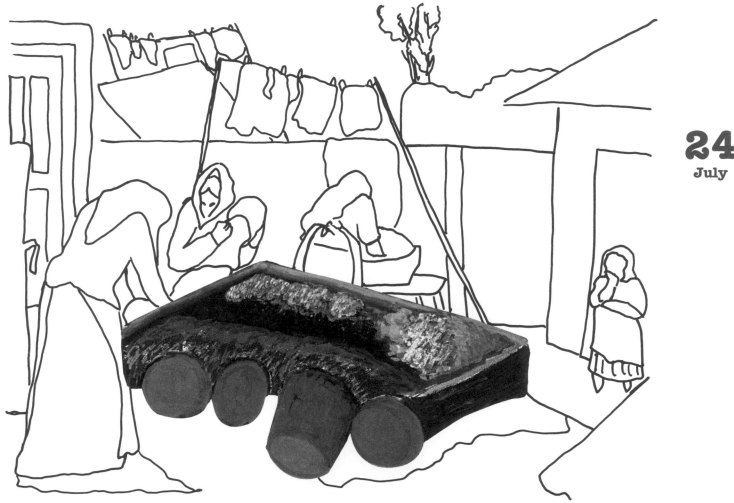

24
July

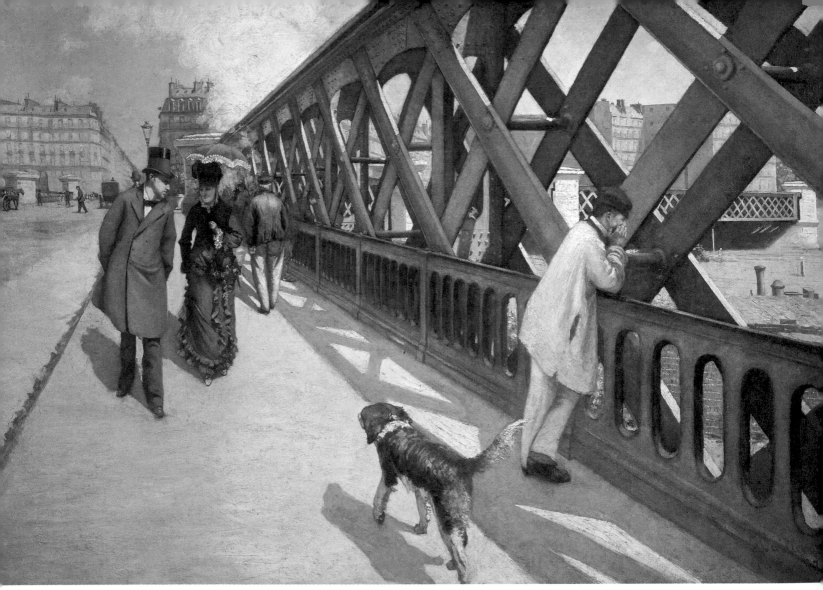

Gustave Caillebotte, On the Europe Bridge, 1876, Musée du Petit Palais, Geneva

It is hard today for us to imagine the change that the railroad brought to people's lives over 100 years ago. Try, for a moment, try to think about life now without cars, trains, planes, or buses. We would be back to horses and wagons, taking a lot longer to travel less distance. When this painting was made, many artists painted trains and train stations. Here we can't see a train, but the man on this bridge is looking down at the train station.

You can draw what the man sees here!

26
July

Kazimir Malevich, 2-Dimensional Self-Portrait, 1915, Stedelijk Musem, Amsterdam

Look at the geometric shapes in the picture. Is the light-colored rectangle resting on the smaller square or pushing it down?

How would you describe this painting?

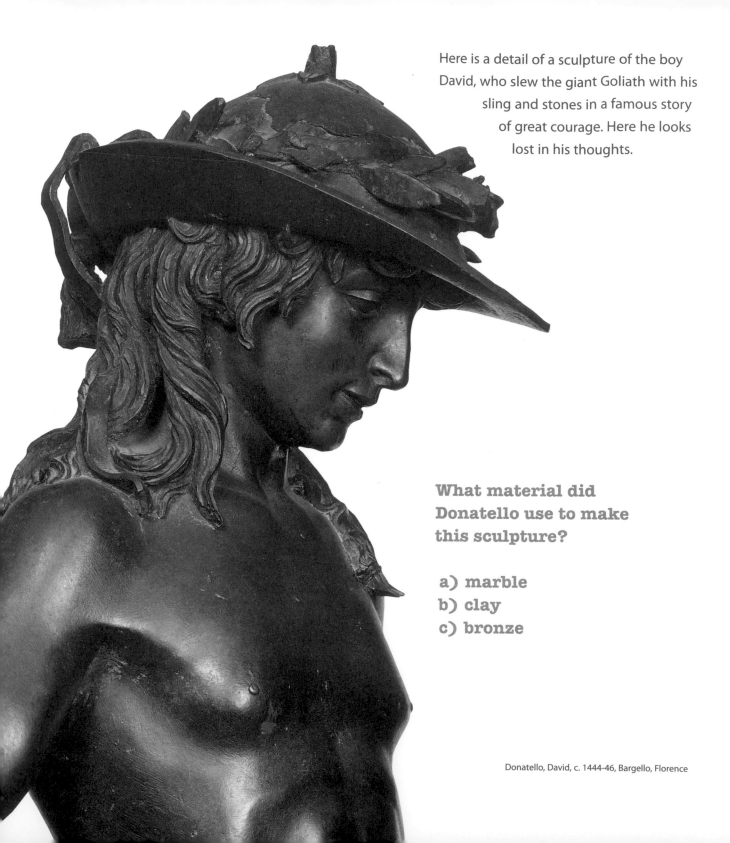

Here is a detail of a sculpture of the boy David, who slew the giant Goliath with his sling and stones in a famous story of great courage. Here he looks lost in his thoughts.

28
July

What material did Donatello use to make this sculpture?

a) marble
b) clay
c) bronze

Donatello, David, c. 1444-46, Bargello, Florence

29
July

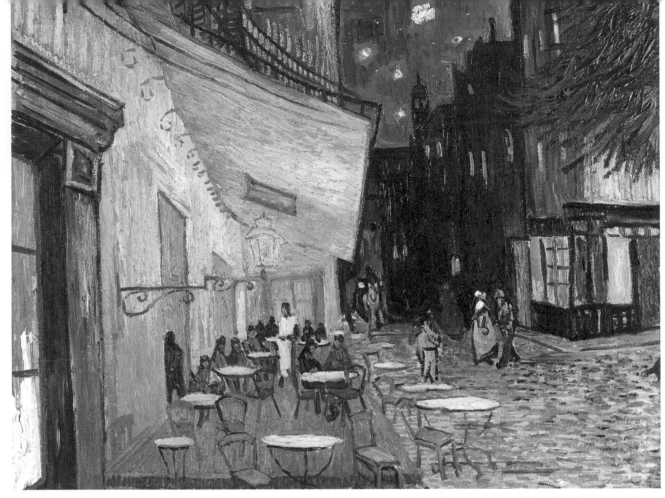

Vincent van Gogh, Café Terrace at Night, 1888, Kröller-Müller Museum, Otterlo

It took 20 hours for Vincent van Gogh to travel by train from Paris to the south of France, to Arles, where he spent time painting many pictures, like this outdoor café in the evening.

What do you think Vincent van Gogh named this painting?

a) Café Terrace at Night
b) Finally Arrived
c) My Holiday in the South

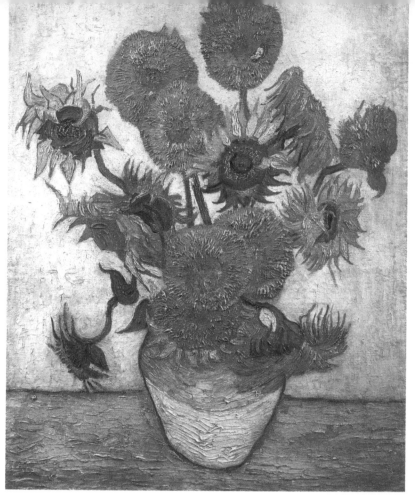

Vincent van Gogh, Fourteen Sunflowers in a Vase, 1889, Yasuda Insurance, Tokyo

Van Gogh was not famous when he was alive. It was very discouraging to keep painting, having very little money and needing help from his family to live. His brother, Theo, supported him with encouragement as well as money for paints, canvases, food, and housing. They wrote each other many letters. Vincent may not have been able to paint this painting had it not been for his brother's support.

30
July

Would you also like to paint a large bouquet of flowers?

Who knows, maybe someday you too will become famous for your pictures!

31
July

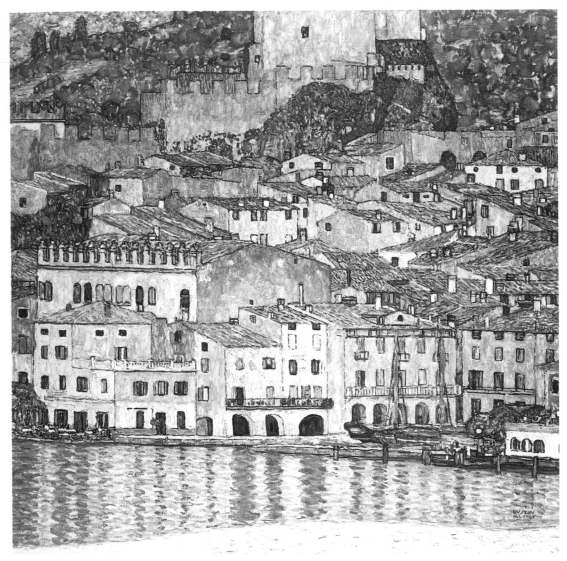

Gustav Klimt, Malcesine on Lake Garda, 1913, lost in a fire at Schloss Immendorf 1945

Can you find these details in the picture?

Another beautiful day! The water is sparkling and gleaming in so many shades of blue. The family is heading to the other side of the lake.

You can add more to Mary Cassatt's painting. Perhaps some life jackets?

1
August

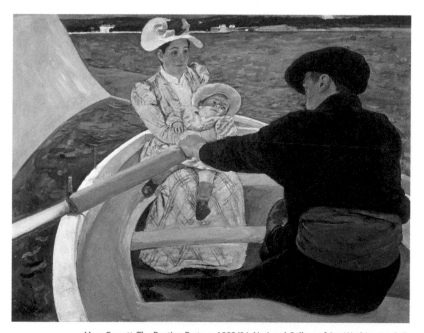

Mary Cassatt, The Boating Party, c. 1893/94, National Gallery of Art, Washington D.C.

This picture, by Henri Matisse, is like a painting, a collage, and a drawing all at once! Matisse described his technique as "drawing with scissors!" He was the first major artist to produce silhouette pictures. Some are as large as walls, as you see here.

Matisse called this picture "The Parakeet and the Mermaid." Can you find them?

Henri Matisse painted the paper and then he cut out the shapes with his scissors, "drawing" the shapes, not following a drawn line.

You can try this with flat or even folded paper. If folded, cut the open edge. When you open the paper, you will have the mirror of what you made as well.

3
August

Henri Matisse, The Parakeet and the Mermaid, 1952-1953, Stedelijk Museum, Amsterdam

4
August

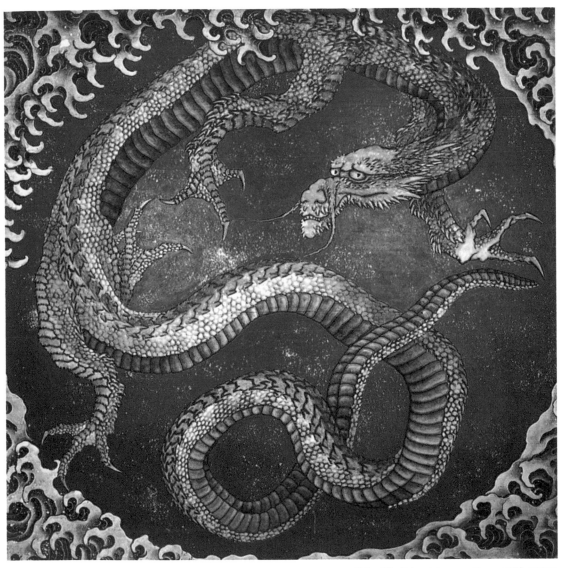

Katsushika Hokusai, Japanese Dragon, 19th century

The Japanese artist Hokusai painted this dragon against a red background. Can you see his sharp claws? They look really dangerous.

And can you find these details?

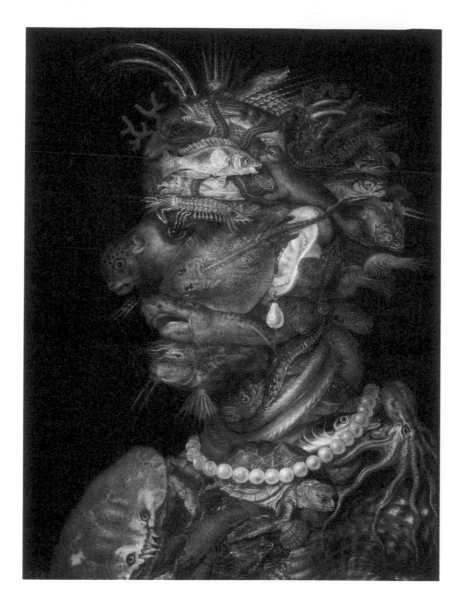

Giuseppe Arcimboldo, Water, 1566, Kunsthistorisches Museum, Vienna

Here is our artist-magician again! No books, flowers, fruit or vegetables this time. What has Guiseppe Arcimboldo painted here?

Can you find the hidden creatures?

It is unusual to combine these animals with fancy pearls.

Vincent van Gogh, The Langlois Bridge at Arles with Women Washing, 1888, Kröller-Müller Museum, Otterlo

Many wagons traveled over this railroad bridge when Vincent van Gogh painted nearby. He often walked on the bridge and saw the women washing clothes by the river. You can see all of these things in this painting.

What else do you see near the river?

7
August

Match the details shown here to notice more of the painting.

Here is a wedding celebration pictured a long time ago! The bride and groom are pictured on the bottom left. A young boy is handing a glass of wine to them. A miracle has just happened. Jesus, who is sitting at the center of the table, has just made wine from water! There is a lot of conversation and music. There are animals as well as people, and lots of food and drink.

There are dishes here waiting for you to add food. What would be a good choice to eat?

8
August

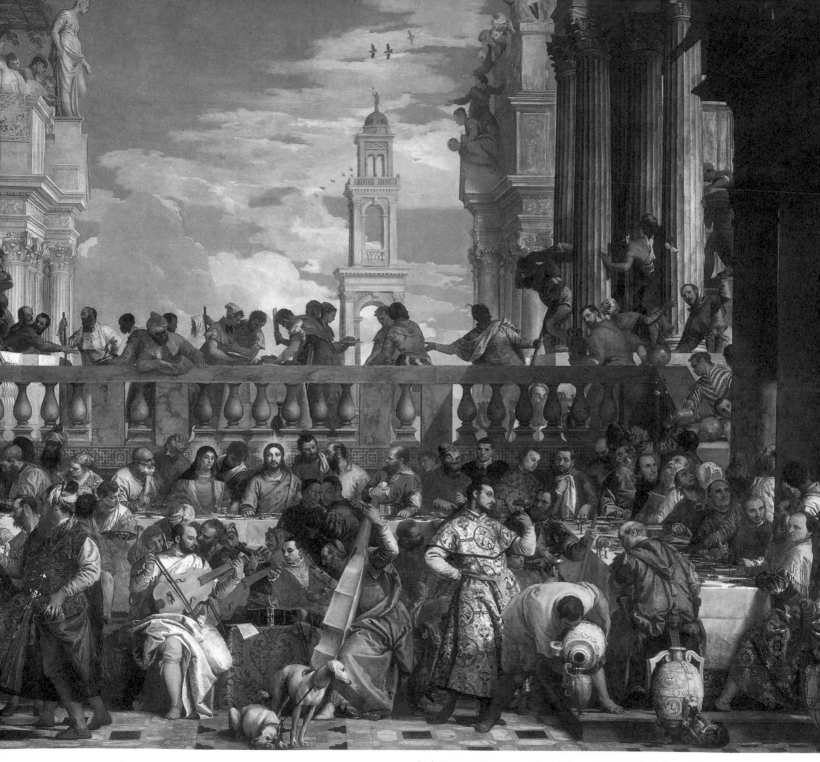

Paolo Veronese, The Marriage Feast at Cana, c. 1570, Musée du Louvre, Paris

August Macke, Zoo I, 1912, Lenbachhaus, Munich

When was the last time you went to the zoo?

How many animals do you recognize here?

There is space here to add more to this picture.
What else will you include?

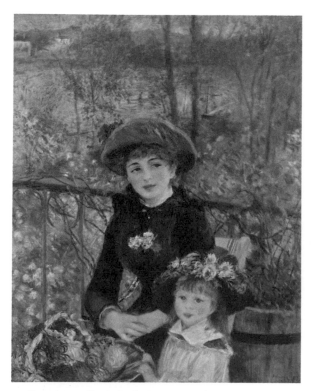

Pierre-Auguste Renoir, On the Terrace, 1881, The Art Institute, Chicago

11
August

King Louis XIV was one of the most powerful rulers of France. He was known as the Sun King. His coat is lined with precious fur.

Which animal does it come from?

a) fox
b) ermine
c) ocelot

12
August

What does the Roman numeral XIV mean?

a) 15
b) 14
c) 19

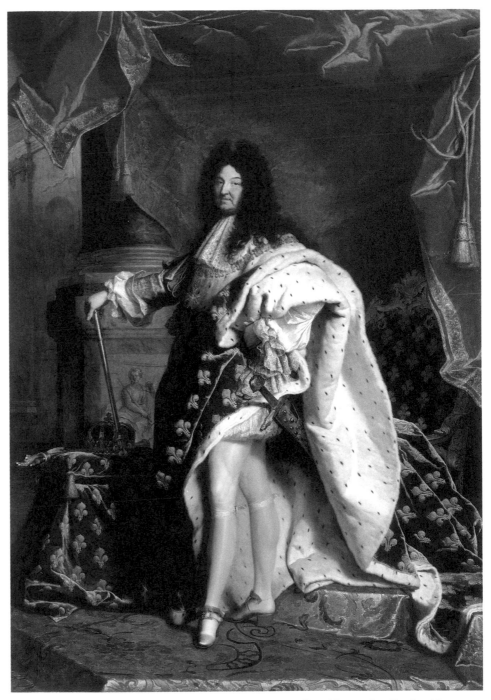

Hyacinthe Rigaud, Portrait of Louis XIV, 1701, Versailles, Grand Apartement

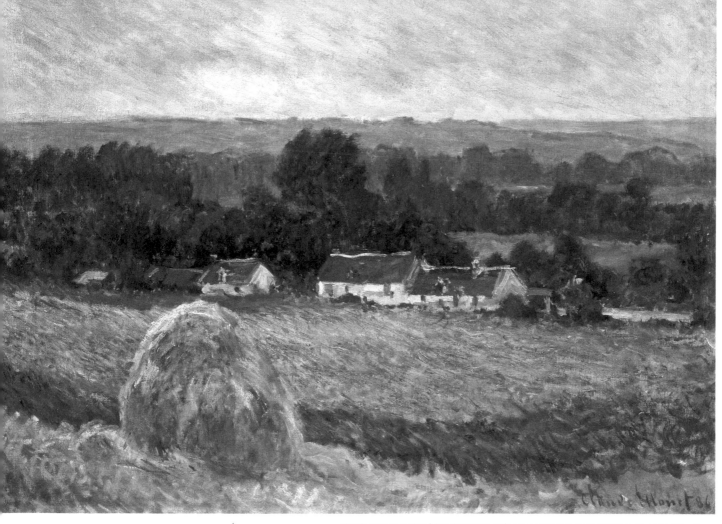

Claude Monet, Haystack in a Summer Landscape at Giverny, 1886, The Hermitage, St. Petersburg

Can you find
these details in
this picture by
Claude Monet?

What do you think about the
colors that he has used?

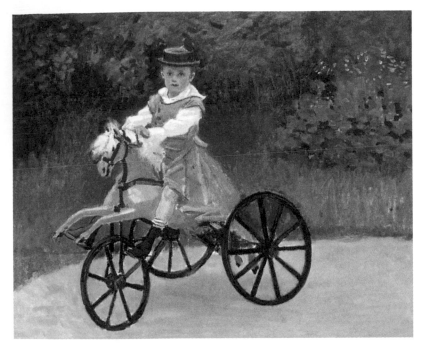

Claude Monet, Jean Monet on his Hobby Horse, 1872, Metropolitan Museum of Art, New York

14
August

So you think that pink is a typical color for girls? Well, do you remember little Jean, the son of Claude Monet? (May 12) Here he is again—in a pink dress! At the time when this painting was made, boys wore pink because red was the color of rulers, and that usually meant men. So "little" red was reserved for their sons. Blue was the color for women and girls. (Monet had eight children, so there was a lot of pink and blue clothing at home).

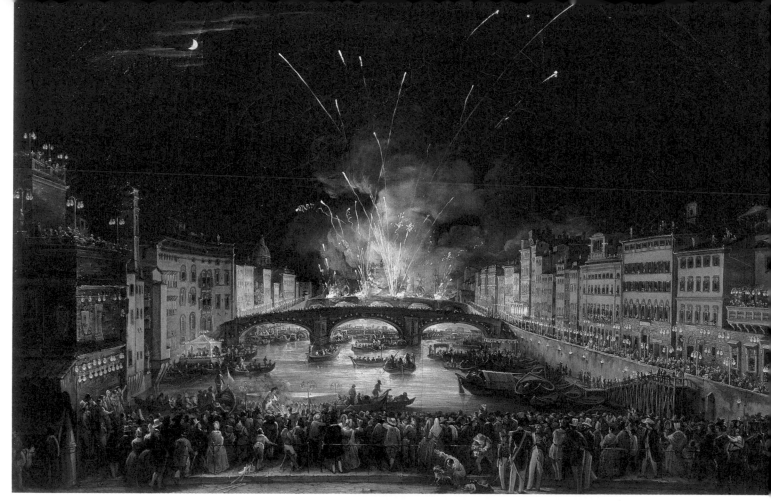

Giovanni Signorini, Fireworks over Carraia Bridge in Florence during the Festival of John the Baptist, 19th century, Uffizi Gallery, Florence

Look for the details in the main picture.

The city of Florence is celebrating a festival! There are fireworks with lots of sparks lighting up the sky. The whole city is celebrating, but it is not the new year.

16
August

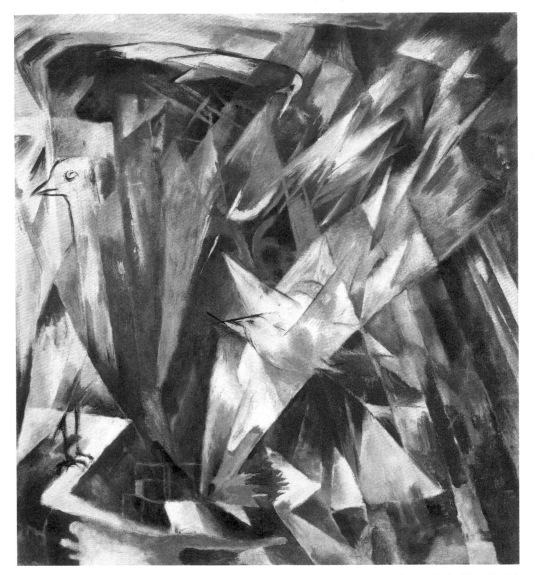

Franz Marc, Birds, 1914, Lenbachhaus, Munich

We have seen some of Franz Marc's foxes. Animals were among his favorite subjects. After he had been painting for a while, he decided to paint his animals differently from the way they really look. He divided his subjects into shapes and painted them in bright colors.

Can you recognize the birds in this picture? Franz Marc often signed his pictures with his initials. How do you sign your pictures?

Here you can color in the picture as you like.

17
August

Imagine a story and draw a picture to illustrate it!

18
August

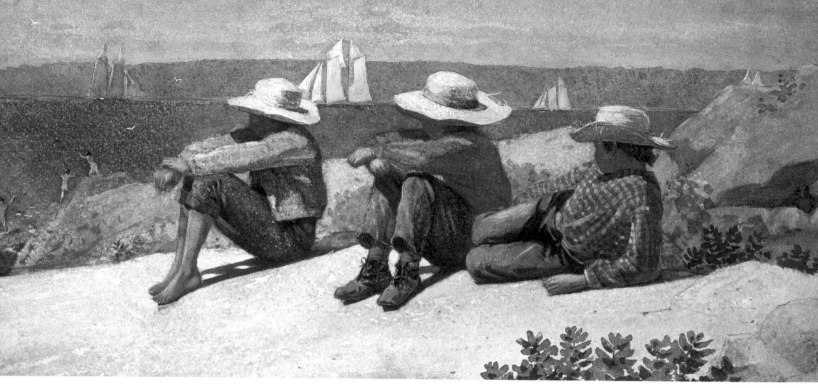

Winslow Homer, Boys on the Seashore, 1875, Forbes Collection, New York

19
August

**Where would you rather be in this picture
—climbing on the rocks or sitting in the sun?**

Here you can draw the angry giant Polyphemus, with a single eye in the middle of his forehead!

20
August

Can you find these details?

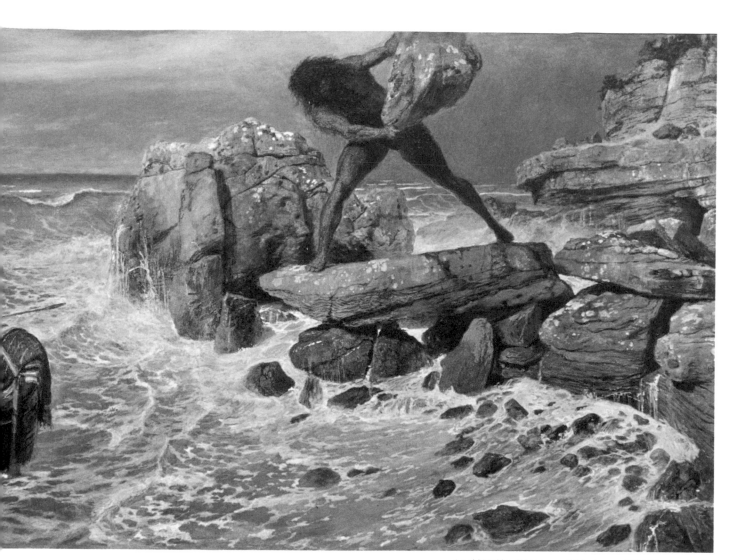

21
August

Arnold Böcklin, Odysseus and Polyphemus, 1896, Private collection

Polyphemus, a one-eyed giant from another Greek myth, throws a bolder in a fit of rage onto a boat full of people and just misses! Polyphemus's father was very powerful—he was Poseidon, the god of the sea. He made Odysseus wander on the ocean for ten whole years before he finally found his way back home.

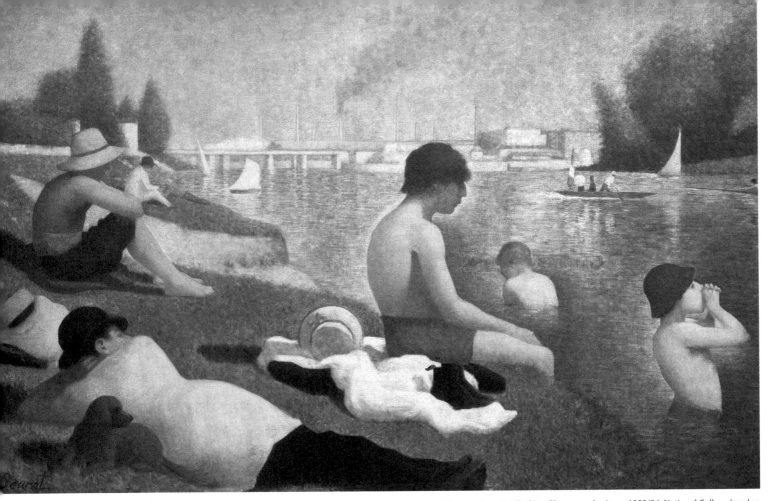

Georges Seurat, A Bathing Place near Asnieres, 1883/84, National Gallery, London

Can you find these details?

No one had seen a painting made like this before George Seurat made this painting. Hundreds of painted dots of many, many colors were added to make this picture. It made George very famous. You may remember other painters who also used this technique.

We have seen pictures from Tunisia. Here is a picture painted in Tahiti by Paul Gaugin who was a peer of Vincent van Gogh.

Imagine: What else can you add to this picture with the two girls?

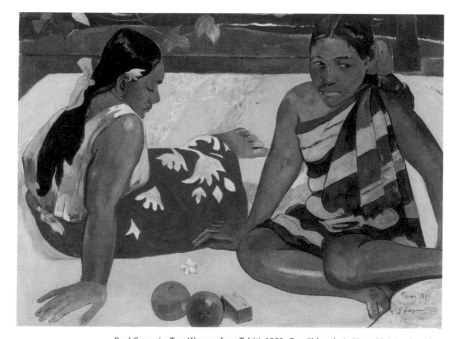

Paul Gauguin, Two Women from Tahiti, 1892, Gemäldegalerie Neue Meister, Dresden

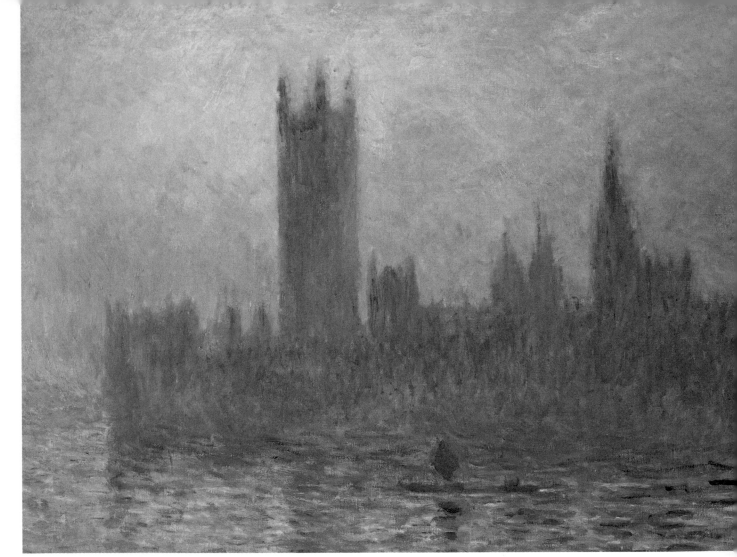

Claude Monet, The Parliament in London at Sunset, 1903, National Gallery of Art, Washington D.C.

24
August

If you remember seeing a Haystack painting by Claude Monet, then you may see something similar here by the artist. Monet was very interested in the way that light changed the way things look (February 17). That is why in this painting you can only see the outline of a building and its reflections in the water in front of an orange-red sky.

Can you also draw some boats on the river?

25
August

This picture by Pieter Brueghel is from a series of six pictures in which he shows the life of the peasants at different times of the year. Did you know that in those days the calendar was still divided into six seasons—Early spring, Spring, Early summer, Late summer, Fall, and Winter?

Here you can see the hay harvest in spring:

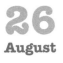 A man is sharpening his sickle.

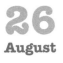 Another is packing the hay on the cart by walking on it.

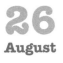 Twelve workers are raking the hay into piles.

Can you find all of that?

26
August

Pieter Brueghel the Elder, The Harvest, 16th century, National Gallery, Prague

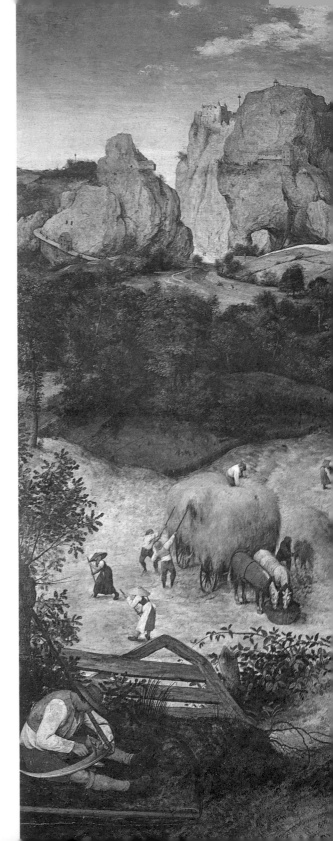

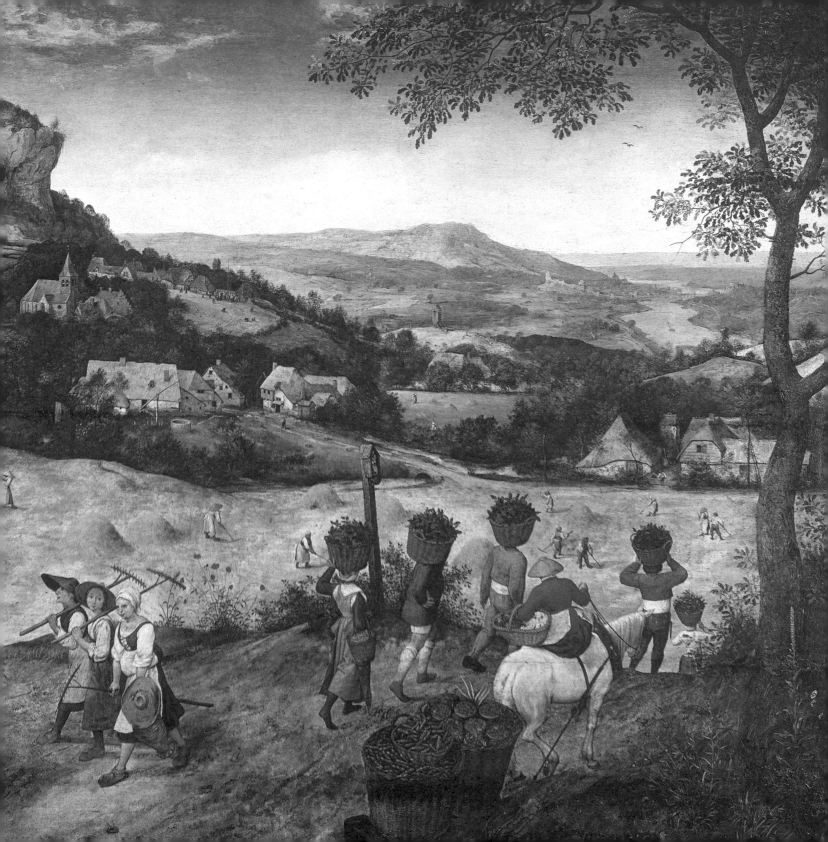

28
August

Rembrandt, Self-Portrait, 1632, Art Gallery and Museum,
Burrell Collection, Glasgow

Rembrandt van Rijn was a Dutch painter who painted lots of Bible stories, Greek myths, and historical personages. He made his pictures look very dramatic—like a dark stage with bright spotlights shining on the main characters. Rembrandt became very famous because of his paintings and even during his life-time other artists tried to paint as he did. Throughout his life he also painted portraits of himself wearing different clothes. This self-portrait shows him as a young man.

Rembrandt has painted 34 people in this painting! The famous "Nightwatch" is the portrait of an entire company of soldiers with their captain.

Can you find the only woman among all these men? What is hanging from her belt?

a) a purse
b) a dead chicken
c) an umbrella

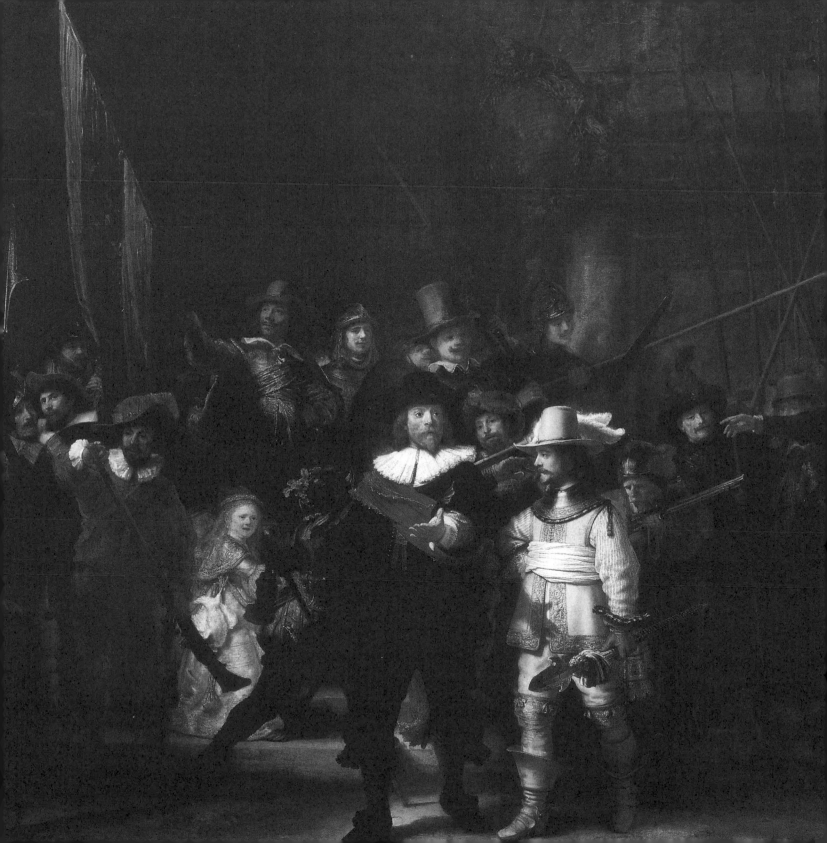

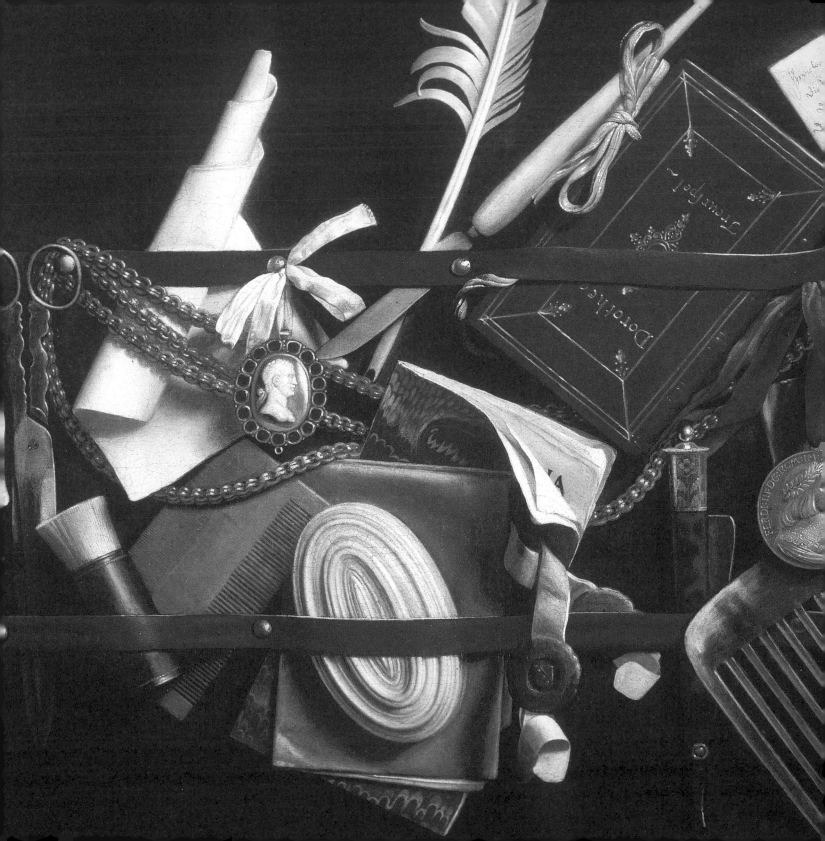

Did you ever have the feeling that an artist wanted to trick you? That their skill was so great, they could paint something that looked real enough to touch and hold! Samuel van Hoogstraten was one of these artists, as you can see in the picture. Van Hoogstraten wanted to paint more than a realistic picture. He wanted his pictures to look as real as life itself. This style of painting is called "trompe-l'œil." It is a French word and means "optical illusion." The objects in this painting were pinned to a board and arranged as the subject for painting almost 350 years ago!

Do your eyes deceive you here?

What is painted and what is real?

a) Everything here has been painted.
b) The coin is real.
c) The cameo is real.

31
August

Samuel van Hoogstraten, Quodlibet, 1666, Staatliche Kunsthalle, Karlsruhe

1

September

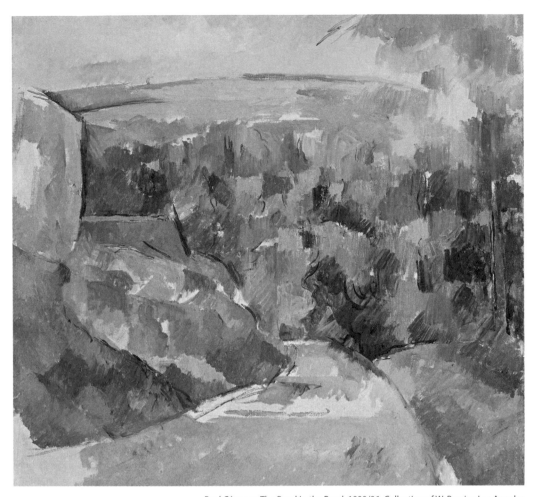

Paul Cézanne, The Bend in the Road, 1900/06, Collection of W. Bareiss, Los Angeles

Paul Cézanne is considered to be the father of modern painting, yet during his lifetime he did not achieve much success. People over 100 years ago preferred paintings that were realistic and showed the world as it appears. Many people today still prefer this way of painting. Cezanne painted landscapes, like this one, still-life paintings, and portraits.

Can you find these details?

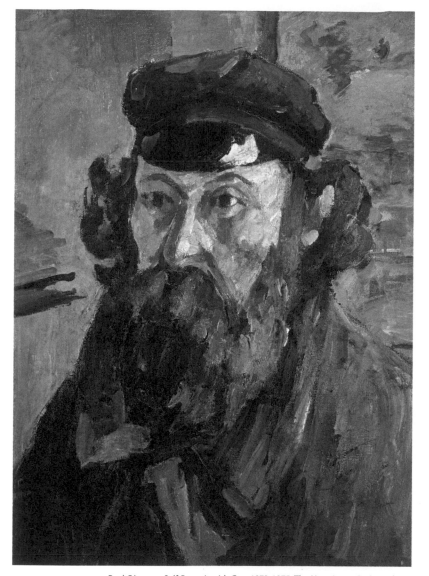

Paul Cézanne, Self-Portrait with Cap, 1873-1875, The Hermitage, St. Petersburg

Notice how Cézanne used color and his brush, as if light is coming through the painting. In some places you can even see the white from his canvas peeking through! Here is a self-portrait by Paul Cézanne! How many different shades of green do you imagine that he used? There are so many colors! I wonder why he chose to look off to the side, instead of out at us, the viewer?

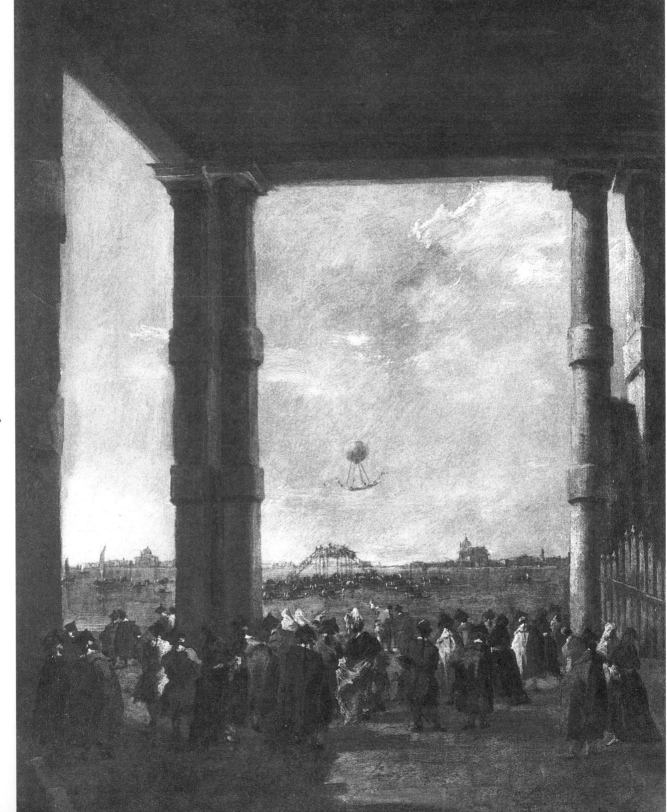

Many spectators are watching this event:

Can you find these details in the main picture?

4
September

One of the first hot-air balloons is flying in the air! It is made of strong paper filled with gas. You can write a story here about it. Maybe it reminds you of someone named Dorothy, her dog Toto, and …

..

..

..

..

..

..

Francesco Guardi, The Hot Air Balloon Launch, 1784, Gemäldegalerie, Berlin

The hay has been harvested. The birds are flying low in the rain. Try and imagine painting each and every brushstroke!

There are details here too!

5
September

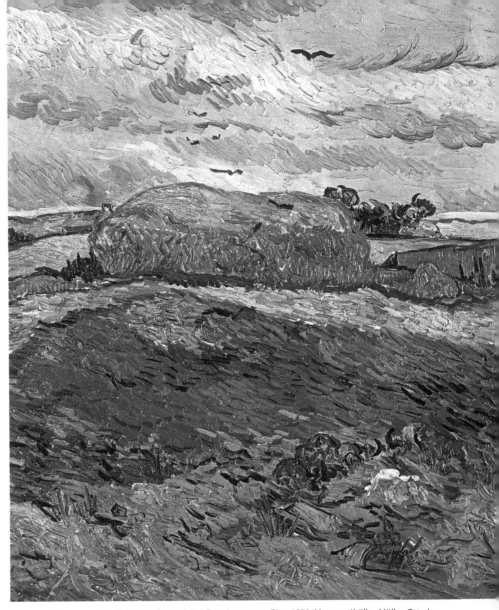

Vincent van Gogh, Haystack on a Rainy Day, Auvers-sur-Oise, 1890, Museum Kröller-Müller, Otterlo

You can paint in the air with your hand instead of a brush and experience all of the energy and movement this painting needed. Move your imagined brush while looking at the painting.

Look what is happening here! These fishermen have caught a whale.
What would it be like to be on this boat right now? A whale can weigh
over 150 tons—quite a match for the fishermen!

You can draw some more whales here.

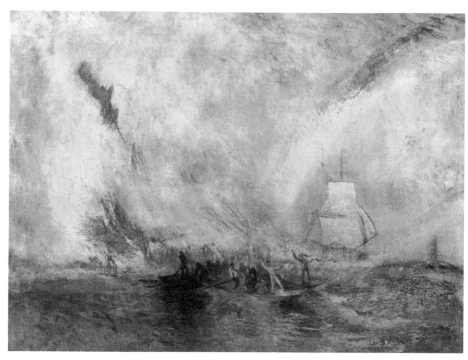

J. M. W. Turner, Whalers, Tate Gallery, London

6
September

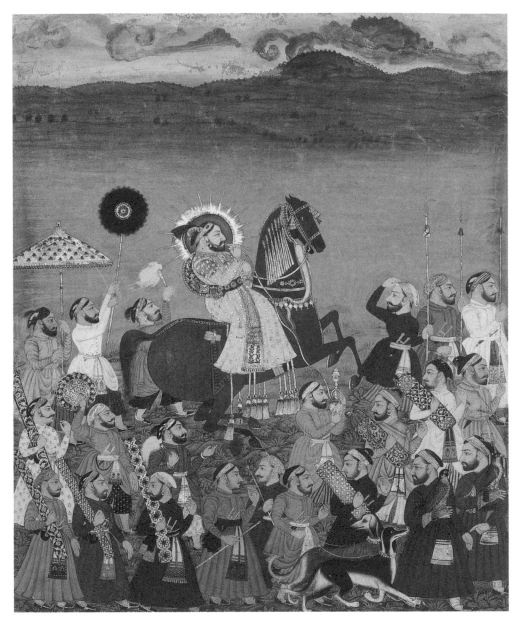

Maharana Sangram Singh of Mewar Out Hunting on His Horse, Jambudvipa, 1720-30, Khalili Collection

7
September

What a celebration! The Indian emperor is sitting on his horse, ready to set off for the hunt.
His servants are following him with many things.

Can you find ... a torch? ☀ two falcons? ☀ a brown dog?

What do you notice about the way this lion is shown? His front legs are facing down on the ground and his back legs are facing up! Why do you think the artist painted the lion this way?

You can add more to this picture if you like.

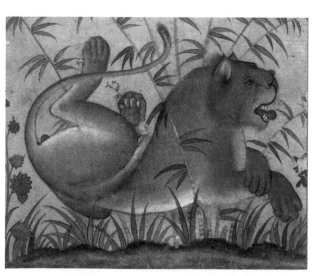

Lion at Rest, Miniature Painting from the Mughal Era, c. 1585,
Nasli and Alice Heeramaneck Collection, New Haven

9
September

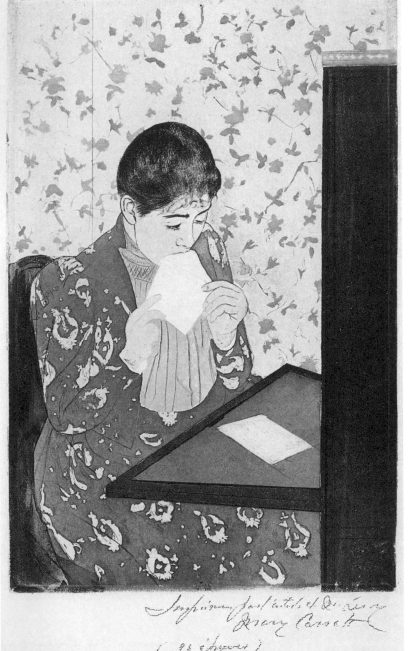

Mary Cassatt, The Letter, 1891, Library of Congress, Washington D.C.

One hundred years ago e-mail had not been invented yet and people wrote each other letters if they wanted to stay in touch—like the woman in this picture by Mary Cassatt. She is licking the envelope to seal the letter before putting it in the mail.

What do you think she has written?

Dear

..

..

..

..

..

..

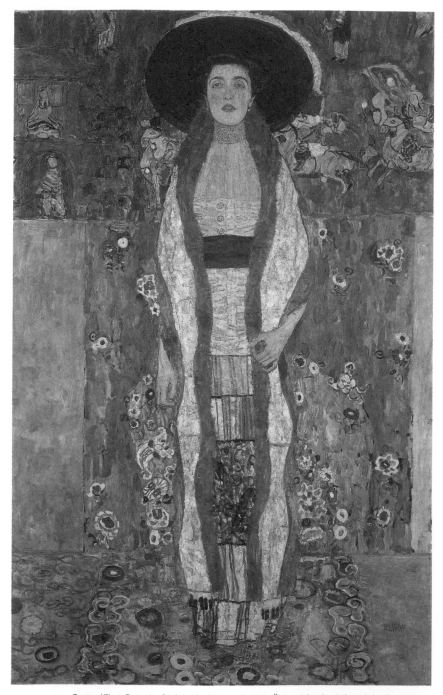

Gustav Klimt, Portrait of Adele Bloch-Bauer II, 1912, Österreichische Galerie Belvedere, Vienna

This very elegant woman is Adele Bloch-Bauer. She had to be a very patient model for Gustav Klimt because as he painted, he continued to add new details. He needed a great deal time to paint and observe her.

Can you find these details in his painting?

10
September

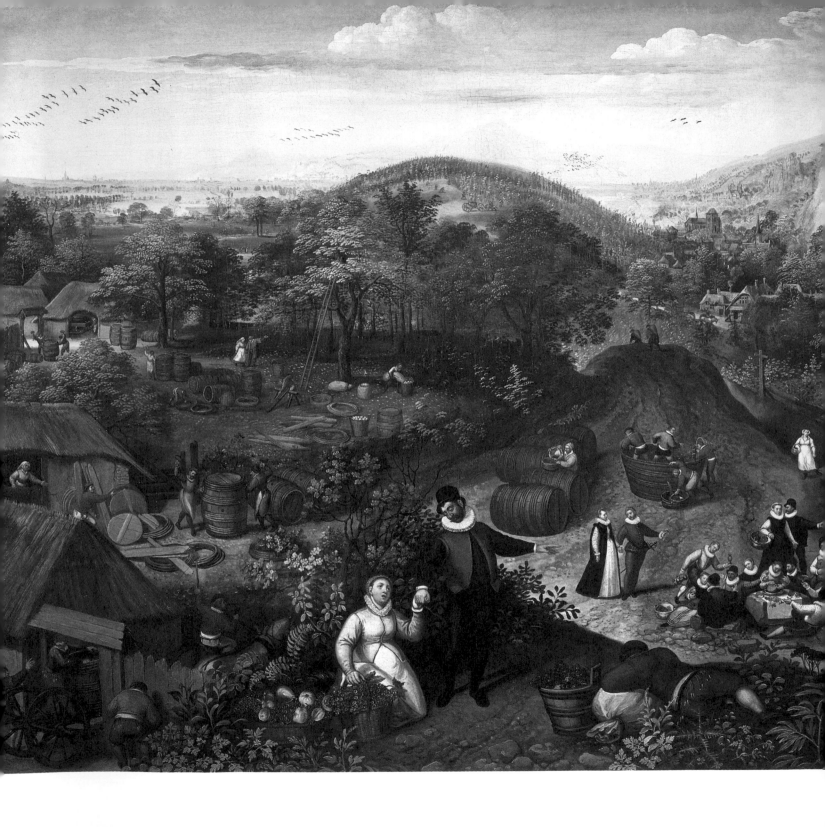

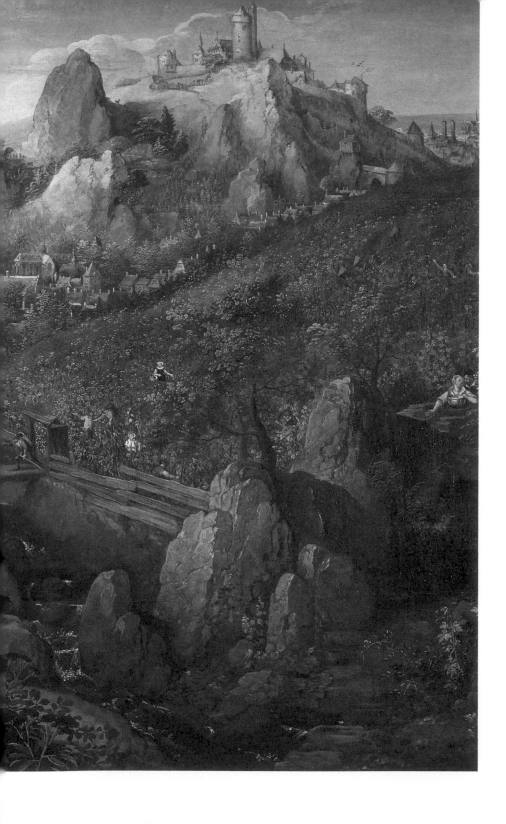

Have you ever designed a calendar? September is when the grapes are ready for harvesting! In his picture for the month, the artist shows us people making wine after harvesting their grapes:

* Barrels are built to hold the wine.

* Men and women crush the grapes with their bare feet in large vats.

* The wine is tasted.

Have you found everything?

12
September

Lucas I van Valckenborch, Autumn Landscape with Vineyards, 1585, Kunsthistorisches Museum, Vienna

13
September

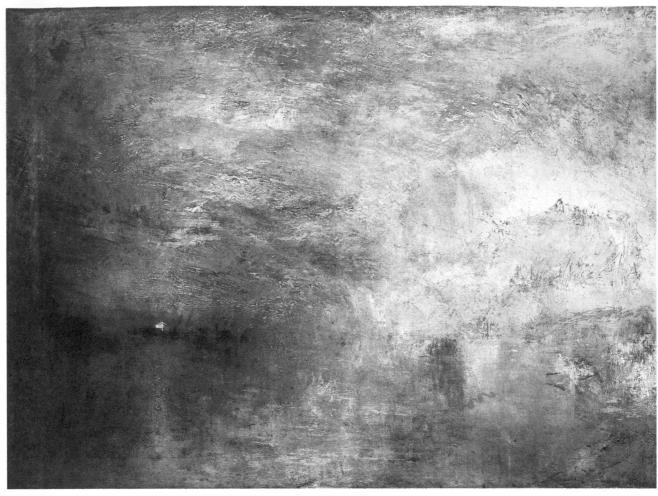

J. M. W. Turner, Sun Setting over a Lake, c. 1840, Tate Gallery, London

This English painter J. M. W. Turner loved watching the way the colors of the sky changed all the time. How different dark clouds before the rain can look from clouds on a sunny day! Turner, like Claude Monet, painted at all times of the day. Instead of haystacks, he painted skies, the ocean, and changing light on them.

Is it possible to figure out when this was painted?

a) in the morning b) at noon c) in the early evening

Birdman

Here is a memory game that you can make. It is like the game con-
centration. Paint the cards in pairs with the same picture, so that
you always have two identical cards. Cut them out and place them
with the colored side facing down. Take turns turning over two
cards at a time. Whoever finds two cards of the same card gets to
keep them. And the person with the most cards at the end wins!

15
September

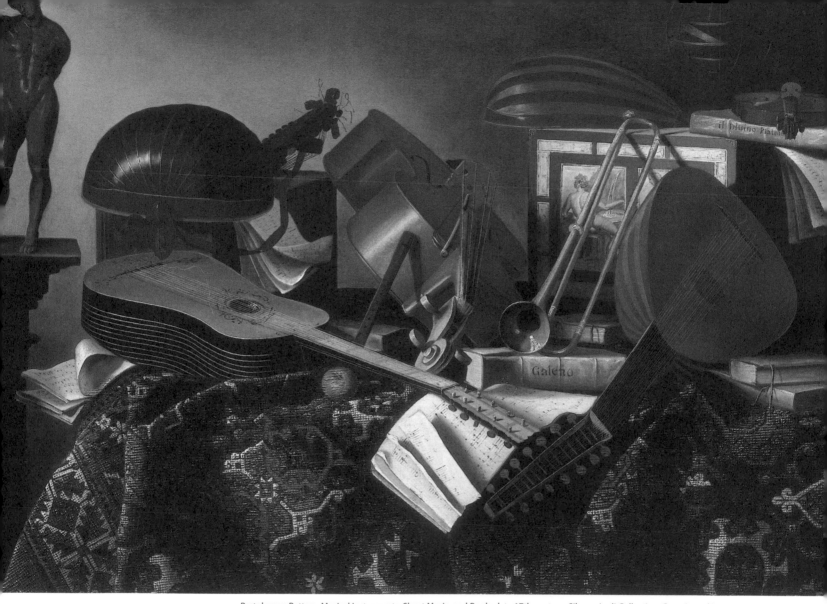

Bartolomeo Bettera, Musical Instruments, Sheet Music, and Books, late 17th century, Silvano Lodi Collection, Campione d.l.

Which instruments can you recognize?

Many hundreds of years ago, before people spent their time with electronics, TV, and computers, people enjoyed making and performing music in homes or palaces instead of concert halls. You may not necessarily recognize the 3 lutes, but you probably recognize the other instruments.

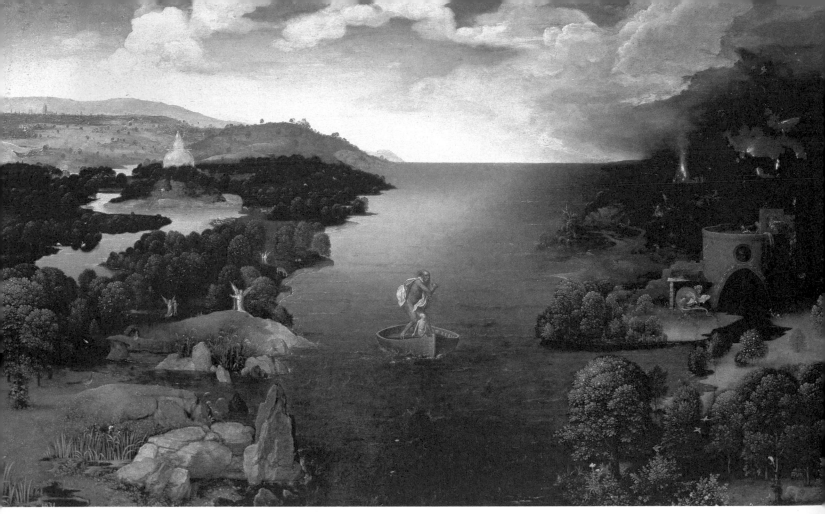

Joachim Patinir, Charon Crossing the Styx, the River to Hades, 1512/24, Prado, Madrid

The ancient Greeks believed that people wandered between the Earth and the underworld after they died until the boatman Charon, pictured here, came to take them across the River Styx into the kingdom of Hades. (Hades was the god of the underworld). But the dead had to pay to travel across the river! That was why the Greeks used to place a coin called an "obolus" under a dead person's tongue. This way, it was believed, souls would not wander forever.

The entrance to the underworld was guarded by Cerberus, the vicious and frightening hound of Hell. He has many heads and a serpent's tail.

Do you see what is hidden behind him?

18
September

People are dressed in their very best clothes! If you lived back in 1715, this is how you would have dressed if you were wealthy and lived in England. Some of the clothes here were copied and worn by people who admired the artist's designs—as well as his painting! What would you choose to wear?

I spy with my little eye:

* a dancing couple

* two black and white dogs

* a lady in black with a glass in her hand

* a fountain

* a musician is sitting on the floor

**19
September**

**There's someone else
watching the dancers:
A secret observer behind
a balustrade.**

Jean-Antoine Watteau, Les Plaisirs du Bal, 1715/16, Dulwich College Gallery, London

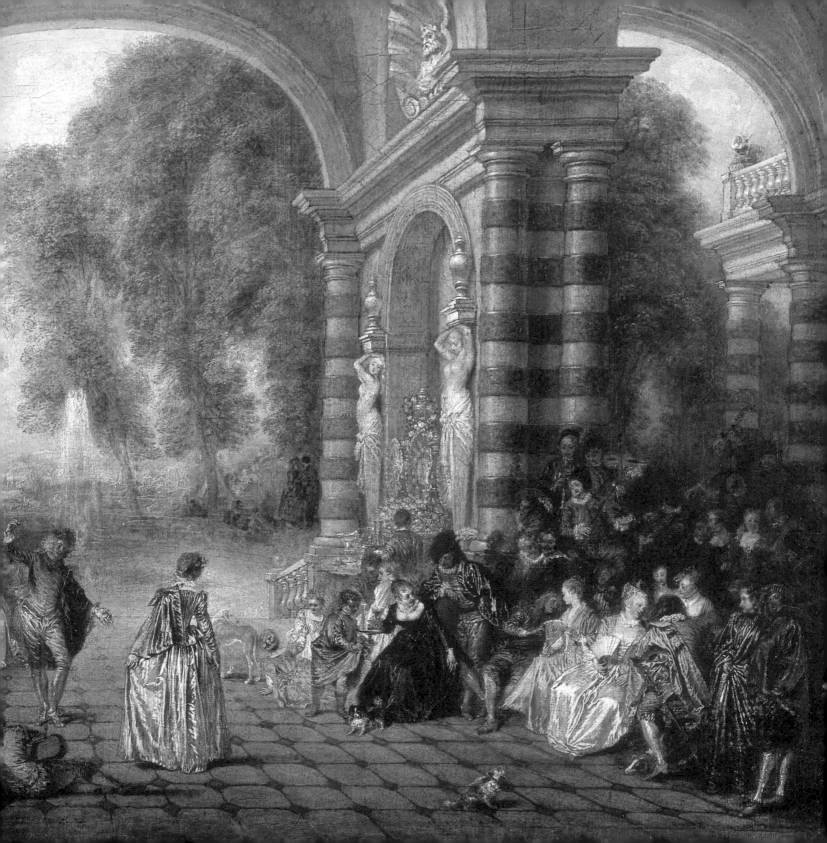

21
September

Wassily Kandinsky, Oriental, 1909, Lenbachhaus, Munich

Take time to look at this picture. At first, you notice
the colors and shapes. Slowly, you will begin to see
more of what these colors and shapes are showing.

The artist who painted this is named Wassily Kandinsky. He divided his
pictures into different spaces for color and painted them very brightly.

Have you ever started a picture this way?

22
September

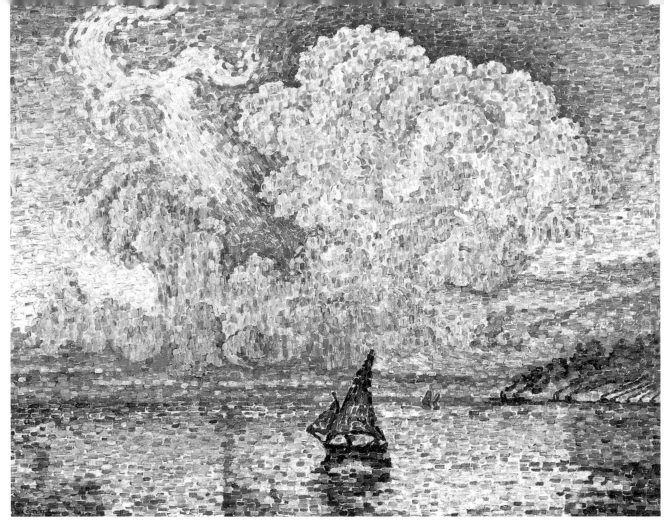

23
September

Paul Signac, Antibes: The Pink Cloud, 1916, Private collection

Do you remember other paintings
made with points and dots of colors?
You can also look at the details to
the right.

There are a lot of things in this store that the man is selling.

If you like, you can add more!

August Macke, Merchant with Jugs, 1914, Westfälisches Landesmuseum
für Kunst und Kulturgeschichte, Munster

24
September

25
September

Clockwise from top left: Andy Warhol, Self-Portrait, 1966/67; Self-Portrait, 1966; Self-Portrait, 1967; Self-Portrait, 1966,
José Mugrabi Collection

26
September

Here we have another self-portrait, but it is by the artist Andy Warhol. He loved using every-day objects and people to make his paintings. But, they were not made with brushes. Andy silk-screened his ideas for pictures onto canvas. He would reuse the same picture and change the colors and repeat the picture many times. Notice how differently each picture of the artist looks here in different color combinations.

Carl Blechen, The Devil's Bridge, c. 1830, Neue Pinakothek, Munich

This looks like it would be a dangerous job building
this bridge. Notice how many workers are here and resting,
and how much more work is left to do.

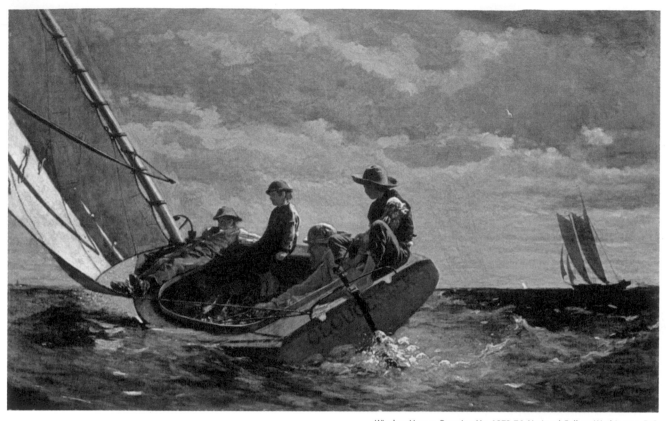

Winslow Homer, Breezing Up, 1873-76, National Gallery, Washington D.C.

28
September

Can you find these details in the main picture?

This picture by the painter Winslow Homer really makes you think of holidays beside the sea, doesn't it! Can you imagine being out at sea in this boat? What can you tell about the picture by looking carefully? Notice the weather, the angle of the boat and sails for a start.

29
September

Egon Schiele, Houses with Clothes Hanging Out to Dry, 1917, Private collection, Santa Barbara

This picture was painted before there were washing machines. It was a woman's job to boil the water in large tubs, to scrub clothes, and carry them out to hang to dry. It was very tiring work.

More laundry! You can make the clothesline longer so there
is more space for clothes.

30
September

Umberto Boccioni, The City Rises, 1910, The Museum of Modern Art, New York

You can feel the movement and action in this
picture. No one seems to be standing still!

What is happening?

What will happen to the boats after this huge wave crashes? The wave is so large that it is not easy to see the boats or the volcano off in the distance.

Can you expand this picture?

Katsushika Hokusai, The Great Wave, from the series "Thirty-six Views of Mount Fuji," c. 1830/31, Private collection

2
October

Nicolas Poussin, Moses Produces Water from a Cliff, 1633/35, National Gallery of Scotland, Edinburgh

Moses didn't have it easy. After 4 days of traveling through the desert, the people of Israel ran out of water. The people were very thirsty and the thirstier they became, the more upset at Moses they were for leading them away. What was Moses to do? He was desperate and prayed to God to send his people water. God commanded Moses to strike a nearby rock with his staff. As Moses obeyed, water poured out of the stone. This story is from the Old Testament.

Do you know any other famous stories about Moses? For example, the one when he was a baby floating down the Nile river in a basket?

Do you know who rescued him?

Here is some space for you to draw the story!

4
October

Do you remember the magician artist who made a librarian of books? This picture, by the same artist, Giuseppe Arcimboldo, is titled Autumn.

How many autumn fruits and vegetables can you find?

What fruits are in your house?

You can arrange them into a design.
You can even add leaves and sticks
(if it is okay with others in your house).

5
October

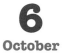

6
October

Giuseppe Arcimboldo, Autumn, 1573, Musée National du Louvre, Paris

7
October

We are looking at a painted sculpture of the Egyptian queen Nefertiti. Does she look like anyone you know? She and her husband Akhenaten, the pharaoh, were thought to be gods as well as rulers. But Akhenaten changed this belief. From this time on, the Egyptians worshiped one god: Aton, the sun god.

The Iconic Bust of Nefertiti 1351-1343 BCE, Egypt, Egyptian Museum, Berlin

How many cats are here?

If this were ancient Egypt, the cats would
be worshiped as gods.

8
October

Franz Marc, Three Cats, 1913, K20K21 Kunstsammlung Nordrhein-Westfalen, Düsseldorf

I spy with my little eye:

⬥ a parrot ⬥ a pipe ⬥ a handwritten piece of paper

9
October

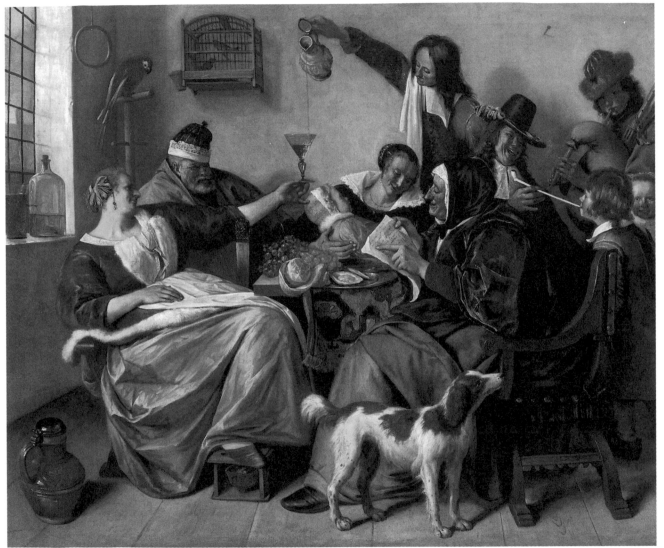

Jan Steen, Joyful Company (The Painter's Family), c. 1657, Mauritshuis, The Hague

Everyone seems to be enjoying themselves. People are reading, eating and drinking, all gathered together, even a dog and bird! This is actually a painting of the artist's family—but many, many years ago.

10
October

Frans Hals, Married Couple in a Garden, 1622, Rijksmuseum, Amsterdam

Look at this couple. They are sitting close together and appear quite happy. The artist titled this painting Married Couple. When this was painted, black was the color for a bridal dress, not white, as it is today. Sometimes, titles can provide more information about pictures. But it is always good to look first!

11
October

Both of these pictures are painted by the same woman. How old do you think this child is? The plants are almost as tall as her! Or, is she standing on something to make herself taller?

Paula Modersohn-Becker, Child with Goldfish Bowl, 1906/07, Pinakothek der Moderne, Munich

Paula Modersohn-Becker, Self-Portrait in front of Green Background with Blue Irises, c. 1905, Kunsthalle Bremen

Paula Modersohn-Becker had many friends who were artists.
They painted and talked together, and learned things about painting
from each other. Here is a self-portrait of Paula Moderson-Becker.
What do you think it says about her?

A circus! It looks like a large audience! The horse is so close to the edge of the ring! In this painting you can see large areas of color and 3 different patterns using dots.

Can you find these details?

13
October

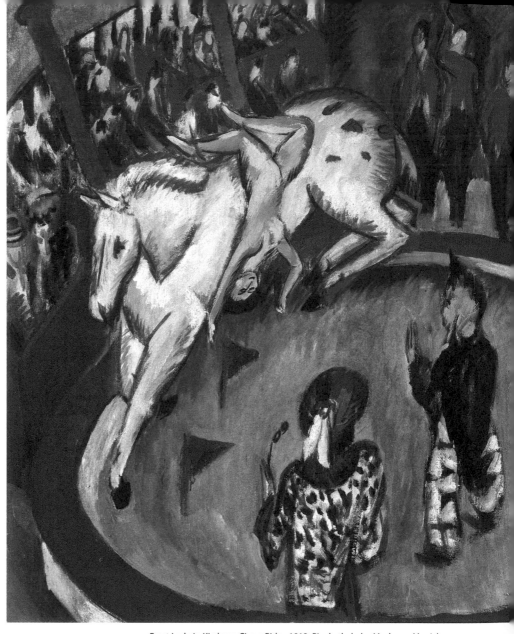

Ernst Ludwig Kirchner, Circus Rider, 1912, Pinakothek der Moderne, Munich

Would you like to draw your own acrobat here?

14
October

The town pictured here appears the way it looked over 500 years ago! Look carefully and you will see a wall around all of the buildings. This wall helped to protect cities from invasion.

15
October

Did you find these details too?

Master of Bamberg, Departure of the Apostles, with View of Bamberg from the East, 15th century, Bayerisches Nationalmuseum, Munich

A fair in Russia! What can you see in the picture?

Try to look past some of the people and you will see some of the things being sold.

17
October

Boris H. Kustodiev, Russian Fair, 1906, Tretjakov Gallery, Moscow

What stands are missing? Can you draw them?

18
October

August Macke, Indians on Horses, 1911, Lenbachhaus, Munich

It may take a moment to see all of the Native Americans in this landscape full of color. The one not on horseback is carrying a staff. He may be a shaman, a healer believed to have great power for his people.

You can write a story here.

20
October

The person pictured here was the leader of The Mandan
Buffalo Bull Society. You can probably tell from his mask.
His shield and staff add to his power and stature.

21
October

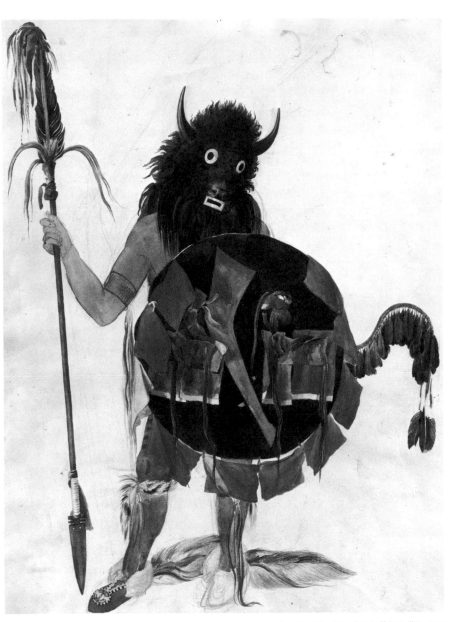

Leader of the Mandan Buffalo Bull Society

Can you guess the animal shown here in this mask?

The spots are a big clue!

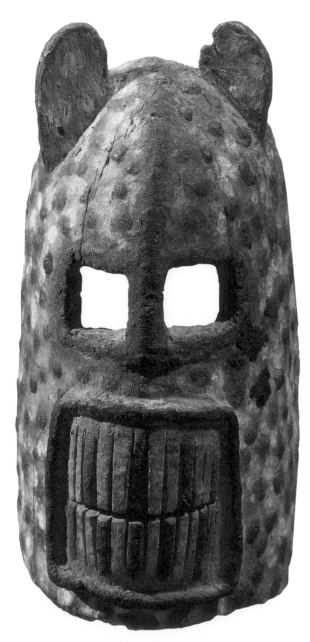

22
October

Leopard Mask, Dogon, Mali, The Graham Collection

The artist has included a lot of animals in
this picture. They seem to all be getting
along. Some are in pairs, as in the painting
of Noah's Ark.

23
October

**Look for these
details in the painting.**

Paul de Vos, The Paradise, 17th century, Kunsthistorisches Museum, Vienna

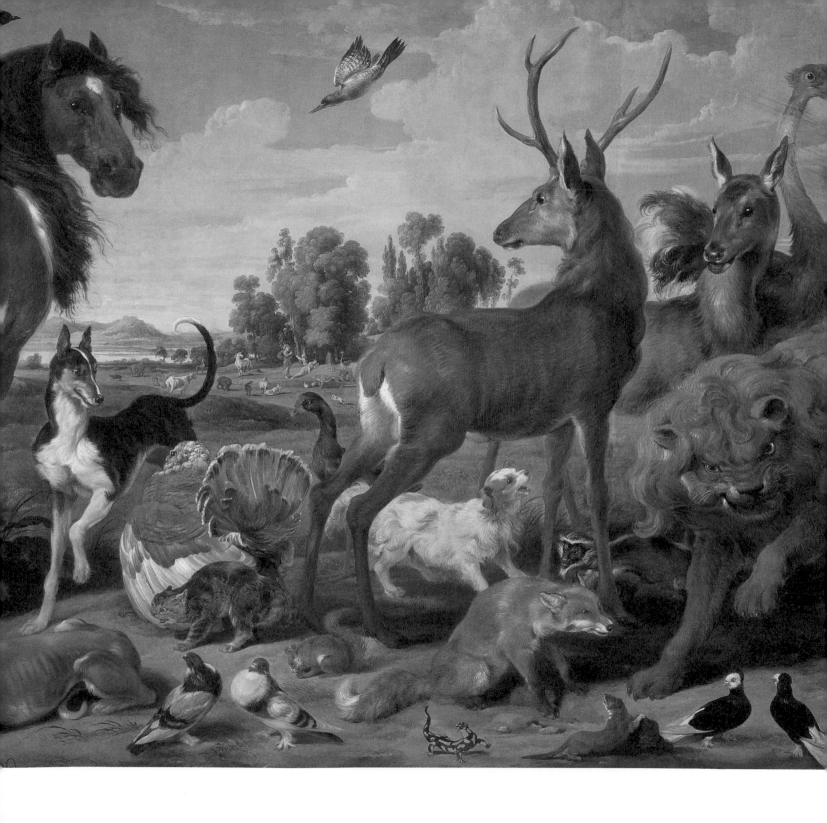

Claude Monet, Water Lilies, detail, 1916-19, Musée Marmottan, Paris

What can you not see in this picture?

a) water lillies b) willow branches c) clouds d) fish

Claude Monet, The Gare Saint-Lazare, the Normandy Train, Detail, 1877, The Art Institute, Chicago

26
October

**Look at the details
included here too!**

A steam engine pulls into a station. Imagine all of the sounds of the engine and brakes! And people too, of course! Notice all of the steam rising to the ceiling of the train station.

27
October

Leonardo da Vinci, Self-Portrait, c. 1516, Turin, Biblioteca Reale

Leonardo da Vinci was a genius of many talents: He was a painter, but also an inventor and explorer, a scientist, architect, and engineer. When he painted this self-portrait, he was 62 years old.

Which famous picture in this book did Leonardo paint?
A hint: turn back to February 22!

Leornardo da Vinci, … mit Leitern zum Landen, Ms. D, Institut de France, Paris

Here is a drawing of one of Leonardo's inventions! His drawings and explanations are very detailed. Almost 500 years ago, he imagined a kind of airplane! He imagined that passengers would climb inside using a big ladder and the weight of their bodies would help make the plane go. This is one of many, many ideas ahead of its time.

Sir Joshua Reynolds, The Waldegrave Sisters, 1780/81, National Gallery of Scotland, Edinburgh

These three women look very similar don't they? They are all relaxing. The women on the right appears to be embroidering. Notice their clothes and hair styles. This was the fashion of wealthy women when this picture was painted.

Would you like to add more to this picture?

30
October

Here is another painting that shows royalty, but this prince and king are from another part of the world. They come from Iran, which was once known as Persia. This painting tells a story. King Zahhak was told that Prince Faridun wanted to overthrow him from power. The king was afraid and so he set out to kill him.

31
October

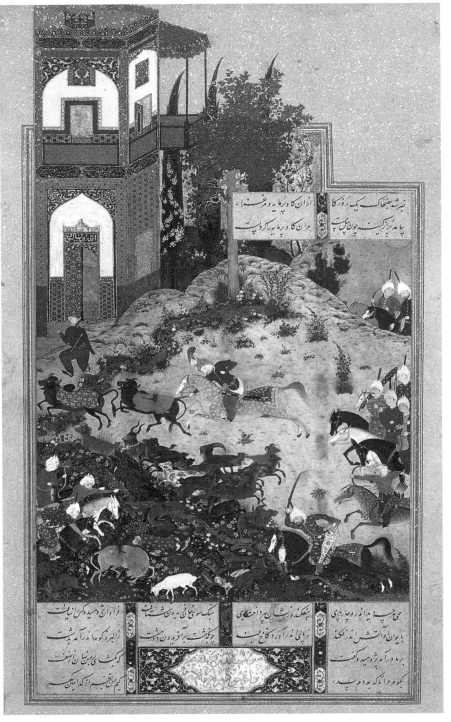

Zahhak kills Birmaye, The Sacred Cow, Which Had Suckled the Infant Faridun, c. 1520, Khalili Collection

Can you find the king? What else do you see?

1
November

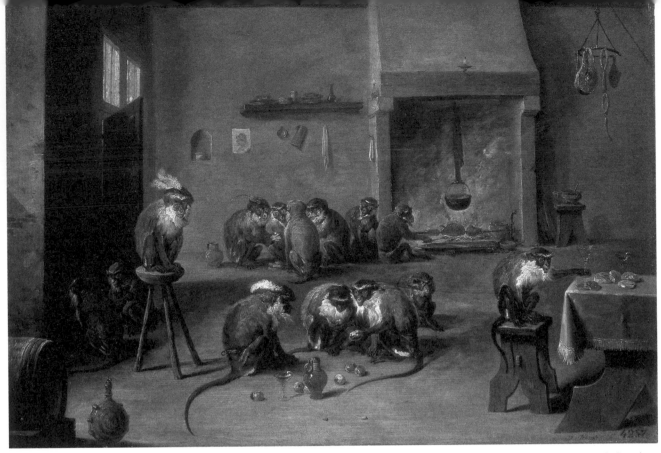

David Teniers, Monkeys in a Kitchen, 1640, The Hermitage, St. Petersburg

2
November

A kitchen full of monkeys! Even over 350 years ago, this would have been unusual.
Imagine how different our world would be if man and animals developed differently!

In this picture, the monkeys are doing things that people normally do instead:

a) play cards
b) sit at a table
c) eat
d) cook meat on a spit over a fire

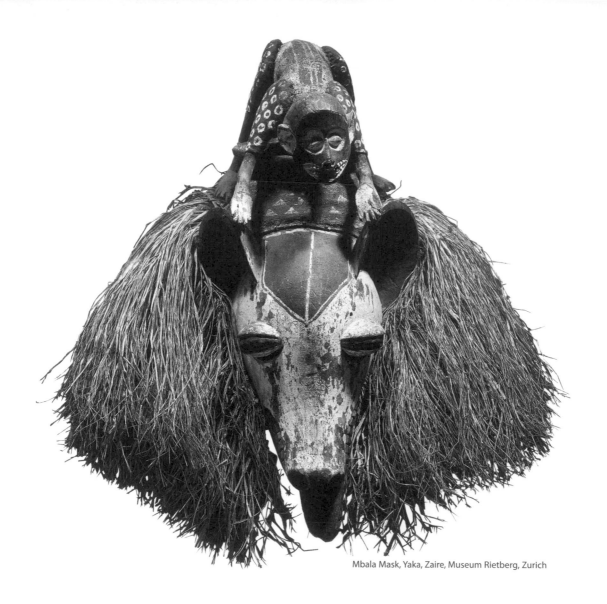

Mbala Mask, Yaka, Zaire, Museum Rietberg, Zurich

3
November

Masks were used in many celebrations and rituals in traditional African society. The celebration could be a thank-you for healthy crops of food, or a coming-of-age from childhood to adulthood. In this mask, several different animals were put together. Here, the large ears are from a hyena.

Which of the following animals is not featured on the mask?

a) monkey b) alligator c) antelope d) leopard

A large celebration among the workers is taking place.

Can you find ...

a) big fish?

b) people dancing?

c) pretzels?

d) empty baskets?

e) a man on crutches?

f) baker's peel with two fishes?

g) a man on a barrel?

h) wine jars?

4
November

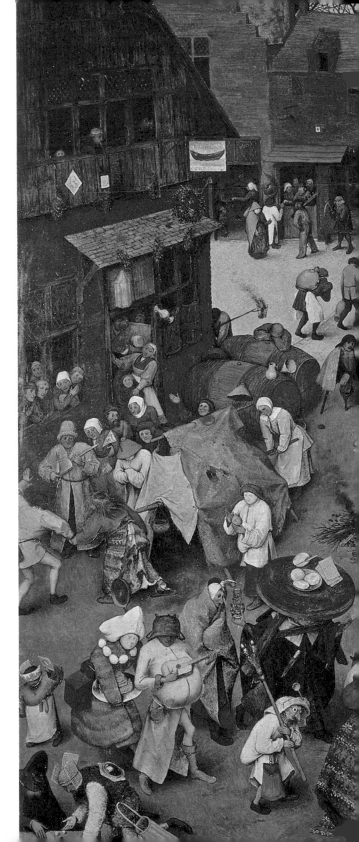

Pieter Brueghel the Elder, The Battle of Carnival and Lent, 1559,
Kunsthistorisches Museum, Vienna

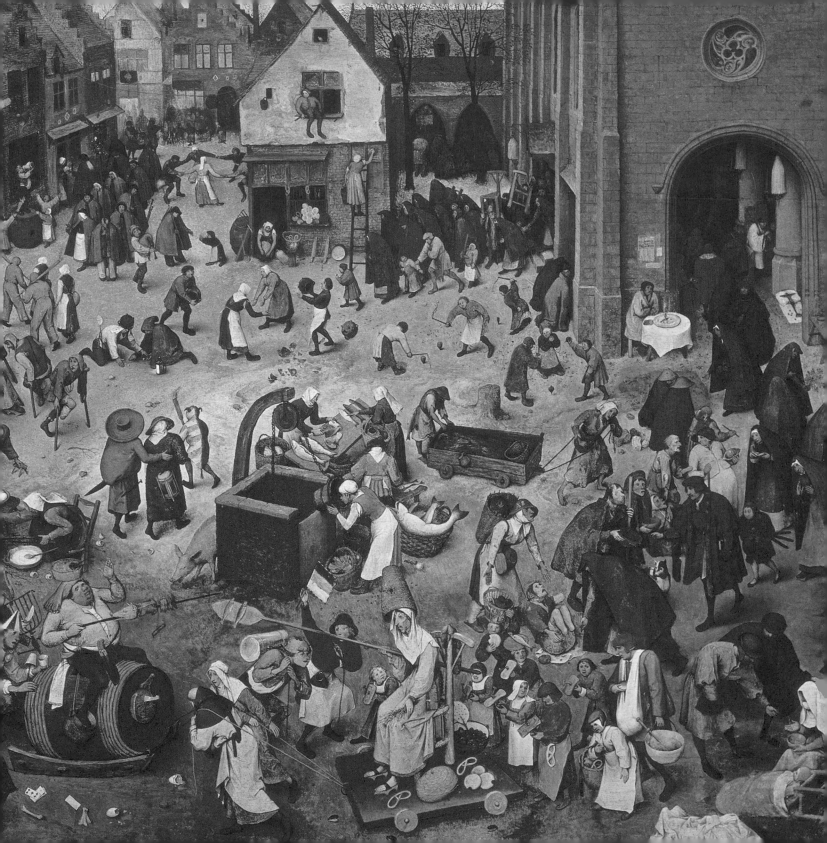

6
November

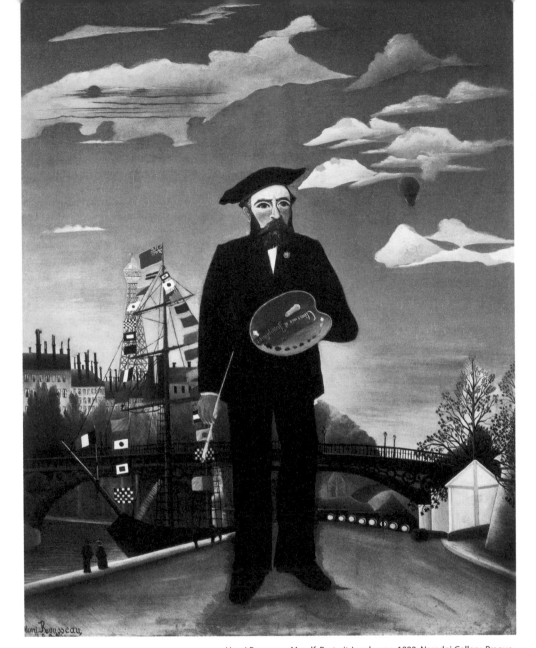

Henri Rousseau, Myself, Portrait-Landscape, 1890, Narodni Gallery, Prague

Henri Rousseau was an artist who taught himself how to paint. Look at how he has shown himself in this painting. He is holding a paintbrush in one hand and a palette for mixing colors in the other. And now we know that he was right-handed. I wonder how much of the landscape is real and how much of it was imagined?

There are some flamingos standing beside the water lilies.

Why not draw a few more!

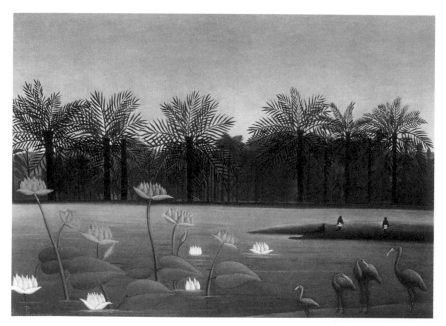

Henri Rousseau, The Flamingos, 1907, Private collection

7
November

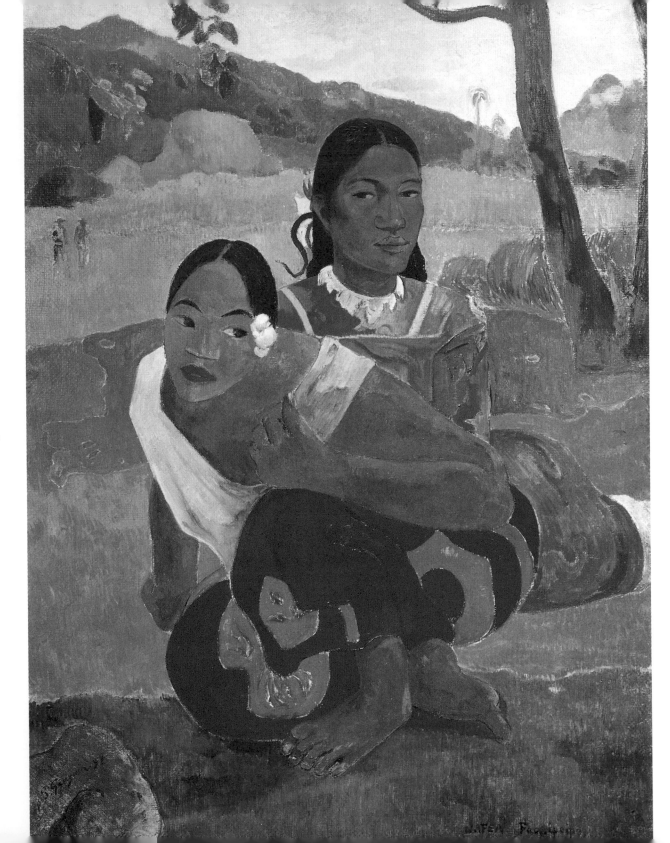

8
November

Notice the bright, intense colors and shapes in the landscape surrounding these two young women.

Do you notice any other people in the picture?
I wonder what they are thinking.

Can you find these details
in the main picture by
Paul Gaugin?

Paul Gauguin, When Are You Getting Married?, 1892,
Rudolf Staechelin'sche Familienstiftung, Basel

In the fall, when the days are shorter, the lights outside are more noticeable.

You can make your own lantern to light the night.

You will need a sheet of construction or other strong paper, scissors, glue, a night-light, and a surface to work on.

Fold the paper in half lengthways and open it up again. Now put it on the cutting board and use the knife to cut slits in the paper crossways. The slits should all be the same length and should run parallel to each other. Make sure that you leave a margin of about one inch on all sides. Roll the paper up and attach the short edges together. The fold in the paper must point toward the outside. Now turn on the night-light. The light will shine through the slits!

10
November

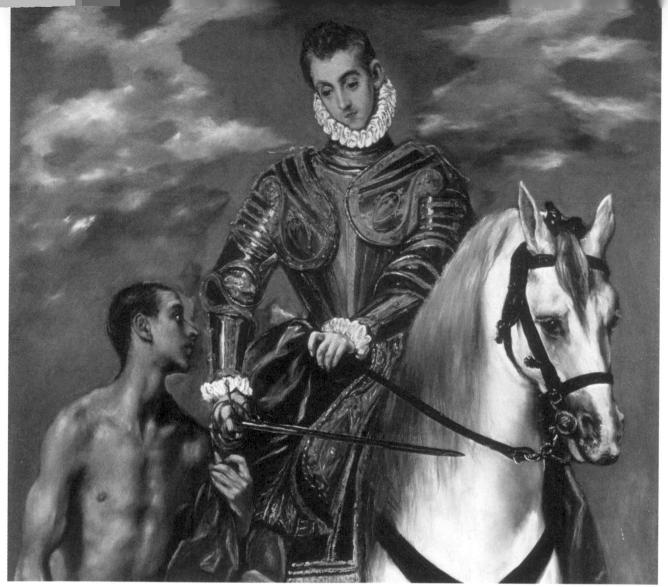

11
November

El Greco, St. Martin and the Beggar, c. 1597/99, National Gallery of Art, Washington D.C.

This picture tells a story. Martin, the man on the horse, is a soldier. While traveling, he met a poor man. It was very, very cold and the man had no clothes. Martin stopped to help the man, unlike other passers by. He only had the clothes he was wearing, so he cut his coat with his sword into two pieces to share with the man.

12
November

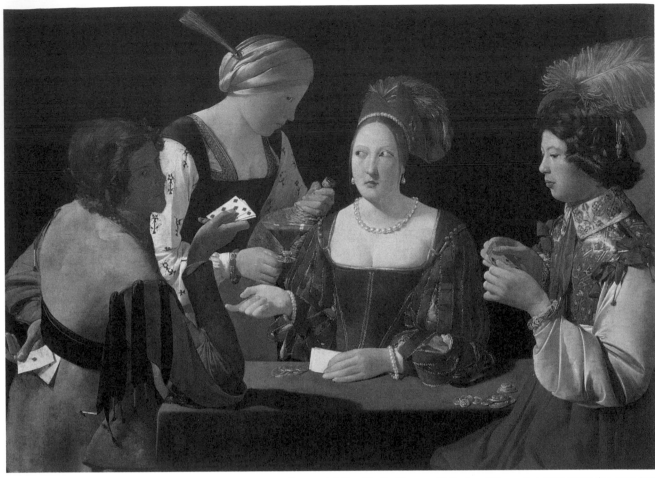

Georges de la Tour, The Cardsharper with the Ace of Diamonds, c. 1630, Musée du Louvre, Paris

A card game over 400 years ago! But someone in the group is cheating:

Can you tell who it is? Or who they are?

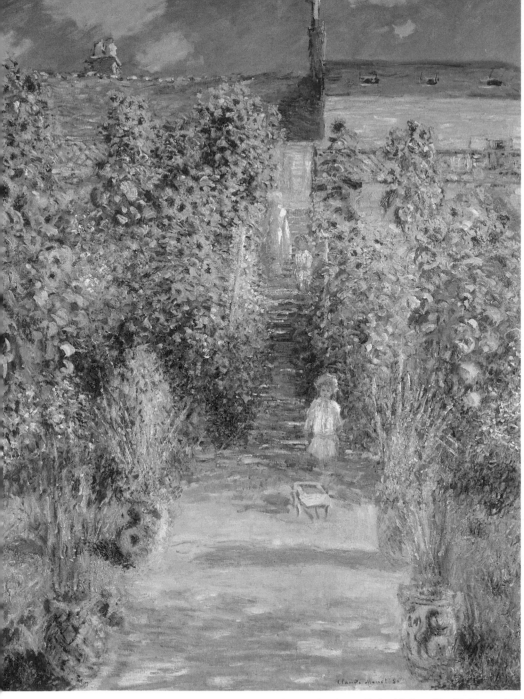

Claude Monet, The Artist's Garden at Vétheuil, 1880, National Gallery of Art, Washington, D.C.

This large beautiful garden belonged to the painter Claude Monet. He loved to paint the flowers and the colors of the changing light outside.

How many people are enjoying this day in his garden?

Find the details too!

13
November

14
November

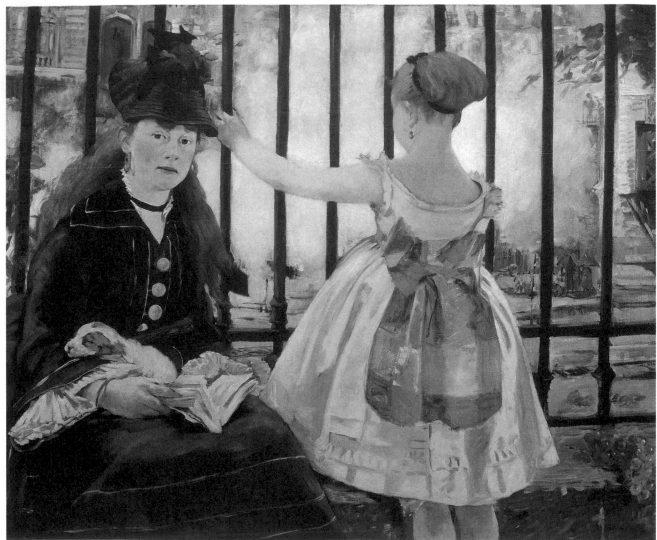

Edouard Manet, The Railway, 1873, National Gallery of Art, Washington D.C.

At the railroad station a mother is looking up from her book while a small dog sleeps.
Her daughter is looking at …

**You can write a story about her. What do you
think they might be waiting for? How will you begin?**

..

..

..

..

..

15
November

..

..

You can add a drawing here.

16
November

Master Bertram, Parting of the Water and the Creation of the Heavens and the Stars. Detail from the Altar of St. Petri, 1383, Kunsthalle, Hamburg

This painting is part of a larger painting from more than 600 years ago! It shows part of a story about of the begnning of the world: the parting of water and arrival of stars and the heavens.

Now imagine you could create the world from scratch yourself.

What would you make, and what would you leave out?
Here you can draw a picture of your world!

17
November

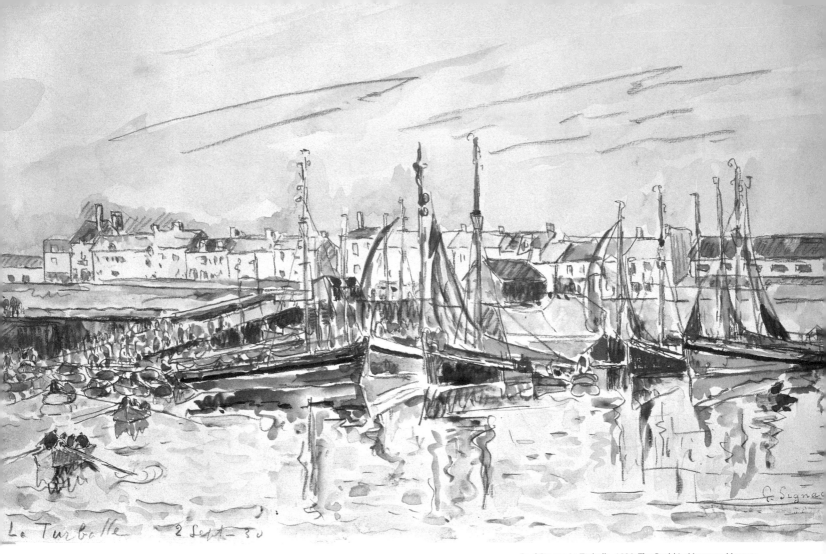

Paul Signac, La Turballe, 1930, The Pushkin Museum, Moscow

Many painters draw a sketch first before they begin their painting. It is easier to make quick sketches of ideas in pencil. You can draw almost anywhere. Lots of artists always carry a sketch pad and pencils with them, just as writers often have a notebook in their pocket. How do you record the beautiful things you have seen? Do you write them down or do you prefer to make a sketch?

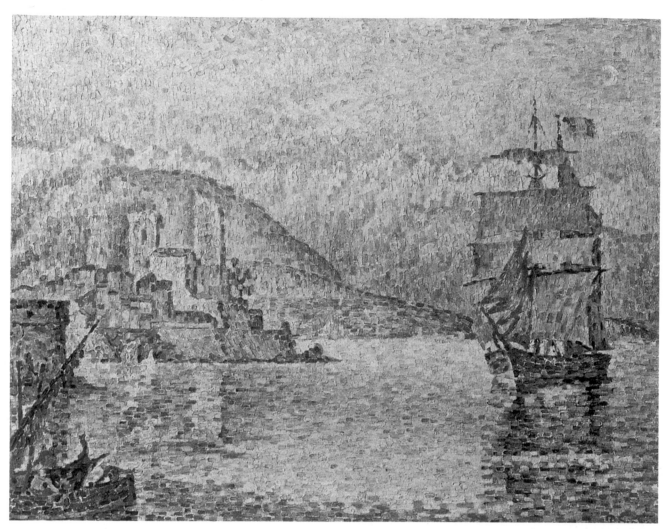

Paul Signac, Antibes, Evening, 1914, Musée des Beaux-Arts de la Ville, Strasbourg

19
November

Paul Signac loved boats—but this one looks quite different from yesterday's. Which technique has he used for both pictures? You can try it out yourself:

With paper and pencil draw the rough outline of a ship and the horizon line between the sea and sky. Then choose a color for the ship, one for the sky, and one for the sea. Choose colors that go well together. Now fill in the areas you have drawn with dots of color.

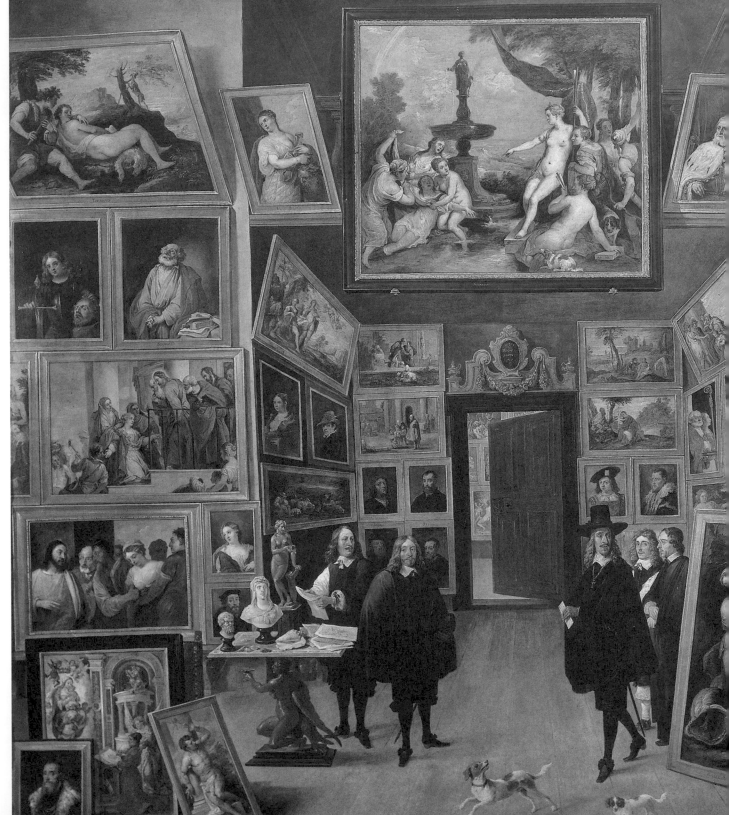

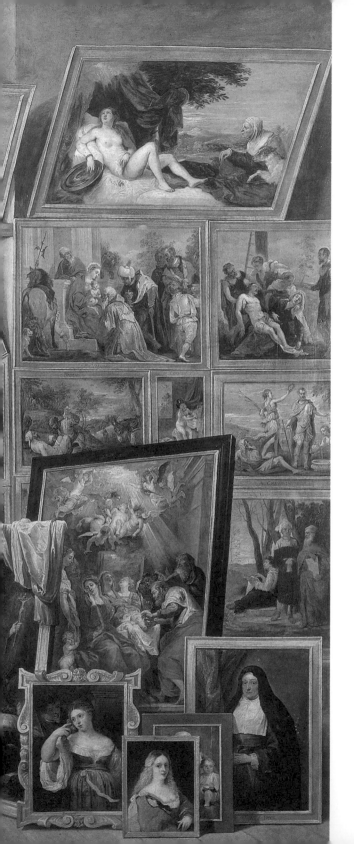

How could people show that they were wealthy, well-educated, and knew a lot about art? Archduke Leopold Wilhelm of Austria had a portrait painted that showed himself with his picture collection. He was very proud of his artworks that he had purchased from famous artists from all over the world. Some pictures have just arrived in his gallery.

Can you find ...

* angels?

* a fountain?

* a small dog?

Look through the door.
What do you see?

21
November

David Teniers, The Archduke Leopold Wilhelm in his
Picture Gallery in Brussels, 1650/51, Prado, Madrid

Here is a picture of part of another Greek myth. In this myth, Mother Thetis was frightened—she had seen into the future and learned that her son Achilles would die at a young age during the Trojan War. She wanted to protect him and so she dipped him in the magical River Styx. He then traveled to a distant island, where he was disguised as a girl and brought up with the princesses of King Lycomedes. Later, when the warships were ready to sail to Troy, Achilles was nowhere to be found. How could the Greeks hope to win without the bravest of all warriors? Where could he possibly be? Clever Odysseus thought of a trick to find him. He disguised himself as a jewelry seller and offered the most beautiful rings, pearls, and necklaces to the court. The king's daughters were delighted, but Achilles was more interested in the weapons that Odysseus had also brought with him. He had revealed himself as a potential soldier! The centaur Chiron, who you can see in this painting, helped Achilles become a great warrior by teaching him to use a bow and arrows.

22
November

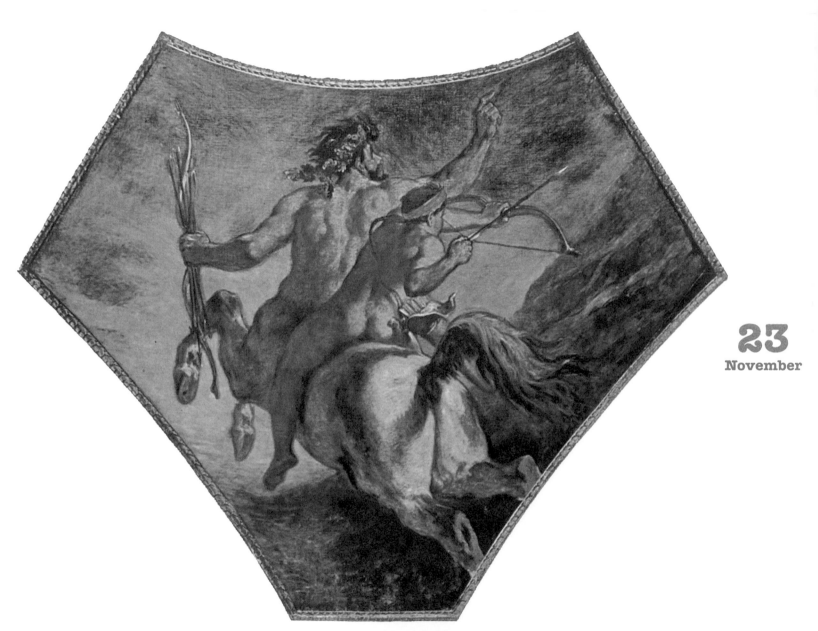

23
November

Eugène Delacroix, The Education of Achilles,
1850, Palais Bourbon, Paris

24
November

How many birds are here?

Do you wonder why the artist added color in only 2 places?

What will you add here for your own picture?

25
November

Birdman

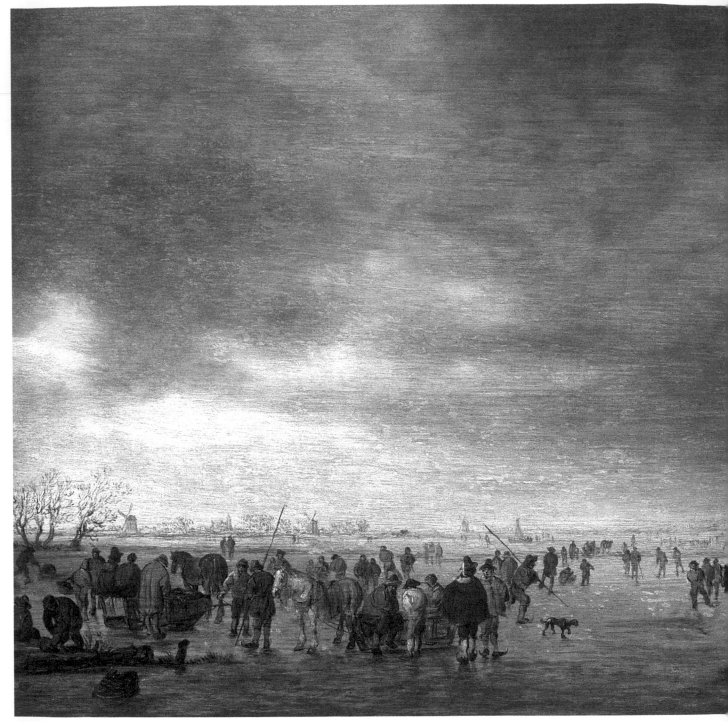

26
November

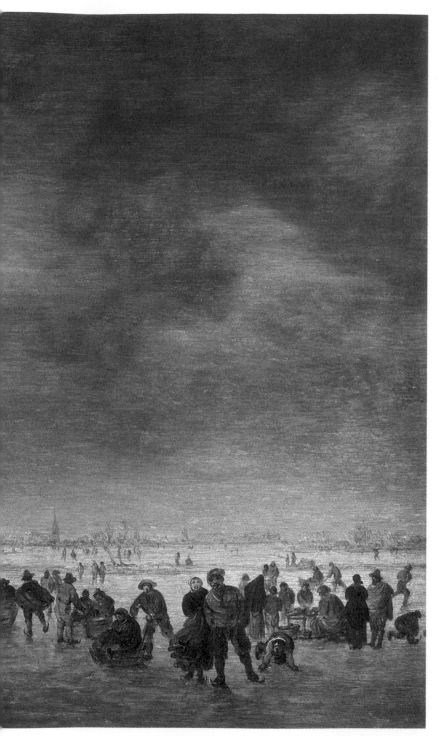

Jan van Goyen, Ice Skaters, 1630/1640, The Pushkin Museum, Moscow

This picture is mostly sky. But look how much color is used to show the sky and the ice below! Can you see the ice skaters? On the horizon, you can see far-away houses.

Where in the picture can you see ...

* a horse-drawn sleigh?

* a steeple?

How many windmills can you make out?

27
November

28
November

Edouard Manet, At the Café, 1878, Oskar Reinhart Collection, Winterthur

This painting was originally much larger. The painter cut his work into two pieces! Each half has its own name. Do you think this was the left or right side? This picture was the right side! It shows three people at a café.

What do you think could originally be seen on the left-hand side of the canvas? Can you complete the other half of the picture?

29
November

Here we can see an artist at work, painting a portrait at his easel in his studio. He steps back, holding his brush and palette, looking at his work. To the right of the painting is his model, the subject of his painting. The light from the open window highlights him. He may have to sit patiently for a while. Sometimes it can be hard to make a client happy. They may not see themselves the way the artist sees them. Do you think the artist will be successful in pleasing this man?

What should the artist do?

a) add more hair
b) change his nose
c) get rid of his double chin
d) eliminate his wrinkles
e) paint him as he is

Do you notice anything on the window sill?

1
December

Carl Spitzweg, The Portrait Painter, c. 1858, Private collection

2
December

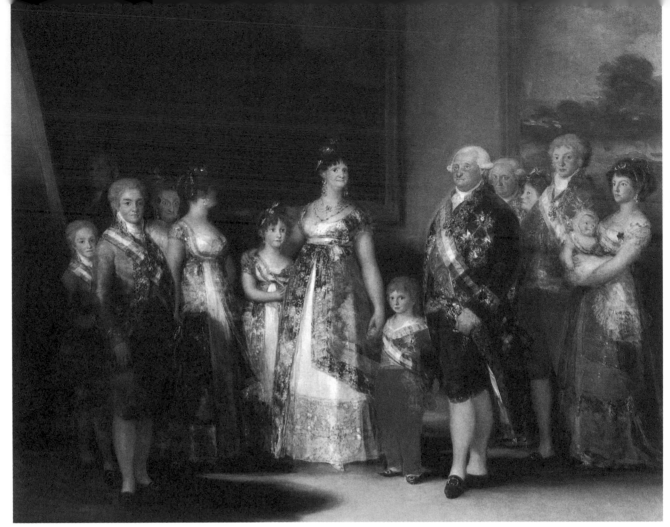

Francisco de Goya, Portrait of the Family of Charles IV, 1800/01, Prado, Madrid

Here the Spanish artist Francisco de Goya painted the family of King Charles IV of Spain. I'm sure they all had to stand still for a very long time for this portrait. Perhaps that is why they all look so solemn and serious.

Can you find these details in the main picture?

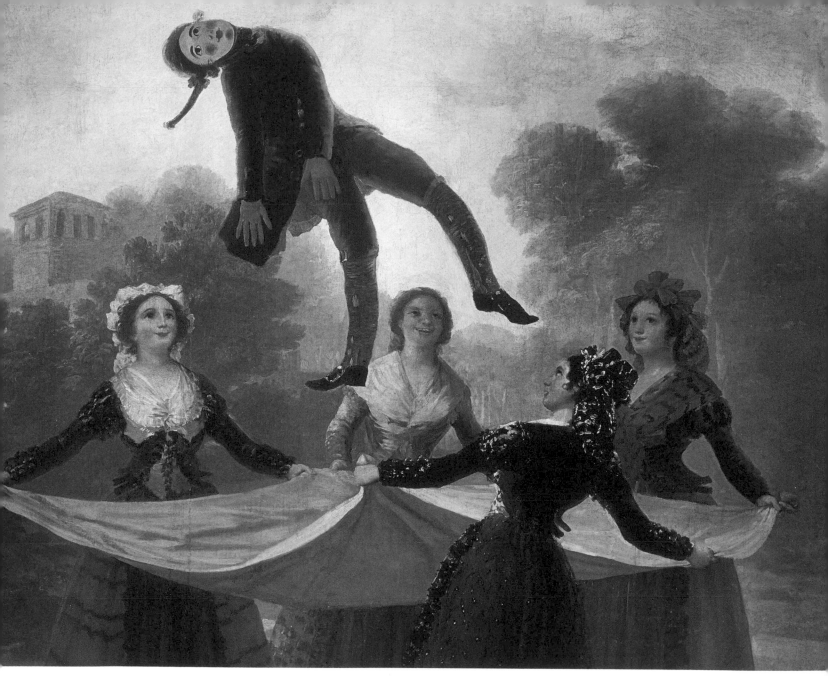

Francisco José de Goya, The Puppet, 1791/92, Prado, Madrid

For many years Goya worked as a court painter in the service of the kings of Spain. But he felt unhappy about his job for a long time. He saw himself as a puppet, as he shows himself here in this painting. Goya felt controlled as a court painter.

This picture has part of a
frame included within it.

**What is outside
the frame within
the picture?**

**Why do you think
the artist made
this choice?**

**Is it telling us
something about
what is going
on in the picture?**

4
December

Riza-i' Abbasi, Feast in a spring landscape, 1612, The Hermitage, St. Petersburg

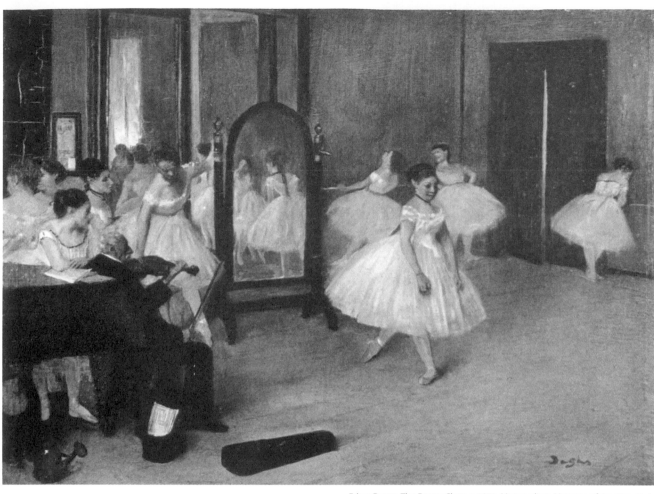

5
December

For the artist Edgar Degas, one of his favorite subjects to paint was dance. In this painting, several young girls are waiting for an audition. The dance studio has mirrored walls and objects scattered on the floor.

Do you recognize what they are?

Can you find these details in the main picture?

6
December

Another picture of a cold winter day.
People seem to be enjoying it—lots
of ice skaters, hockey players, and …
what else do you see? This artist
was never able to hear, even as a
young child. Perhaps this helped
him become such a terrific observer
and artist.

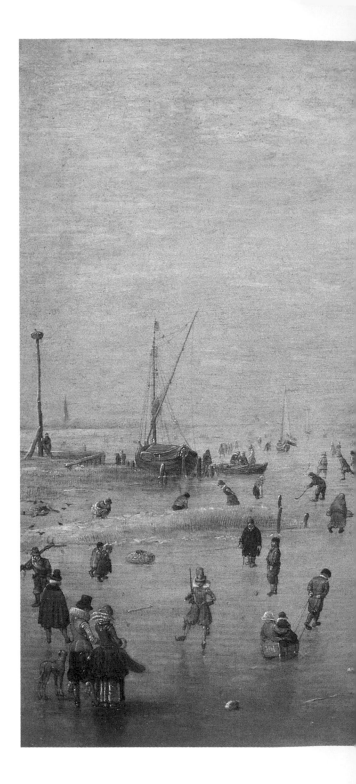

7
December

Hendrick Avercamp, Skaters, 1620s, The Pushkin Museum, Moscow

8
December

Franz Xaver Winterhalter, Elisabeth of Austria, 1865, Kunsthistorisches Museum, Vienna

Her real name was Elisabeth, but everyone called her Sisi.
At 16, she became an empress! She was famous for her beauty,
confidence, and style.

You can design more clothes for Sisi! Just color in the dress below, cut it out, and your paper doll can go to the ball!

9
December

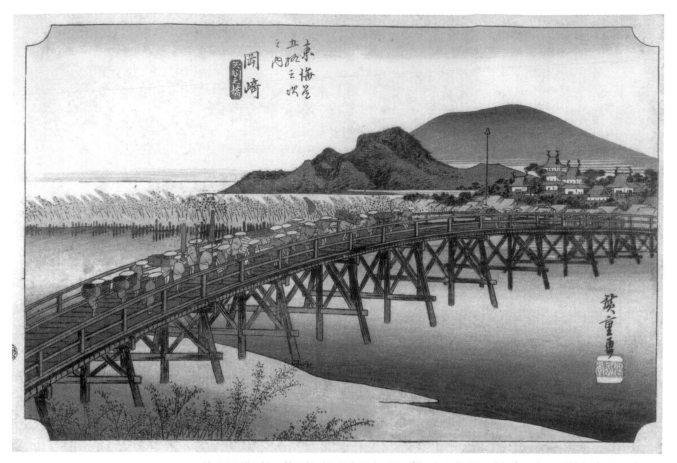

Utagawa Hiroshige, Okazaki, plate 39 from the series "Fifty-three Stations of the Tokaido," c. 1833/34, Private collection

11
December

People here are pictured traveling in Japan, from Edo, now known as Tokyo, to Kyoto, another large city where the Emperor lives. This was a long trip and there were many places to stop and rest. Look how differently the water and sky are painted than some of the pictures that you've already seen. Different parts of the world have different ways of expressing their vision. Some artists, like Vincent van Gogh, were influenced by Japanese art.

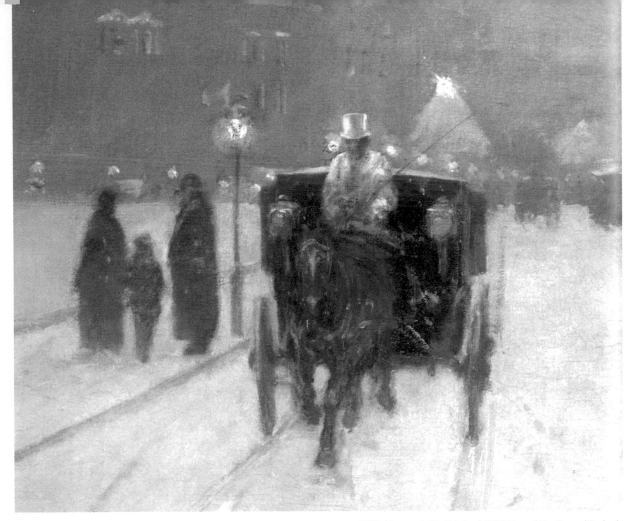

Childe Hassam, A City Fairyland, 1886, Mr. and Mrs. Samuel Peabody

12
December

Evening is approaching and the light is changing. The gas lanterns and horse-drawn carriage show a very different world from our cities and towns of today.

Find the details in the main picture.

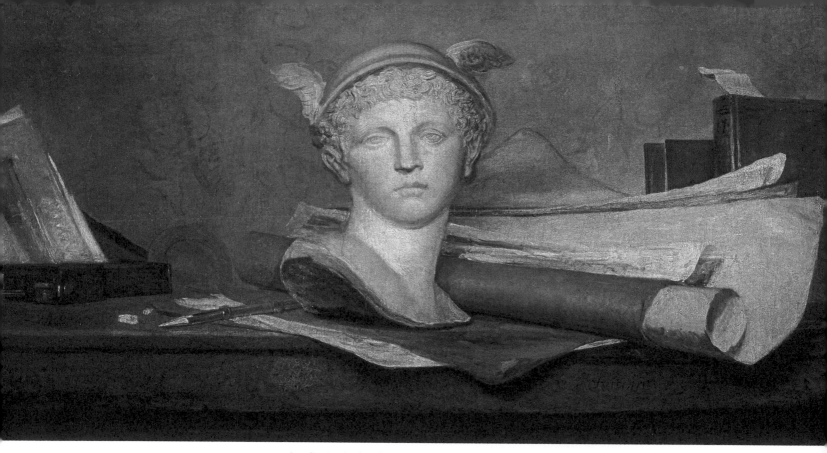

Jean-Baptiste Siméon Chardin, Still-Life with Attributes of Art, late 18th century, The Pushkin Museum, Moscow

In this picture is a statute of Mercury. You can recognize him by the wings on his helmet. In Greek mythology, he was the messenger of the gods. Around him are scrolls of paper and books. The artist has used various symbols to stand for the different artistic disciplines: sculpture, painting, and literature.

Can you match the symbols to the different artistic disciplines: sculpture, painting, and writing?

a) the statute of Mercury b) paper c) books

Charles Hunt, The House of Cards, 19th century, Forbes Collection, New York

Have you ever tried to build a house of cards?
The boy in this painting is trying.

How many cards has he used so far?

Mary Cassatt, Profile Portrait of Lydia Cassatt, 1880, Musée du Petit Palais, Paris

Lydia was the sister of Mary Cassatt, the painter. She often modeled for Mary. If you look at more paintings by Cassatt, you may see her again.

Can you find these details in the main picture?

15
December

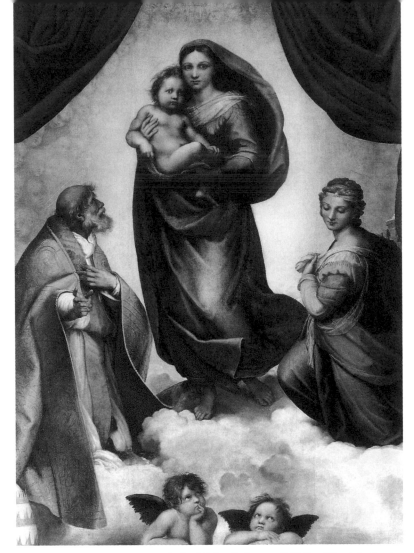

Raphael, Sistine Madonna, c. 1513, Gemäldegalerie, Dresden

16

December

Here is a section of a large painting, painted almost 500 years ago! Look at the expression on all of the faces. You can see the angels at the bottom up close on the next page!

You can cut out these angels and use them for cards
or hang them with string or thread.

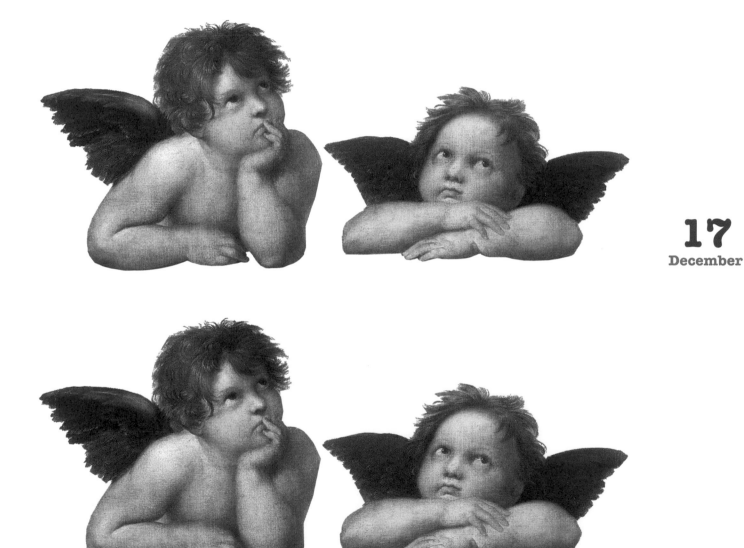

17
December

Raphael, Sistine Madonna, Detail of the Angels, c. 1513, Gemäldegalerie, Dresden

18
December

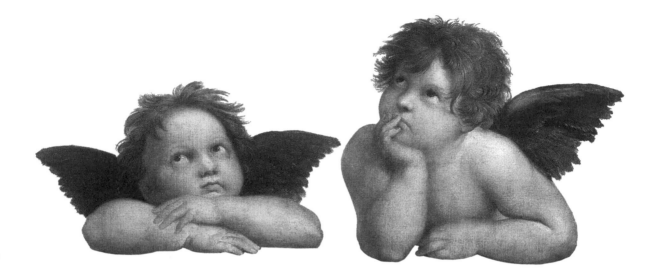

If you could eat one of these pieces of fruit, which one would you choose? On the right, part of the picture is extending off the edge of the canvas. Imagine what it is and expand on the picture.

There is room to add more too!

19
December

Caravaggio, Fruit Basket, c. 1593/94, Pinacoteca Ambrosiana, Milan

Titian, Self-Portrait, c. 1567, Prado, Madrid

20
December

Titian was famous for bringing what he painted to life.
Many wanted their portraits painted by him—noblemen,
even popes. The emperor Charles V was so pleased with
Titian's pictures that he brought him to court and called
him the Knight of the Golden Spur.

Can you find these details in the picture on the right?

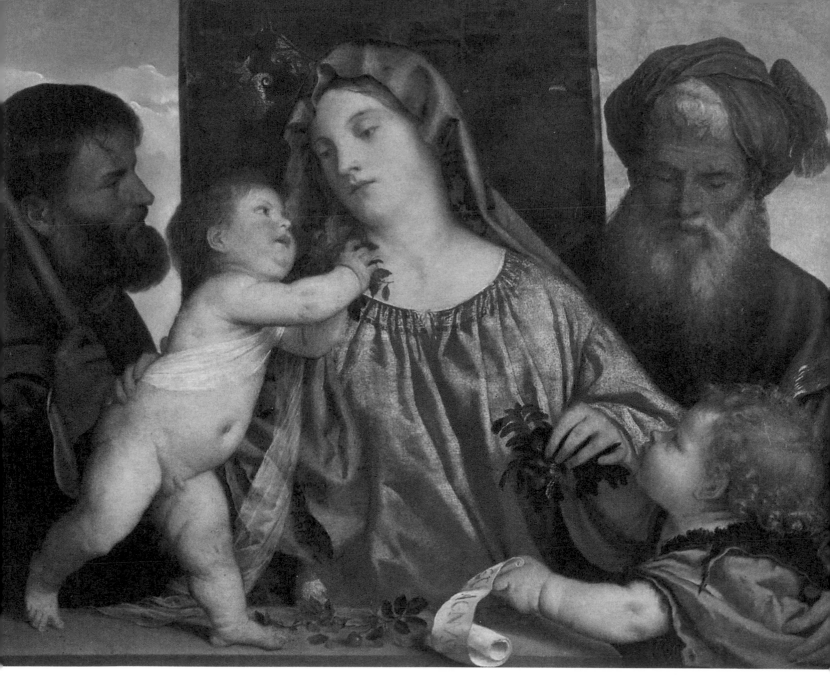

Titian, Virgin with Child and Saints George, Zacharias and John the Baptist (Madonna of the Cherries), c. 1516-18, Kunsthistorisches Museum, Vienna

Look at the dress of the "Madonna of the Cherries"
and you know why Titian's Red became so famous!

22
December

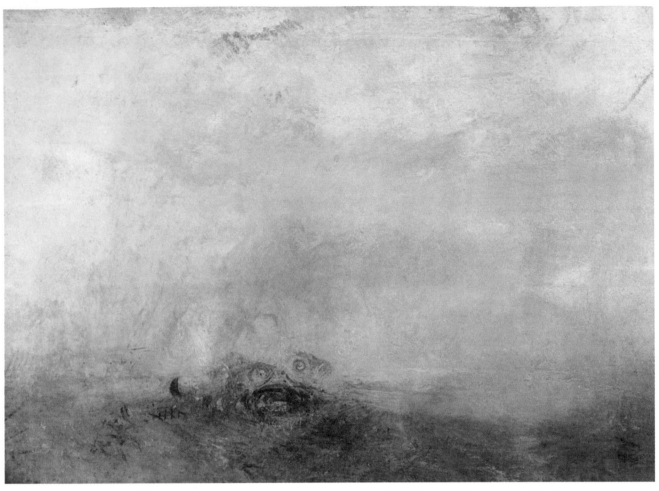

J. M. W. Turner, Sunrise with Sea Monsters, 1845, Tate Gallery, London

Sea monsters! The title of this picture sounds
really gruesome! And yet the colors look cheerful
enough, don't you think?

Can you spot the sea monsters in the picture?

By the way, the Tate Gallery is a great museum.
If you ever go to London, don't forget to visit it!

Write your ideas and thoughts about this painting by J. M. W. Turner.

...

...

...

...

...

...

...

23
December

...

...

24
December

Stephan Lochner, Madonna in the Rose Bower, c. 1450, Wallraf-Richartz-Museum, Cologne

The angels are surrounding the Madonna and Child. Some are playing music on their instruments.
The Child holds a golden apple, a symbol of power often shown with kings. It is Christmas, the birthday
of Jesus Christ.

**Can you find
these details in
the picture?**

There is a lot to see.

**You can draw another
Christmas picture here!**

25
December

A fancy room, elegant clothes,
music, food …

Can you find …

* a man playing the lute?

* a raised wine glass?

* two children with a dog?

26
December

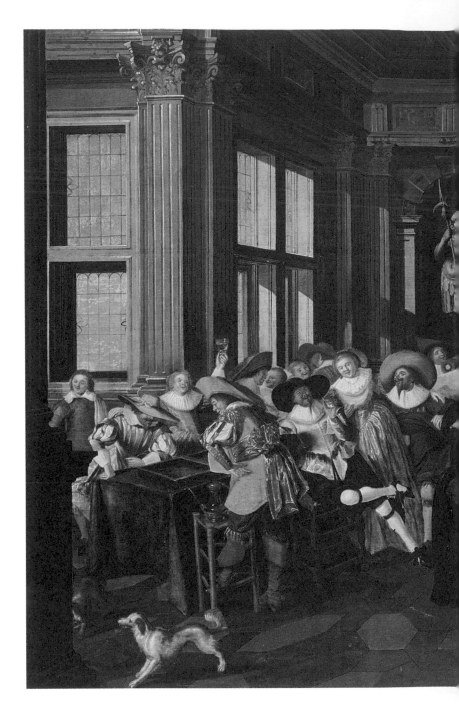

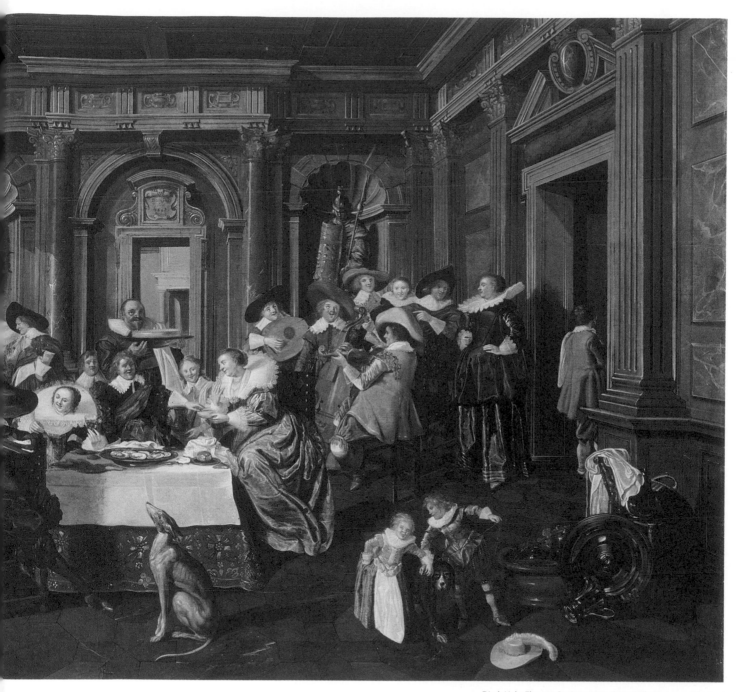

27
December

Dirck Hals, Elegant Society 1628, Frans Hals Museum, Haarlem

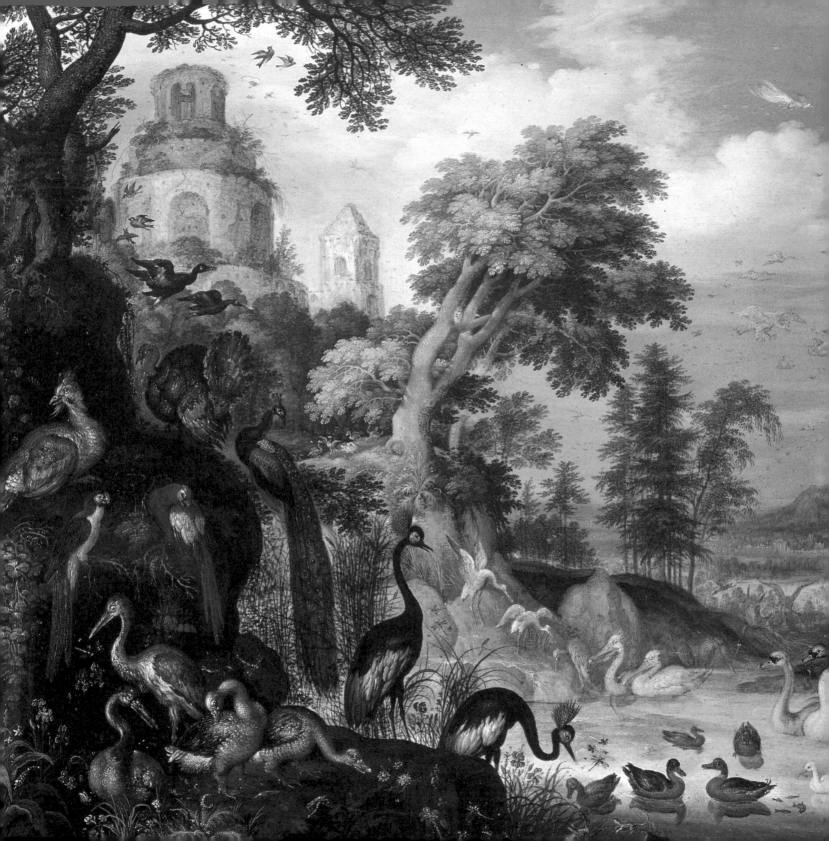

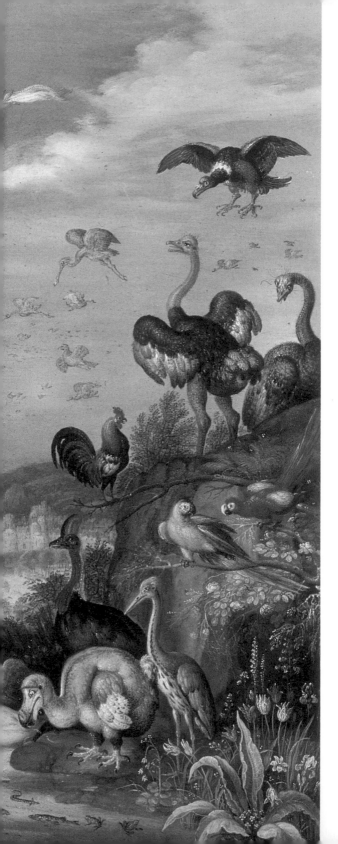

There are so many birds in this picture!

Do you recognize ...

a) peacocks?
b) swans?
c) parrots?
d) chickens?
e) a rooster?
f) ostriches?

You can draw more here!

29
December

Roelant Jakobsz Savery, Landscape with Birds, 1628, Kunsthistorisches Museum, Vienna

Utagawa Hiroshige, Arai, from "Fifty-three Stations of the Tokaido," c. 1833/1834

The boats in this picture appear to be sailing toward the land in the distance. The land has little color

Can you see ... 🌸 a sleeping passenger? 🌸 two coats of arms? 🌸 Japanese calligraphy?

It is the last day of the year. There is space here
to draw some of your wishes and dreams.

Happy New Year!

31
December

The Answers

Heads up! Below, you will only find the answers to the trivia questions. All other questions and puzzles you can answer yourself with the help of your own observational skills and imagination.

January 1: b

January 5:

a) To sit on hot coals (you sit on hot coals when you are impatiently waiting for something)

b) To bang one's head against a brick wall (you bang your head against the wall when you are frustrated)

c) To throw one's money out the window (when you throw your money out the window you are spending it on silly things)

d) To be as meek as a lamb (when you are very patient and quiet, then you are as patient and as quiet as a lamb)

e) The world turned upside down (when everything is the exact opposite as it should be)

f) To swim against the stream (you have a different opinion than most other people)

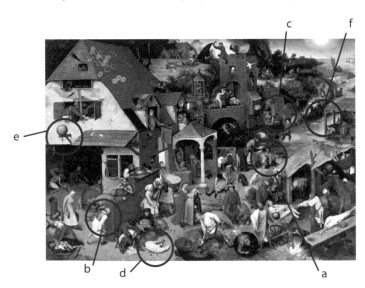

Are you curious? You can look up all the 80 Dutch proverbs the painter painted in the internet under: http://en.wikipedia.org/wiki/Netherlandish_Proverbs

January 12: b. Japanese art was, at the time, a model for many artists.

January 22: there are 2 foxes.

January 27: c

January 28: b

February 1: You can tell from the foreign letters on the book and the pieces of paper that Hieronymus could read many different languages.

February 9: b

February 12: a

February 19: a

February 21: b. A rainbow is comparable to a prism. A prism separates white light into a group of 7 colors called a spectrum. These seven colors are always in the same order. The colors of the spectrum are red, orange, yellow, green, blue, indigo, and violet.

March 3: c

March 5: a

March 7: b

March 9: spring

March 12: a. Moby Dick is the name of the whale in the famous novel Moby Dick by Herman Melville.

March 13: b

March 18: spring

March 21: c (Africa, America, Asia, Australia, and Europe)

April 10: c. This is a picture of the Waterloo Bridge in London.

April 23: On this mask there is an antelope, a hyena, a rooster, a snake, and a bird.

April 27: The owl is a symbol of wisdom and Athena was also known as the goddess of wisdom.

April 28: b

May 2: b

May 6: b. There are roses, lilies, irises, forget-me-nots, and many others!

May 19: a. A sculpture that shows a persons head and shoulders is called a bust.

May 20: b

May 21: a. Prometheus was saved from his punishment only many hundreds of years later.

May 24: left: The country dance is on the left and the city ball is on the right.

June 6: b

June 8: a

June 9: blind man's bluff

July 2: rooster

July 10: b

July 11: c

July 13: a

July 27: e

July 28: c

July 29: a.

August 12: The answer is b for both questions. By the way, an ermine is a type of weasel.

August 28: b

August 31: The answer is a for both questions.

September 13: c

September 16: In this painting you can find a guitar, a cello, a violin, a trombone, a mandolin, a flute, and two lutes.

October 1: The painter shows the noise of the city by drawing wild horses.

October 4: Moses was found on the banks of the Nile by the Pharaoh's daughter. You can read this story in the Bible if you would like to know more.

October 5: In this picture, the artist uses an apple for cheeks, grapes for hair, chestnuts for a mouth, and mushrooms for ears.

October 22: The animal represented is a cheetah.

October 25: d

October 27: The Mona Lisa

November 3: b

November 12: The person cheating is sitting on the left. He is hiding cards behind his back!

December 13: a) statue of Mercury = sculpture; b) paper = painting; c) books = writing

Authors: Christiane Weidemann, Anne-Kathrin Funck, and Doris Kutschbach

Cover: Andy Warhol, *Sam*, illustration from *25 cats name Sam*, 1954.

© Prestel Verlag, Munich · Berlin · London · New York 2009

© for the works by Marc Chagall, Jasper Johns, Wassily Kandinsky und Sol LeWitt: VG Bild-Kunst, Bonn 2009; Frida Kahlo: Banco de México Diego Rivera & Frida Kahlo Museums Trust / VG Bild-Kunst, Bonn 2009; Henri Matisse: Succession H. Matisse / VG Bild-Kunst, Bonn 2009; Pablo Picasso: Succession Picasso / VG Bild-Kunst, Bonn 2009; Birdman: © Birdman, Hans Langner, Bad Tölz 2009; Andy Warhol: The Andy Warhol Foundation for the Visual Arts / Artists Rights Society, New York 2009.

British Library Cataloguing-in-Publication Data: a catalogue record for this book is available from the British Library; Deutsche Nationalbibliothek holds a record of this publication in the Deutsche Nationalbibliografie; detailed bibliographical data can be found under: http://dnb.ddb.de

Prestel books are available worldwide. Please contact your nearest bookseller or one of the addresses below for information concerning your local distributor.

Prestel Verlag
Königinstrasse 9, 80539 Munich
Tel. +49 (0)89 24 29 08 300
Fax +49 (0)89 24 29 08 335
www.prestel.de

Prestel Publishing Ltd.
4, Bloomsbury Place, London WC1A 2QA
Tel. +44 (0)20 7323-5004
Fax +44 (0)20 7636-8004

Prestel Publishing
900 Broadway, Suite 603, New York, NY 10003
Tel. +1 (212) 995-2720; Fax +1 (212) 995-2733
www.prestel.com

Picture credits
akg-images: Apr. 20, Jul. 4, Aug. 20/21
Artothek: Jan. Jan. 4/5, 6/7, 18, 25, Mar. 27, Apr. 10, 16, May 3, 4, 7, 8, Jun. 9/10, 15, 21/22, 23/24, 27, 30, Jul. 20, Aug. 16, 22, Sept. 1, 21, Oct. 8, 11, 13, Nov. 11, 18, 26/27, Dec. 6/7, 13, 16, 24, 26/27; Artothek/Blauel Gnamm: Jan. 1; Feb. 15, Mar. 16, Apr. 12, May 21, Jun. 25/26; Artothek/Joachim Blauel: Jan. 8, 16/17, 26, May 16, Jun. 5, 17/18, 19, Jul. 1, 5/6, 29, Aug. 6, 10, 23, Sept. 3, 5, Oct. 3, 9, 15/16, 19, 29, Nov. 16; Artothek/Peter Willi: Jan. 9, 21, May 13, Jun. 3, 13/14, Jul. 25, Aug. 9, 13, 19, Sept. 13, Dec. 14; Artothek/Jochen Remmer: Jan. 24, Feb. 11, Jun. 11, Aug. 26/27, Oct. 17, Nov. 28; Artothek/Joseph S. Martin: Jan. 28, Feb. 5, 20, Mar. 7/8, 18, 19, May 18, Aug. 1, Sept. 17, 19/20, 27, Oct. 1, Nov. 4/5, 14, 20/21, Dec. 3; Artothek/Paolo Tosi: Feb. 3/4, 13/14, Jun. 7/8, Aug. 15; Artothek/Photobusiness: Feb. 9/10, 25/26, Mar. 3/4, Apr. 30, May 14, 26, Sept. 11/12, Dec. 28/29; Artothek/Claus Hansmann: Mar. 13/14; Artothek/Christie's: Jul. 30; Artothek/Sophie-R. Gnamm: Sept. 16, 29; Artothek/Westermann: Jan. 15, Artothek/Bayer&Mitko: Mar. 12, Apr. 4; Artothek/U. Edelmann – Städel Museum: Mar. 29
bpk: Mar. 15, Oct. 7; bpk/Jörg P. Anders: Mar. 1, 25, Aprl 1, 14, 18/19; bpk/Jürgen Liepe: Mar. 2

Project Management: Doris Kutschbach
Assistance: Andrea Weissenbach
Translated by: Jane Michael, Munich
Edited by: Debra Pearlman and Ryan Newbanks
Copyedited by: Reegan Köster
Design: Michael Schmölzl, agenten.und.freunde, Munich
Layout: Meike Sellier, Munich
Art direction: Cilly Klotz
Production: Nele Krüger
Origination: Reproline Mediateam, München
Printing and Binding: C&C Printing

Printed in China
ISBN 978-3-7913-4355-6